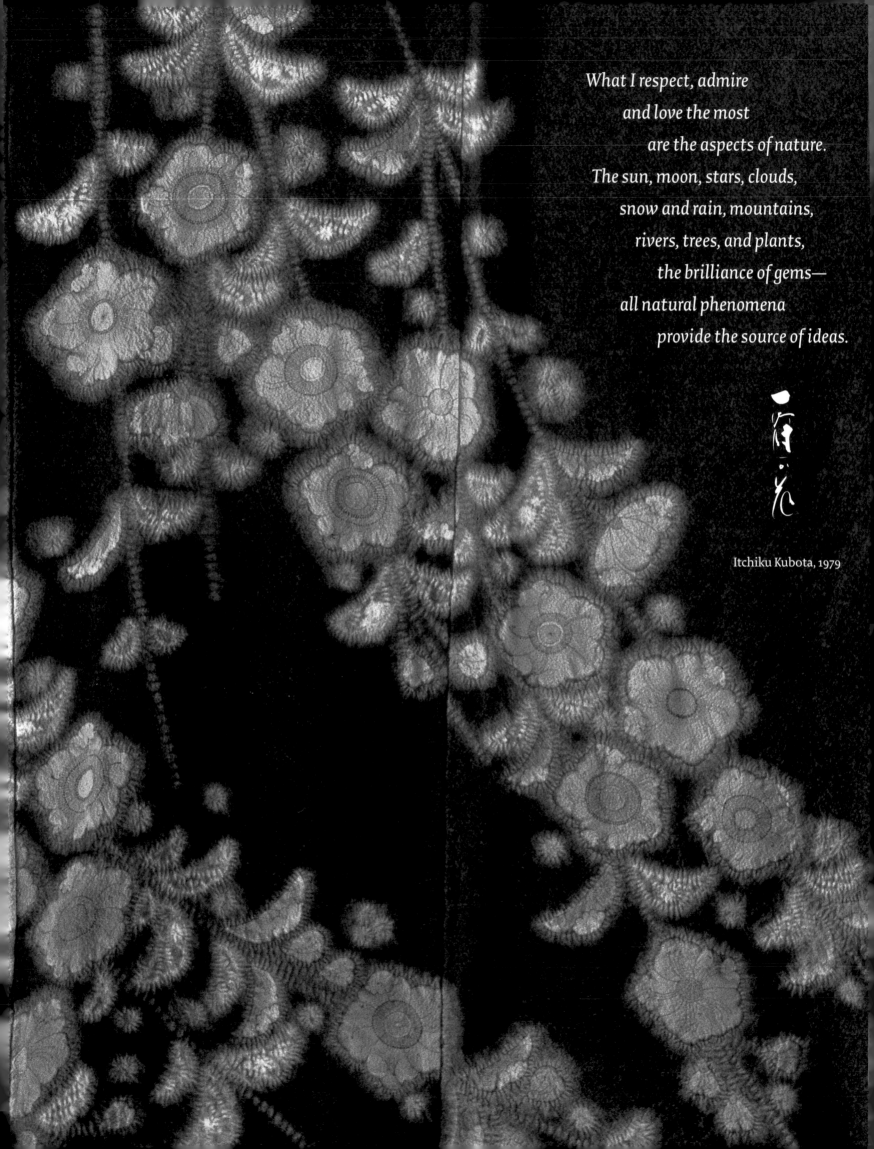

What I respect, admire
and love the most
are the aspects of nature.
The sun, moon, stars, clouds,
snow and rain, mountains,
rivers, trees, and plants,
the brilliance of gems—
all natural phenomena
provide the source of ideas.

Itchiku Kubota, 1979

Kimono as Art
The Landscapes of Itchiku Kubota

EDITED BY

Dale Carolyn Gluckman

WITH ESSAYS BY

Dale Carolyn Gluckman

Hollis Goodall

Satoshi Kubota

WITH 160 ILLUSTRATIONS, 157 IN COLOR

SDMA
SAN DIEGO MUSEUM OF ART

Thames & Hudson

p. 1 Detail of *Hijiri*, Cat. No. 49 (see also p. 141).
p. 2 Detail of *Gen*, Cat. No. 47 (see also p. 139).

Published on the occasion of the exhibition *Kimono as Art: The Landscapes of Itchiku Kubota*, a collaboration between the San Diego Museum of Art, Timken Museum of Art, Canton Museum of Art, and the Itchiku Kubota Art Museum.

Exhibition Tour
San Diego Museum of Art and the Timken Museum of Art, San Diego, California, November 1, 2008–January 4, 2009
Canton Museum of Art, Canton, Ohio, February 8–April 26, 2009

The catalogue and exhibition *Kimono as Art: The Landscapes of Itchiku Kubota* are made possible by support from the Timken Foundation of Canton, The City of San Diego Commission for Arts and Culture, the County of San Diego Community Enhancement Program, and the Members of the San Diego Museum of Art.

First published in 2008 in hardcover in the United States of America by Thames & Hudson Inc., 500 Fifth Avenue, New York, New York 10110

thamesandhudsonusa.com

Library of Congress Control Number 2008924250

ISBN 978-0-500-97685-2

Project Manager: Dale Carolyn Gluckman
Editor: Jennifer Boynton

Printed and bound in China by C&C Offset Printing Co., Ltd.

NOTES TO THE READER

The essay by Satoshi Kubota was translated by Martin Bagish and Hollis Goodall.

Japanese name order (family name first, personal name last) has been used throughout the book, unless the person has adopted the Western practice of using the surname last, as is the case with Itchiku Kubota and Satoshi Kubota.

PICTURE CREDITS

Photographs courtesy of the following: Tokugawa Art Museum, pp. 17, 20, 136; National Museum of Japanese History, pp. 18, 21, 23, 120, 132, 133, 136, 137; Los Angeles County Museum of Art, pp. 19, 29, 30, 31, 34; Chishakuin, p. 27; Shōjōkōji, p. 28; Itsuo Art Museum, p. 30; Imperial Household Agency, Museum of the Imperial Collections, p. 31; Mieidō, Tōshōdaiji, pp. 32, 33; Hyōgō Prefectural Museum, p. 33; Fujisan Hongū Sengen Shrine, p. 36; Bunka Gakuen Costume Museum, p. 134. All kimono not otherwise credited belong to the Itchiku Kubota Art Museum. All photographs not otherwise credited are courtesy of the Itchiku Kubota Art Museum.

CONTENTS

FOREWORD

We hope that many people will share our excitement about *Kimono as Art: The Landscapes of Itchiku Kubota*. The fifty-five works of art in this publication possess a compelling beauty, and their creator, Itchiku Kubota, was a remarkably talented and innovative force in Japan and an internationally acclaimed kimono artist. The opportunity to present these remarkable pieces to American audiences is worthy of celebration in its own right. As the directors of the exhibition venues—the San Diego Museum of Art, the Timken Museum of Art, and the Canton Museum of Art—we are delighted with this special collaboration, one enduring manifestation of which is this handsome book that you hold in your hands. First and foremost, we wish to acknowledge the generosity of our valued colleague Satoshi Kubota, Itchiku's son and artistic heir, and his talented staff at both the Itchiku Kubota Art Museum and the Itchiku Atelier. In particular, Takamura Fumihiko, public relations manager of the Itchiku Kubota Art Museum, has facilitated *Kimono as Art* in every possible way, for which we are most grateful.

This international project began in San Diego, California, in 2005, with conversations between Satoshi Kubota; Jack Timken; the late John Petersen, former director of the Timken Museum of Art; and Dr. Derrick R. Cartwright. The goal of sharing an ambitious exhibition of kimono between the San Diego Museum of Art, Timken Museum of Art, and Canton Museum of Art developed as an initial plan. Several trips to Japan by key staff members of these institutions followed, and the Timken Foundation of Canton offered to become the lead sponsor of both the exhibition and the accompanying publication. We want to take this opportunity, therefore, to express our appreciation—especially to Ward J. (Jack) Timken and his wife Joy, The Honorable W. R. Timken Jr. and his wife Sue, Nancy Knudsen, and all of the members of the Timken Foundation Board—for their early belief in the value of this undertaking and their unstinting support of its excellence. We also wish to acknowledge the distinct pleasure of working with the gifted professionals at Thames & Hudson, especially managing director Jamie Camplin and project manager Jenny Wilson. The publishers have ensured that this catalogue will serve as a lasting tribute to Itchiku Kubota's work and as a significant addition to the field of contemporary Japanese art and craft. Among the professionals who have made important contributions to the *Kimono as Art* exhibition and catalogue, it is essential to emphasize the key role of Dale Carolyn Gluckman, an internationally recognized curator of Asian textiles, who brought her considerable expertise to the multifaceted position of exhibition guest curator, lead author and academic editor of the catalogue, and project manager.

At the San Diego Museum of Art (SDMA), creating collaborative cultural endeavors has been a cornerstone of recent institutional practice. The SDMA Board of Trustees is to be credited for its wholehearted embrace of partnerships such as this one. In searching for innovative, productive, and gratifying ways to work in an increasingly global manner, SDMA hopes to continue to pursue international projects to the benefit of the large and diverse communities it serves. The following SDMA colleagues, and the talented teams they supervise, deserve thanks. Julianne Markow, deputy director for operations and finance at SDMA, provided careful administration of the budget and sensitive shepherding of this complex project. Vasundhara Prabhu, deputy director for education and interpretation strategies, developed the broadest conceivable public programming. Katy McDonald, deputy director of external affairs, coordinated a variety of opening events in San Diego, most done in tandem with the Timken Museum of Art and partners at the Mingei International Museum and the Japanese Friendship Garden, all located in

San Diego's beautiful Balboa Park. Dr. Sonya Quintanilla, curator of Asian art at SDMA, who originally invited guest curator Dale Gluckman to join the team, provided just the right balance of independence and support. The arrival of Dr. Julia Marciari-Alexander as deputy director for curatorial affairs at SDMA, in July 2008, ensured the smooth and efficient installation of these breathtaking works of art.

The Timken Museum of Art Board of Directors and staff were delighted to participate in this groundbreaking collaboration with the San Diego Museum of Art and pleased to share this spectacular collection with museum members and the extended community of San Diego. This occasion reinforced the tradition and reputation of both institutions for staging exceptional exhibitions. The Timken expresses gratitude to Carrie Cottriall, deputy director, who played an instrumental role in coordinating efforts with the San Diego Museum of Art; to Kristina Rosenberg, education director, who produced comprehensive exhibition-related programming; and to Jim Petersen, museum administrator, and Jen Singer, development coordinator, who provided operational and administrative support. The Timken also extends sincere appreciation to Dale Carolyn Gluckman for all her work toward the realization of this project. We express our deepest gratitude to the Timken Foundation of Canton for its vision and generous underwriting, which made this unprecedented exhibition in San Diego possible.

The Trustees and staff of the Canton Museum of Art greeted *Kimono as Art* with enthusiasm, seeing it as a unique opportunity for a museum of modest means to share in a major exhibition. Thanks are extended to everyone involved in bringing *Kimono as Art* to the United States and especially to Canton, Ohio, particularly the Canton Museum's Board of Trustees, and the Timken family and the Timken Foundation of Canton: such a monumental undertaking—the largest in the history of the Canton Museum—would not have been possible without their commitment. Thanks to the efforts of ArtsinStark, the energetic leadership of its president and CEO Robb Hankins, and the efforts of the chairperson of its Board Jane Timken, the exhibition in Canton was transformed into a three-month-long celebration of Japanese art and culture throughout the community. More than one hundred volunteers from the community were organized into subcommittees that took charge of marketing and publicity, educational outreach to grade schools and colleges, related events such as concerts and films, and much more. Co-chairs Carole Savastano and Heather Fisher supervised all the volunteers, and their long records of community service served them well. Laurie Fife Harbert joined the staff of ArtsinStark, where she coordinated the various committees. The Canton Museum of Art administrative staff—including marketing manager Robb Hyde, business manager Kay McAllister, curator Lynnda Arrasmith, education coordinator Lauren Kuntzman, and administrative secretary Lynn Daverio—were involved in all planning and installation phases of the exhibition.

* * *

Working with objects of enduring beauty and historical significance is one of the deep pleasures of being affiliated with art museums. As museum directors, each of us has felt both the privilege and responsibility of this task as we have come to know the kimono produced by Itchiku Kubota, and the continuation of that master's legacy by his sons and studio. We hope that by temporarily assembling these memorable works in Southern California and Northern Ohio, we have made a valuable contribution to art history. If *Kimono as Art* succeeds in introducing fresh ideas about the artistic possibilities of the quintessentially Japanese garment and a new appreciation for the art and culture of Japan in our respective communities, even as it suggests new possibilities for international museum collaborations, we will be most pleased.

M. J. Albacete
Executive Director
Canton Museum of Art

Dennis Burks
Interim Executive Director
Timken Museum of Art

Derrick R. Cartwright
The Maruja Baldwin Director
San Diego Museum of Art

ACKNOWLEDGMENTS

Itchiku Kubota was one of the most elegant men I have ever met. In 1992, he and his son Satoshi came to the Los Angeles County Museum of Art (LACMA) to see an exhibition of Japanese kimono of the Edo period (1615–1868) that a colleague and I had organized. Itchiku was dressed in the traditional wide skirt-like trousers (*hakama*) and short jacket (*haori*). His haori was subtly dyed by his own hand, and on the cord holding his jacket together was a beautiful piece of old Indian silver, complementing his silver-white hair. Little did I realize at the time that this self-effacing gentleman, whose attire was so seemingly out of place in the modern world, was an innovative kimono dyer in Japan and as familiar with impressionist art as he was skilled in Japanese ink painting. I later visited him at his studio, Itchiku Kōbō (like many artists in Japan, his given name is also his studio name), with a small group of LACMA members, and he greeted us warmly and graciously even though he and his wife were preparing to leave for a wedding shortly after our meeting. Quite by chance, I saw an exhibition of his work at the Smithsonian's Museum of Natural History in Washington, D.C., in 1995 and was struck by the extraordinary beauty of his Symphony of Light installation. It was an unexpected pleasure, therefore, to be invited to participate in the presentation of his work in San Diego and Canton.

The first international exhibition of Kubota's work was held in Southern California. It was organized in 1980—just three years after his first exhibition in Tokyo—by Dextra Frankel, then director of the Art Gallery, California State University, Fullerton. Although many international exhibitions followed, only the Washington show mentioned above had a venue in the United States. Thus it seems particularly fitting that, twenty-eight years later, an exhibition highlighting Kubota's mature work should be presented by the San Diego Museum of Art and the Timken Museum of Art. Things, it seems, have come full circle.

An international project such as the exhibition and catalogue *Kimono as Art: The Landscapes of Itchiku Kubota* could not have been realized without the dedication and professionalism of many people. I want to extend my personal appreciation to the Timken Foundation of Canton, for its generous support, and to Satoshi Kubota, who has been as cooperative a lender as one could wish. Takamura Fumihiko, public relations manager of the Itchiku Kubota Art Museum, has been patient in the extreme with the dozens of e-mail requests and questions that this project has required, especially its catalogue, which was produced in record time. Hollis Goodall, curator of Japanese art at LACMA, wrote a brilliant essay situating Itchiku's work within the larger lexicon of the traditions of Japanese painting and prints. She has been a true colleague and friend throughout this process and I have frequently relied on her excellent Japanese language skills. I also wish to thank Martin Bagish and Robert T. Singer, curator and head of LACMA's Japanese art department, for their translations and suggestions. Colleagues Amy McFarland, head of graphic design at LACMA, and Rochelle Kessler, advisor to the director for curatorial affairs at San Diego's Mingei International Museum, gave me sage advice every step of the way. To managing director Jamie Camplin and his team at Thames & Hudson, including in-house editor Jenny Wilson, catalogue designer Karin Fremer, production manager Susanna Friedman, and their associates goes my appreciation for the beautiful publication that has resulted from our collaboration and their talents. I thank Mary Dusenbury, Terry Satsuki Milhaupt, and Liza Dalby, who have unstintingly shared their extensive knowledge of Japanese textiles, textile techniques, and kimono culture. Any errors, however, are strictly my own.

At the San Diego Museum of Art (SDMA), executive director Dr. Derrick R. Cartwright has never flagged in his support and enthusiasm for this endeavor. Dr. Sonya Quintanilla, curator of Asian art, former chief curator Scott Atkinson, and Dr. Julia Marciari-Alexander, deputy director for curatorial affairs, have all been welcoming and the most congenial of colleagues. Working with deputy director Julianne Markow has been a constant joy, and we are living proof that curators and administrators can be "on the same page" throughout the entire experience of organizing an exhibition and catalogue. Her administrative assistant, Lina Veinbergs, cheerfully supplied any information needed. Vas Prabhu, Katy McDonald, and Christianne Penunuri have infused this project with incredible creative energy. Special thanks to David L. Kencik, collections data manager, who gathered all the necessary photo permissions under considerable time pressure, and to Gaby Beebee, for her beautiful drawings. Scot Jaffe and his team did a wonderful installation both at SDMA and the Timken Museum of Art, where Dennis Burks, Carrie Cottriall, Kristina Rosenberg, and Jim Petersen have all embraced this project. I take this opportunity to thank Mr. and Mrs. James Haugh for their generous hospitality during my innumerable visits to San Diego. I also acknowledge the multiple contributions of Hal Fischer, formerly with the Timken Museum of Art, with whom I began this project and who introduced me to the Timken and its wonderful exhibitions and publications, many realized under his direction. Hal brought Thames & Hudson on board and organized our first trip to Japan. Everyone at the Canton Museum of Art has been wonderful to work with, and their excitement over this project has been palpable from the beginning. And finally, my deepest appreciation goes to my husband, Jonathan, who is not only my own "in-house" editor but has been unfailing in his patience and encouragement during this entire project.

Dale Carolyn Gluckman
Guest curator

CHRONOLOGY OF JAPANESE ART HISTORICAL PERIODS

Only periods and imperial reign dates (*nengō*) mentioned in the text are listed.

EARLY HISTORICAL PERIOD

552–645	**Asuka period**
645–794	**Nara period**
794–1185	**Heian period**
1185–1333	**Kamakura period**
1333–1573	**Muromachi period**

EARLY MODERN PERIOD

1573–1615	**Momoyama period**
	Keichō era (1596–1615)
1615–1868	**Edo period**
	Early Edo 1615–88
	Genna era (1615–24)
	Kan'ei era (1624–44)
	Kanbun era (1661–73)
	Mid-Edo 1688–1781
	Genroku era (1688–1704)
	Late Edo 1781–1868

MODERN PERIOD

1868–1912	**Meiji period**
1912–26	**Taishō period**

HOMAGE TO MY FATHER

SATOSHI KUBOTA
Director, Itchiku Kubota Art Museum, Yamanashi
Itchiku Atelier (Itchiku Kōbō), Tokyo

Itchiku Kubota entered the world of paste-resist dyeing (*yūzen-zome*) at the age of fourteen. By the age of twenty he first encountered, and was fascinated by, *tsujigahana*, a style of kimono decoration that had reached its height of popularity by the latter half of the sixteenth century. He was determined to develop a new style called "Itchiku Tsujigahana," an effort that would occupy his creative energies for the rest of his life.

After World War II, having spent three years as a prisoner of war in Siberia, he was demobilized at the age of thirty-one. Returning to Japan, he began to make a living as a painter of silk kimono using the yūzen dyeing technique. Gradually, he began researching how to recreate tsujigahana.

In 1961, when he was forty-four years old, he established the Itchiku Atelier (Itchiku Kōbō) and began to investigate tsujigahana in earnest. At the age of fifty-nine, he finally achieved success with the completion of the kimono *Gen* (see Cat. No. 47), which summed up all of his research. In 1977, at sixty years of age, the first exhibition of his personal work was held in Tokyo.

For the next twenty-five years, until his death in 2003 at the age of eighty-five, he wholeheartedly pursued his dreams, one of which was to establish his own art museum. Innumerable times he had taken Mount Fuji as his subject; consequently, he determined that the area around Mount Fuji was the only location for his art museum. The construction of the museum was suspended a number of times, because my father used his own limited funds, but in 1994, after three years, the Itchiku Kubota Art Museum was born.

Another grand dream was to create a scheme of eighty kimono, known as the Symphony of Light, displaying a contiguous representation of The Four Seasons (which includes The Oceans) and The Universe; it would represent the grandeur of the universe. Forty kimono in this series have been completed to date, including part of Autumn, Winter, and The Oceans within The Four Seasons and one from The Universe. There is still a long road ahead before the entire work is realized. Itchiku Kubota's dream has been handed down and that work continues today.

I would like to share a song that was sung at Itchiku's first exhibition:

> *They've dyed Itchiku's destiny,*
> *This tsujigahana.*
> *Life: The living brilliance of the flowers,*
> *A vision.*

To which my father replied:

> *The tsujigahana of old,*
> *With its ephemeral beauty, seemed an illusion;*
> *But my own "tsujigahana" will bloom forever.*

Even if we are to realize only a part of Itchiku's dreams, I think we will be filled with joy. And finally, to all those who worked so hard to assist me in putting together the exhibition, I thank you from the bottom of my heart.

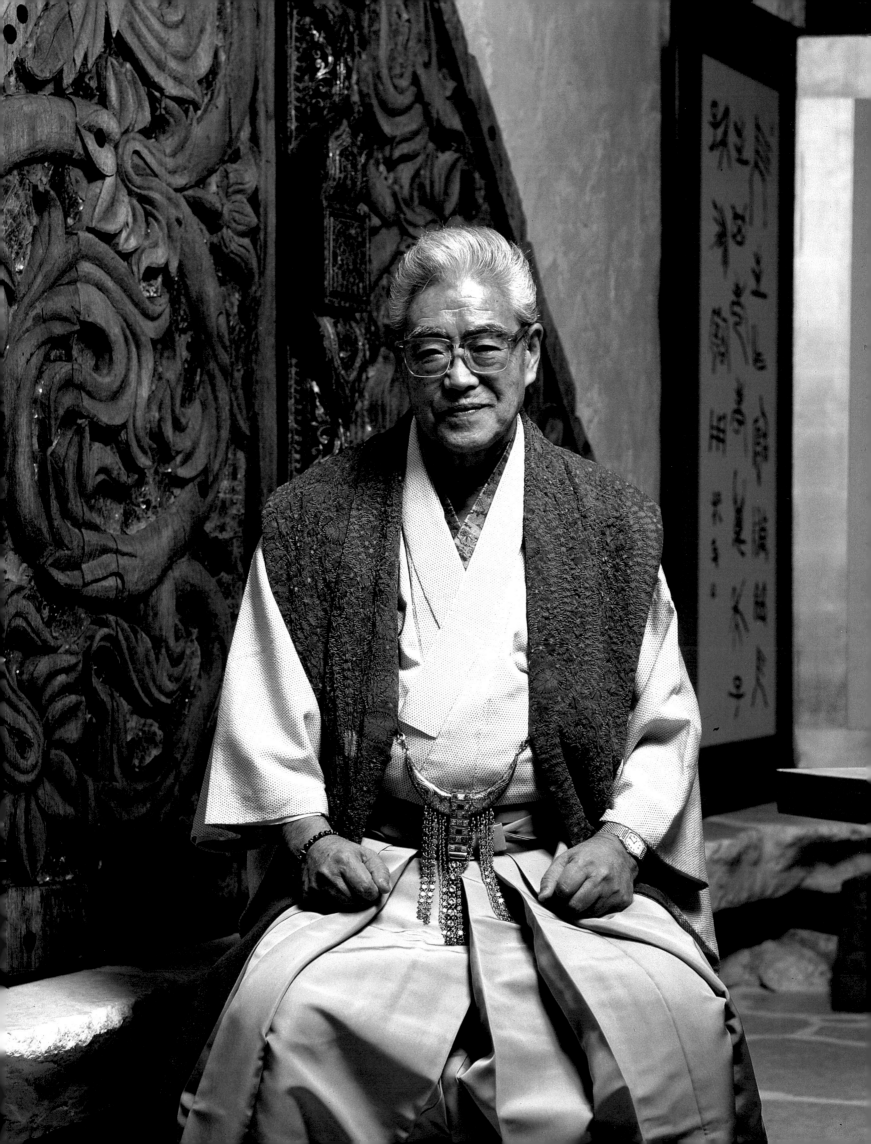

VISIONS OF THE ITCHIKU KUBOTA ART MUSEUM
An Interview with Satoshi Kubota

DERRICK R. CARTWRIGHT

The following dialogue took place at the Itchiku Kubota Art Museum near Lake Kawaguchi, Japan, on April 3, 2008. The principal conversation was between Derrick R. Cartwright, the Maruja Baldwin Director of the San Diego Museum of Art, and Satoshi Kubota, director of the Itchiku Kubota Art Museum and the son of the artist/founder. Thanks to Maurice Kawashima, trustee at the San Diego Museum of Art, for serving as an occasional translator for some of the more subtle ideas expressed during the interview itself and in the transcription that follows.

Derrick R. Cartwright: Would you tell me the story of this special place, and how your father came to imagine this museum as a permanent home for displaying his life's work? And, if you don't mind, explain how you came to be involved in the concept of this building?

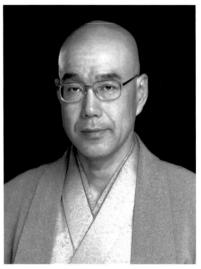

Satoshi Kubota

Satoshi Kubota: This museum was truly my father's dream. Sometimes I think he must have thought that it would never really come true, but it existed quite strongly in his imagination for some time. More than twenty years ago, he came to this region, which is well known in Japan as a beautiful destination. He felt that the place for building his museum was here, right by the lake, with Mount Fuji itself dominating the view from the museum. The mountain is one of the most important symbols in my father's work, as you know. It appears as a dominant form in the decoration of the kimono, as does nature more broadly, which is also a theme of his work and is integrated into virtually every design. This is immediately visible to us in the hills surrounding the museum. Birds can be heard and seen around the museum, and sometimes you will see wild monkeys playing outside the tearoom windows. This was the ideal spot for making clear Itchiku Kubota's personal connection to landscape, and the acquisition of this property complemented his hopes for showing his kimono as an art form.

After my father purchased the land, he used all of his funds to begin construction on the museum. This did not happen all at once. He would build for a while and when his resources ran out, he would stop. Then, once he had saved enough money, the work on the museum would continue. This was not by choice; it was the way it had to be. I got involved early helping my father to realize his dream of building this place. My role was less in determining the creative dimensions of the museum than in the bookkeeping and long-term planning. That has changed a bit since his death but, at the outset, my role was usually that of negotiator on behalf of my father and his museum dream. This meant, essentially, that I got to deal with the banks while he was able to focus exclusively on the kimono [*laughs*]. The kimono, and what this museum would ultimately look like. Itchiku was impressed by the architecture of Antoni Gaudi, and this museum's form emulates Gaudi freely, don't you think?

DRC: Yes. It strikes me that your father was, somewhat paradoxically, an artist for whom honoring traditional forms was imperative and, at the same time, a great innovator in his commitment to reinventing the important but lost technique of *tsujigahana* textile decoration. This is also reflected in what you just said about his wish to incorporate an homage to the modern architecture of Gaudi into a Japanese museum. In what ways do you think this combination of impulses reflects Itchiku Kubota's and perhaps your own ambitions for this museum?

SK: This is complex. Well, let's start with the fact that the precise processes used to create tsujigahana were, unfortunately, lost to us about four hundred years ago; it became a so-called dead art form in the early Edo period. Also, while we can certainly appreciate the fragments of this art that survive today, we cannot recreate the taste of the people who patronized the makers of early tsujigahana textiles. My father revitalized and, to a large extent, reinvented tsujigahana effects, but his work exists in a time that is quite distinct from that in which traditional tsujigahana works were produced and worn. His way of expressing this technique is different, for a different time, and it is new. He recognized this but did not feel limited by the insurmountable distance that existed between the past and his own current interests. It is possible that some people, when they see Itchiku Kubota's work, may complain that it is not "real," because it is not a perfect replication of the original art form, but those critics are missing the point. My father spent much of his life experimenting with and adapting the traditional form to his own taste, and feeling that it was a reflection of his own time. I think the museum, as well as the works inside it, expresses this effort to adapt to the modern world while still revering the creativity of the past.

The building is a unique interpretation of my father's worldview. It is wholly contemporary in the sense that it reflects his particular sensibility, his idiosyncrasies, just as his kimono reflect a particular, unique perspective on Japanese textile traditions. I hope that when people visit, they immediately sense that it is a distinctly different museum, an original place with its own dynamic character. If they do, it is my father's wish that they experience it so deeply.

Since 2003, I have been in charge of both the Itchiku Kubota Art Museum and Itchiku Kōbō, the atelier in which work continues today on the projects Itchiku conceptualized during his lifetime. My brothers are my strongest partners in carrying on our father's artistic vision; it is more than enough work for us to challenge ourselves by following in his footsteps. We are continuing to carry out his wishes, and his assistants are fulfilling his commitment to the art form that he refined during a lifetime of dyeing kimono. Today, there are twenty-four people continuing "Itchiku Tsujigahana" at the Itchiku Kōbō. On a daily basis, I actually spend most of my time at the atelier, directing this effort. When I visit the museum, it is a great relaxation for me to be among the works that my father made, and to see the progress the atelier is making on the completion of his designs. I feel very different here. But it is all part of the commitment I made to try to fulfill his dreams in precisely the way that he envisioned. I feel I have made a commitment to both his appreciation for the historical work and also to expressing this in a contemporary mindset.

DRC: What is the place of the kimono in contemporary life? Are you conscious of preserving something intrinsic to Japanese culture?

SK: Japan has changed a lot in the past generation. The lifestyle here has become very Western. Look at us all today, wearing business suits; I am dressed just like you are. Although I do wear kimono regularly for ceremonial purposes, I do not wear one every day. There are many people in Japan who seldom, if ever, wear kimono. Apart from what might appear to be merely self-interest, I do wish that contemporary people would hold on to this expression of our culture. The kimono is quintessentially Japanese, but it is disappearing from our lives and this is a sad thing. It also needs to be said that the most elegant kimono, in addition to being very costly, can be cumbersome to put on properly without assistance, which may be one reason for its virtual disappearance from our daily life. I can also tell you that when someone appears in a public place wearing a kimono, they are doing something important. They look completely different; people do notice them, and not without feeling some pride in Japan. It is a special thing to wear the kimono.

DRC: Your father's kimono have only occasionally been seen outside Japan. When they were shown in the West, it was exclusively in the context of museum exhibitions. Does the critical reception of these works by Westerners matter to you?

Mount Fuji in winter, as seen from the Itchiku Kubota Art Museum.

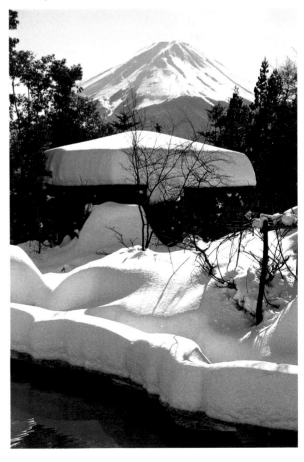

SK: Even though a museum visitor in the United States may not be intimately familiar with the kimono and the particular qualities of the tsujigahana technique that so motivated my father, yes, yes, the response is very important to me. In fact, there is an interesting difference that pleases me a great deal. Japanese people may look at the kimono primarily as something to wear; they are familiar with it as a garment. But in the West, you are not as familiar with the ritual of dressing and wearing these elaborate textiles; therefore, it is more likely that you will look at the kimono purely as an art form. This is actually closer to my father's ideal of how his work was meant to be viewed. The kimono he designed are only very rarely made to be worn: they were mostly conceived as sophisticated objects for display. In the end, I am not sure how I expect people who are not Japanese to react to the works. I hope they will find them beautiful and moving. But the fact that the works are being shown in the kind of installation that we envisioned for them is what most intrigues me, and is most important to the memory of my father.

DRC: Perhaps the greatest expression of Itchiku Kubota's vision is the series called Symphony of Light. In concept, it is an enormous undertaking, and your father died before it was even half completed. Do you have a timetable for bringing these eighty pictorially related kimono to a state of completion?

SK: *[Laughs]* I don't think that Symphony of Light will be finished in my lifetime, either. I really don't think so. Nonetheless, we celebrate the completion of each kimono in the series by the Itchiku Kōbō with an exhibition here at the museum. It takes more than a year to finish each new kimono. This requires great patience on the part of the atelier as well as the public. Some people make a special trip to the museum just to see the newest addition to the series. My father planned every work in advance, so it is really a matter of following his instructions closely and having the dedication to see it through. I think it will be up to my own successors to see the project through to completion, and I hope they will be as steady and patient as I have been.

DRC: Is there any relationship between Itchiku's kimono and other Japanese art forms that reach an international audience? I am thinking about the celebrity achieved by some contemporary Japanese artists—Mariko Mori or Takashi Murakami, for example. Does their success carry significance for you on a professional level?

SK: To be honest, I've never thought about a parallel between the activities of those exhibiting artists and the work of the Itchiku Kōbō. Perhaps it doesn't exist. We are making something totally different from a painting, sculpture, or photograph. Yes, what we do has an installation component, but the work is very different from what most contemporary artists produce. I am glad these Japanese artists are recognized by art museums throughout the world, as well as critics, collectors, and the public in general.

My father was somewhat well connected with the artists of his time, but he was really more influenced by art history outside Japan. He traveled to Barcelona to see the work of Gaudi; he avidly collected glass and ceramic beads in Africa that are displayed here in a small gallery; and he brought many architectural decorations from India that now form parts of this museum's design. He was also deeply interested in the impressionist works of Claude Monet. This points to a certain worldliness in his approach; ultimately, however, his biggest reference and most consistent source of inspiration was nature itself. I just don't see much of a connection to nature in the work of many of today's Japanese artists.

Maybe where Itchiku Kubota found the most connection to the art world of his time was in the fields of music and theater. He loved the performing arts, and I believe some of the earliest commissions for his kimono came from actors. Today, occasionally, we will produce costumes for theatrical performances, and some musicians have asked to wear

The African bead gallery in the Itchiku Kubota Art Museum.

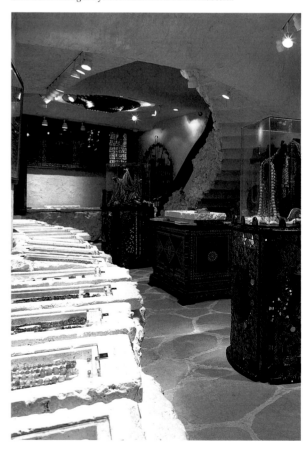

The grounds of the Itchiku Kubota Art Museum in autumn.

my father's kimono as well. Every autumn, we host a performance of noh drama on an outdoor stage at the museum. It is through these events that my father's vision is sometimes brought to a different level of public understanding.

DRC: This building is situated in one of the loveliest sites in the world. The lake and Mount Fuji sit before the museum, and the hillside and forest rest behind. Do you have plans to grow or extend this complex in the future? Or would you prefer that it remains just as it is now?

SK: The main dream of Itchiku Kubota was to create a museum, and to keep it open so that many people could enjoy it. We also have to continue working toward the completion of the Symphony of Light series. These are not small tasks, and I am completely satisfied with focusing on them as our goals. So for the time being, no, there is no plan to expand the museum. It is already a strong, pure expression of Itchiku Kubota's aesthetic, and that is enough for me.

Part of my vision for the future is to do more international exhibitions. My father would be most happy with the development of cross-cultural collaborations. He was pleased to have the opportunity to expose people to his ideas, and he enjoyed the response to his exhibitions abroad. As museum culture becomes more global in nature, the main joy is in generously sharing our creative works with different audiences, really with as many people as possible. It would be rather nice if this could continue long into the future. International traveling exhibitions are a lot of work, but they are worth it.

DRC: I agree, of course. We are very proud of this collaboration with you, and I hope that the resulting project will fulfill all of your expectations for exposing a new audience to the fine art that your father created.

SK: Thank you. It has indeed been a pleasure working with the people in Canton and in San Diego on this project. I've made new friends in both places, and that has to be counted as one of the many satisfactions of my job. Again, it is my great hope that visitors to your museums, and the readers of this catalogue, will take inspiration from Itchiku Kubota's efforts. Both in Japan and in the United States, these are works that should give a great deal of pleasure.

THE KIMONO REDEFINED

Tradition and Innovation in the Art of Itchiku Kubota

DALE CAROLYN GLUCKMAN

Itchiku Kubota (1917–2003) brought to his work a fascination with the effects of light on color and an emotional response to nature that runs deep in the Japanese psyche. He was well versed in many aspects of traditional culture. Yet he was also unafraid to experiment or to question established ways of doing things. Throughout his career, he continually looked for new directions in presentation, format, materials, and techniques. The story of Kubota's professional development and an understanding of the historical transformation of the kimono into a vehicle of artistic expression are essential to an appreciation of the unique blending of tradition and innovation that characterizes his art.

FOUNDATION: KUBOTA'S TRAINING

Kubota was not born into a family involved with kimono production, yet every aspect of his training prepared him for his artistic career. (For a detailed chronology of the artist's life, see pp. 150–51.) His father was a curio dealer in Tokyo. In 1931, at the suggestion of one of his teachers, Kubota apprenticed himself at age fourteen to Kobayashi Kiyoshi, a freehand *yūzen* dyer, entering Japan's long tradition of the transmission of craft instruction from master to novice. Yūzen is a technique for decorating kimono in which rice paste (a resist) is used to outline a design directly on the fabric. Color is then painted into the areas defined by the rice paste, after which these details are covered entirely by the resist and the background dyed with a wide brush. The technique is akin to painting and permits detailed pictorial imagery on cloth, thus allowing Kubota to develop his considerable innate drawing skills and gain a steady hand with a brush. In Kobayashi's workshop, he learned to paint the flowers, carts, and flowing water associated with *goshodoki*, a decorative kimono style once worn by elite, samurai-class women. On his own, he studied Okinawan stencil dyeing (*bingata*), also involving a dye-resistant paste similar to yūzen, and batik (*rōketsuzome*), which uses wax to protect design areas from the dye bath. Kubota further honed his artistic skills while still apprenticed to Kobayashi by studying Japanese-style painting (*nihonga*) with one artist and portraiture with another.

A year after being released from his apprenticeship at the exceptionally young age of nineteen and working as a professional yūzen dyer, Kubota began to study *Kaga-yūzen*, a variant of the popular yūzen technique that uses stencils rather than a brush for outlining shapes. Three years later, he became the assistant to a master of stage design for kabuki and *shinpa* (new school) plays. Kubota, by producing costumes for these theatrical performances, in addition to beginning the study of traditional Japanese dance (*nihon buyō*), gained "insight into the practical application of dyed materials."[1] While he was in a Siberian prisoner-of-war camp during World War II, the inmates formed a theater troupe. Kubota was in charge of costumes, stage properties, make-up, and other aspects of production. Painted paper was used for costumes. Unfortunately, the performances were soon prohibited, but this experience united his creativity and his theatrical sense. Many years later, these qualities would come to the fore in the presentation of his work.

HISTORY: THE KIMONO AS A MEDIUM FOR PICTORIAL EXPRESSION[2]

The garment known today as the kimono probably began in the Asuka-Nara period (552–794) as a humble bast-fiber robe (*kosode*) for commoners. A kosode is a robe with a small wrist opening at the sleeve, and the general term for a kimono (literally, thing to wear)

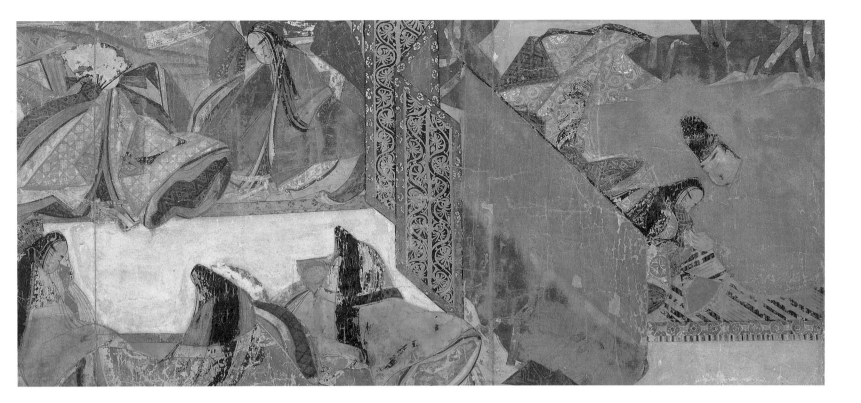

Figure 1
Genji monogatari emaki (Tale of Genji handscroll)
Heian period, early 12th century
Ink and color on paper
Tokugawa Art Museum, National Treasure

until the modern era. In the succeeding Heian period (794–1185), aristocratic women wore an ensemble called *kasane shōzoku* (Figure 1), consisting of multiple layers of the *ōsode* (a wide-sleeved robe, with a wrist opening that extended the full length of the sleeve). The color of each robe was carefully chosen so that the combination of hues functioned as poetic or literary allusions that revealed the wearer's character and emotional sensitivity. These layers of color often made seasonal references—one of the first such examples in Japanese dress. This courtly style required yards of expensive woven silks, some with small repeated patterns created by embroidery (*nui*), tie-dyeing (*shibori*), or ink painting. Commoners wore cruder, simpler forms of tie-dyeing, or fabrics that were not dyed.

In the Kamakura period (1185–1333), the warrior class (samurai) gained ascendancy and controlled the government for the next 683 years. Although the imperial court, at times greatly impoverished, still existed, de facto political power resided with the military governor, or shogun. Because samurai were originally commoners, they initially would have worn the unlined bast-fiber kosode as their primary garment. As their social and economic status rose, they began to wear kosode made of silk, thus broadening the demand for luxury textiles. Toward the end of the Kamakura period, large-scale designs of horses, oxcart wheels, and birds appeared on the dress of commoners. The aristocracy and highest levels of the samurai class, however, continued to wear woven silks with overall floral or small geometric patterns. During the Muromachi period (1333–1573), the ten-year-long Ōnin War (1467–77), a devastating civil conflict, nearly destroyed the city of Kyoto, which was the center of textile production and fashion at the time. The war's destruction and upheaval hastened the adoption of the kosode as the primary outer garment of the elite and spurred an interest in surface design. The prolonged fighting blurred class distinctions, permitting greater social mobility. At the same time, the adoption of the simpler kosode as the main outer garment of the elite accelerated because it allowed greater freedom of movement. The destruction also increased demand for new clothing. Techniques such as tie-dyeing, embroidery, metallic leaf (*surihaku*), and painting enabled decorated fabrics to be produced more quickly than by weaving, because several artisans could work on the same piece simultaneously. By the close of the fifteenth century, the kosode had become the daily attire of men and women of all classes, with the well-to-do adding two or three under-robes and an over-robe. The multilayered dress of the Heian nobility, in which motif had played a secondary role to color, was now replaced by the kosode and an emphasis on decoration, in which motif and color worked together.

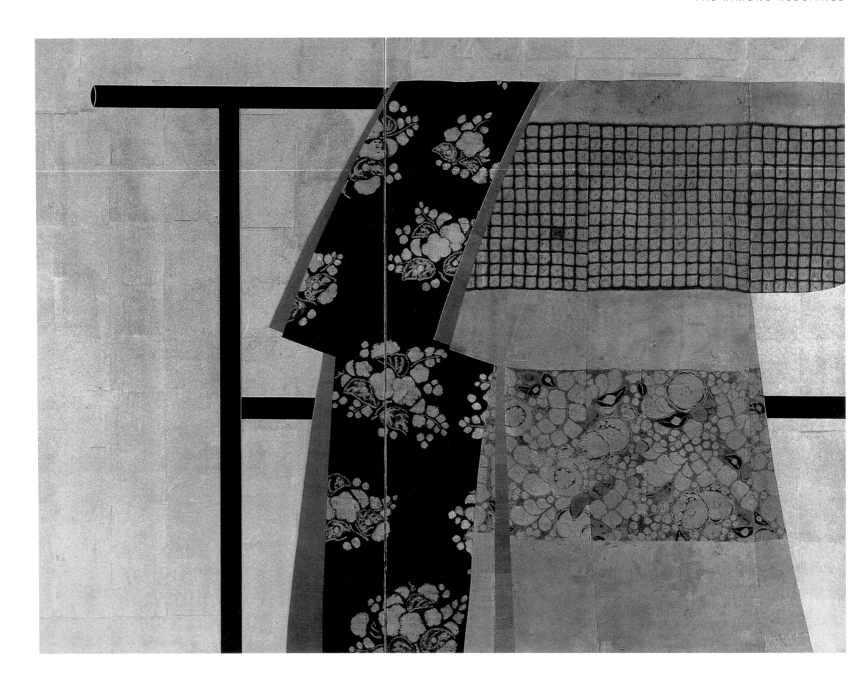

Figure 2
Kosode Fragments Mounted on Screen
Momoyama period, late 16th–early 17th century
Left: Kosode fragment with scattered floral motifs
Tie-dyeing on plain-weave silk (*nerinuki*)
Right: Kosode fragment with one horizontal band of squares and another
of camellias and wisteria
Tie-dyeing and ink painting on plain-weave silk (*nerinuki*)
75 x 68¼ in. (190.5 x 173.4 cm)
National Museum of Japanese History, Nomura Collection

OPPOSITE ABOVE
Figure 3
Kosode Fragment with Fan Roundels, Flowering Vines, and Wild Ginger Leaves
Momoyama period, late 16th–early 17th century
Tie-dyeing, embroidery, ink painting, and gold leaf on plain-weave silk
(*nerinuki*)
25¾ x 15¼ in. (65.4 x 38.7 cm)
Los Angeles County Museum of Art, gift of Miss Bella Mabury, M.39.2.304

OPPOSITE BELOW
Figure 4
*Kosode Fragment with Mountains, Snowflake Roundels, Wisteria, and Plants of the
Four Seasons*
Edo period, early 17th century
Tie-dyeing, embroidery, and stenciled gold and silver leaf on figured silk
satin (*rinzu*)
27⅛ x 11½ in. (68.9 x 29.2 cm)
Los Angeles County Museum of Art, Costume Council Fund, M.85.188

In the sixteenth century, corresponding to the later Muromachi period and early Momoyama period (1573–1615), techniques that previously had been used individually—tie-dyeing, brush painting (*kaki-e*), and applied metallic leaf—were now combined. This style was given the name *tsujigahana* by collectors and dealers in the late nineteenth century, although it is unclear precisely to which textiles the term originally referred.[3] Essential to the success of this style was the fabric, *nerinuki*, a thin but firm plain-weave silk of glossed and unglossed yarns (see glossary) with a lustrous finish. The properties of nerinuki allowed for the placement of tiny, closely spaced stitches of *nuishime* shibori (stitch resist), necessary for giving a sharp outline (often enhanced with an ink line) to small motifs such as flowers (Figure 2). Tsujigahana marked a shift to the greater use of stitch resist to define small areas that were either left white or filled in with ink-drawn flowers or tiny landscapes and were often embellished with embroidery, and gold and silver leaf (Figure 3). The surface-decorating techniques that made up tsujigahana liberated kimono design from the repetitive motifs of woven textiles. While this was the first of many steps leading to an integrated pictorial image on the kosode, the garment was not yet seen as a unified design field; rather, elements were juxtaposed in irregularly shaped areas or bands (see the kimono on the right in Figure 2). As discussed in the next section, more than three hundred years later one of the relatively few surviving fragments of tsujigahana was to have an unexpected and profound grip on Kubota and a lasting influence on his art.

A patterned silk damask (*rinzu*) introduced from China at the beginning of the seventeenth century contributed to a stylistic change in kosode decoration. Known today as *Keichō-somewake* or "Keichō-era (1596–1615) parti-colored dyeing," the style actually extended through the Kan'ei era (1624–44) in the Edo period (1615–1868) and is thus more accurately called the Keichō-Kan'ei style. Unlike so-called tsujigahana, which left relatively large areas of undyed ground, Keichō-somewake filled the entire ground with large, abstract shapes, predominantly in red and/or brownish black, over which were stenciled minute geometric patterns in metallic leaf. Tiny embroidered flowers and delicate ink-drawn landscape elements (in areas reserved from the dye) further embellished the surface (Figure 4). Although the asymmetrical and abstracted shapes that suggest landscape elements (mountains, waves, and mist) impart a sense of movement to the surface, the scene is still not unified and the scale and perspective are not internally consistent. The design field, however, during this period gradually began to display larger undecorated areas, a result of social changes that would soon revolutionize kosode design (see detail of *Kosode on Screen*, p. 121).

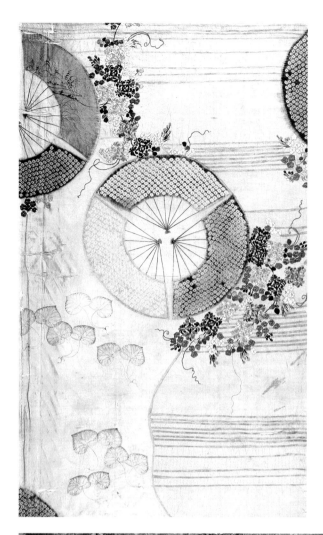

By the mid-seventeenth century, *chōnin* (townspeople, including merchants, artisans, and others, who were below the samurai class) began to challenge the fashions of the samurai elite. At that time, many chōnin such as actors, courtesans, and retainers asserted their identity by wearing garments that had large, bold images or characters on the back (Figure 5). Chōnin in effect pushed kimono dyers to use the techniques of Keichō-somewake to create a new style in which design elements were exaggerated and placed dramatically to one side of the back of the robe (see *Kosode with Oversized Grass Blades*, p. 132). This dynamic style became known as Kanbun, after the era in which it was popular (1661–73). As a professional kimono dyer, Kubota undoubtedly knew his Japanese costume history well. He was particularly inspired by the bold scale and asymmetrical format of the Kanbun style (see Individual Works, pp. 138–47, specifically Cat. Nos. 47 and 53). In the full-blown Kanbun style, the back of the kimono had become a unified surface, as on *Kosode with Flower-Filled Maple Leaves* in the Nomura Collection (see p. 136). On this kosode, the stenciled gold foil of Keichō-somewake has been completely abandoned, resulting in an undecorated ground against which stitched and capped resist–dyed leaves are embroidered in silk and metallic thread (newly introduced from China). Juxtaposed with these leaves are other leaves filled with the tiny tie-dyed circles called *kanoko shibori* ("fawn spot" dyeing), an important decorative element of the earlier Keichō-Kan'ei style.

From the late seventeenth to the end of the eighteenth century, wealthy townsmen, now able to afford silk clothing, infused the older styles with new vigor. The introduction of pattern books and the development of a new dyeing technique were key factors in this sartorial renaissance. Comparable to modern fashion magazines, these popular pattern books helped to develop and disseminate the bold Kanbun style. However, it was the new textile-dyeing technique called yūzen, which appeared during the Genroku era (1688–1704), that was to revolutionize kimono design. In yūzen, a brush was used to apply a paste resist to protect parts of the fabric from dye, making it possible to achieve pictorial designs that had been unattainable with earlier techniques. This is the tradition in which Kubota initially trained.

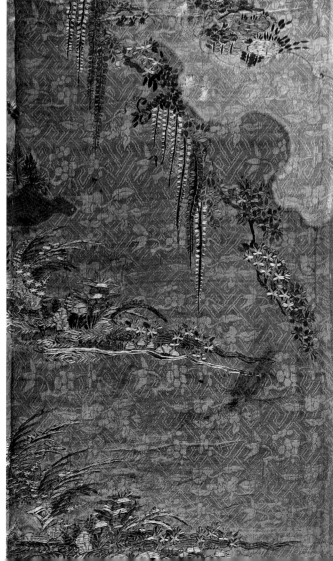

In terms of kimono styles, the Genroku era was to some extent an extension of the earlier Kanbun era. Although the designs were less bold in scale, they were still positioned asymmetrically, with the weight of the composition on the right side of the back. The design extended across the lower portion of the kosode; the undecorated space on the left now occupied only a small area at the waist (see *Kosode with Bridges, Plum Blossoms, and Water Plantain*, p. 135). During the early eighteenth century, at the end of the Genroku era, the composition began to extend to the front of the kosode as well. A design, now bisected by the side seam, was symmetrically placed on the lower skirt area of the front and back sections. From the mid-eighteenth century, the design around the lower skirt could be read continuously from the left front around the back to the right overlap.[4]

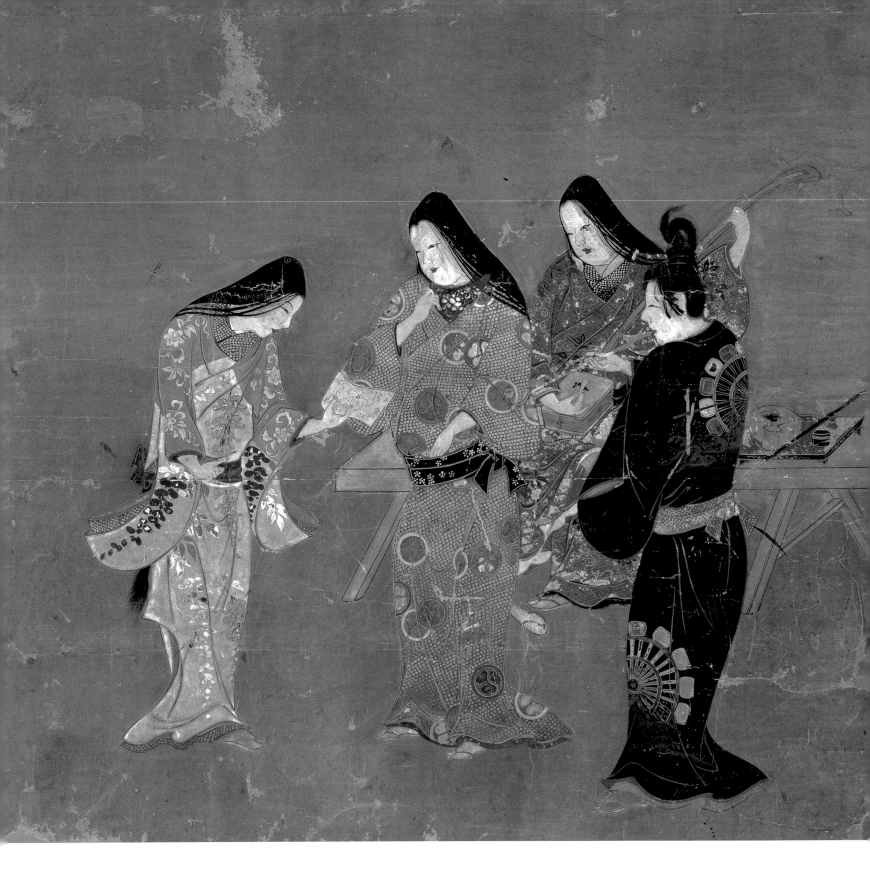

By the early nineteenth century, the design covered the entire back of the garment, creating a pictorial format similar to a hanging scroll. The representational possibilities of the kosode were also being exploited with the full repertoire of techniques: yūzen, embroidery, and many forms of tie-dyeing (see *Uchikake with Mandarin Ducks and Cherry Blossoms*, p. 134). Some wealthy patrons even had prominent artists paint directly on the kimono, creating perhaps the first examples of art-to-wear (Figure 6).

MAGNIFICENT OBSESSION: KUBOTA AND TSUJIGAHANA

As previously mentioned, it was an encounter with a fragment of tsujigahana when he was twenty years old that set the course of Kubota's artistic life. Of this experience, he later wrote:

Figure 5
Honda Heihachi ō and Princess Senhime (detail)
Edo period, first half of the 17th century
Two-panel screen; ink and color on paper
28⅝ x 62 in. (72.7 x 157.5 cm)
Tokugawa Art Museum, Important Cultural Property

> I came across an old strip of tsujigahana in a museum and was mesmerized by its complexity and mysterious beauty…I was struck by the delicate tie dyeing (shibori) on the gauze-like material…. This find seemed like a revelation from God and I vowed then to devote the rest of my life to bringing its beauty alive again.[5]

This experience took place at the Tokyo National Museum, in a nearly empty gallery. Kubota commented further:

> I continued to look at that small piece of fabric, as if placed under a spell, for over three hours. Just as if that small piece of fabric had grasped me with an invisible hand and would not let me go…. The thought later came to me that if there is such a thing as the transmigration of souls, had I not carried out that *Tsujigahana* dyeing myself in some previous existence? The effect that this encounter had on me was that profound.[6]

Kubota began to try to reconstruct tsujigahana in his spare time. His life and work were interrupted by World War II. When he was finally demobilized, he resumed painting yūzen for a living and began experimenting again in an effort to recreate tsujigahana.

The delicate, faded, and deceptively simple textile fragments exhibiting the sixteenth-century decorative style called tsujigahana that survive today belie the extraordinary skill, patience, and exhausting labor that went into their creation. These early textiles incorporated all of the surface-decorating techniques then available: bound and stitch resist, ink painting, metal foil, and sometimes embroidery. The dyers of this period particularly pushed the technical possibilities of stitch resist to its limits in making small, clean-edged shapes. Duplicating these techniques today, however, poses a problem. There are no texts describing how tsujigahana was made. Nerinuki, the silk fabric so critical to the process, has not been woven since the early seventeenth century and cannot be recreated. Kubota spent more than twenty years attempting to perfect his version of tsujigahana, and during that time he did not show his work publicly. In 1980, he said, "Those years were a succession of experiments in dyeing, of failures and disappointments, with a new method conceived from the very next day and a new start made from scratch."[7] This perseverance when confronted with repeated failure was one of Kubota's strengths; it was reinforced by the fact that he learned his meticulous and time-consuming craft in the Japanese apprenticeship system. As an apprentice, he would have developed patience while kinesthetically absorbing technique; neither the idea of efficiency nor the concept of "short cuts" exists in the world of traditional Japanese crafts.[8]

After much experimentation and many failures, Kubota came to the realization that he faced insurmountable technical problems trying to recreate tsujigahana. He could find no substitute for nerinuki, and although natural dyes fascinated him, he could not achieve his desired results through their use. In 1959, Kubota switched to modern synthetic dyes, which also required repeated experimentation. By 1961, he developed his own dyeing method. As he explained, "The problem with synthetic dyes is that they separate when overdyed [overdyeing is essential to achieve the variety of shades for which Kubota was striving] and the result is a muddy mess. Finally, however, I managed to create a mixture of colors with delicate shades."[9]

Kubota encouraged an intentional and controlled blotchiness of color, a dyeing innovation that was both subtle and ingenious. Finding a suitable ground fabric also

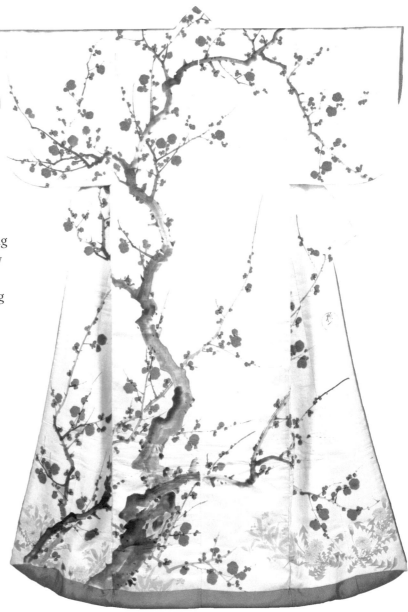

Figure 6
Sakai Hōitsu (1761–1828)
Kosode with Plum Tree and Flowering Plants
Edo period, early 19th century
Ink, color, and gold leaf on undyed silk satin
61 x 46⅛ in. (154.9 x 117.2 cm)
National Museum of Japanese History, Nomura Collection

proved elusive, but eventually Kubota realized that he would have to use a modern substitute. He turned to *chirimen*, a relatively heavy silk crepe often woven with gold or silver threads. Modern plastic thread and steel needles enabled him to have a level of control once thought possible only on nerinuki. Although he availed himself of contemporary materials, at no time did Kubota consider short cuts, assembly-line production methods, or cost-cutting measures. For Kubota, "modernization" meant achieving the effects he wanted with the materials at hand rather than slavishly trying to recreate the past. As Professor Yamanobe Tomoyuki has pointed out in the catalogue for the 1995 Kubota exhibition in Canada and the United States, the artist was concerned with recreating the beauty of tsujigahana, not the exact process.[10] Professor Yamanobe also encouraged Kubota to apply dyes with a brush, which was a technique the artist had mastered in yūzen and a dyeing method unknown in the sixteenth century.

There was another aspect of tsujigahana that needed addressing by Kubota. In the sixteenth century, the ink painting typical of tsujigahana was probably added to the textiles by professional painters and not by the dyers themselves because they were separate craft skills. Until the Meiji period (1868–1912) brought greater contact with Western culture, little distinction was made between artists and artisans: painters and dyers collaborated to produce the dyed and ink-painted textiles of tsujigahana. This might be difficult to recreate in a contemporary world, where kimono dyeing and ink painting have completely diverged. Kubota, however, was both painter and dyer, a result of his broad training. (For an illustrated sequence of Kubota's basic production techniques, see pp. 152–53.)

In 1962, he called his unique invention "Itchiku Tsujigahana," in homage to the fragment that inspired him and to its popularly recognized, if historically ambiguous, name. He continued to experiment to the end of his life, changing his techniques slightly to express his ideas for each piece he created.

KINETIC PRESENTATIONS: THEATER AND DANCE

Kubota repeatedly sought to present his kimono in new and innovative ways. In 1980, at the American Club in Tokyo, "Tōjūrō and Itchiku Tsujigahana," a performance of a traditional dance featuring his kimono, offered Kubota an opportunity to show his works in motion.

His "Itchiku Tsujigahana Grand Show," a new form of kimono fashion show, took place in 1982. He chose to have Western high-fashion models wear his kimono and commented:

> I took personal responsibility for all matters of production and stage effects. My goal was to make the entire show into a single piece. I tried to present new ways of thinking about the kimono. In particular I had been bothered by traditional rules: for example, the idea that one should not mix Western high heels or jewelry with kimono. If the Japanese kimono is to remain important in our lives today, it must be brought up to date. We must go beyond the staid tradition of conceiving the kimono as a uniform with set rules. This rigidity in the Japanese mind is one thing that I would like to breathe new ideas into.[11]

Two years later, in 1984, the exhibition *Itchiku Tsujigahana: Light and Wind* was held at the Laforet Museum in Tokyo. Although a traditional installation, Kubota nonetheless wanted a sense of drama and movement: "My objective here was to fill the entire show with lively, dancing light. I achieved this through the use of transparent acrylic, a modern material which gives a delicate glitter."[12] The same year, his kimono were used as costumes for a performance titled "Dance of the Dream Robe" at the Shinbashi Theater in Tokyo. Kubota said, "The performance combines arts of the modern era into a whole to express a theme of deep, constrained love."[13] His atelier also began creating kimono for Tokyo's Takarazuka (all-female theater troupe) in 2007, as well as for annual noh performances at the Itchiku Kubota Art Museum.

TRADITION AND INNOVATION: SYMPHONY OF LIGHT

Symphony of Light, Kubota's largest body of related works, is also one of the most complex examples of his willingness to step beyond the boundaries of historical convention while simultaneously honoring it. Kubota's use of the kimono format as a vehicle for an artistic statement is both contemporary and traditional. In concept, the series has more in common with Sakai Hōitsu's early-nineteenth-century painting on a kosode (see Figure 6) than it does with the formulaic imagery established for kimono during the second half of the nineteenth century. Kubota has manipulated scale, thematic imagery, and presentation in original and interesting ways.

Scale: During the Edo period, samurai-class women began to wear *uchikake*, an outer robe with a single padded hem. By the nineteenth century, uchikake were worn by affluent townswomen on all formal occasions; today they are mainly bridal attire (see *Uchikake with Mandarin Ducks and Cherry Blossoms*, p. 134). The average height of a nineteenth-century uchikake, measured from the top of the collar to the edge of the hem down the center back seam, is approximately 66 inches (168 cm); many of Kubota's kimono range from 78 to 95 inches (198 to 241 cm). With Symphony of Light (and his Mount Fuji series), Kubota broke with tradition and enhanced the height of the pieces, to emphasize the monumentality of his subject, by adding up to 29 inches (73 cm) to the hemlines. He also occasionally used this device on his individual works. Kubota achieved this added height with fabric and rolled and padded hems (*fuki*), always being careful to integrate them completely into the robe's coloration and to vary their configurations. His kimono, therefore, are not technically uchikake, but his own invention.

Theme: The largest section of works within Symphony of Light is The Four Seasons, a common theme in Japanese art. A brief review of previous presentations of this theme on kimono will make the uniqueness of Kubota's treatment evident. As discussed at the beginning of this essay (see p. 17), the layered dressing (kasane shōzoku) of the Heian period required subtle color combinations that indicated poetic or literary allusions, often with seasonal connotations. Therefore, the color combinations (and the poem) had to be appropriate to the season in which the garment was being worn. Later, in the Momoyama period, seasonal flowers were placed within a design field that was divided into squares, with one season in each square. This type of composition was known as *dan-gawari*.[14] In the Keicho-Kan'ei era, tiny, loosely embroidered flowers of the four seasons were sometimes combined on the same robe (see Figure 4).

In general, from the eighteenth century on, a single season was frequently represented on a kimono, usually with its conventional flowers and other plants. Cherry blossoms and wisteria (spring), irises (summer), maple leaves and chrysanthemums (autumn), and pine and bamboo (winter) are a few examples from the vocabulary of seasonally associated plants. Certain combinations of plants—for example, bamboo, pine, and plum blossoms—became common tropes for a specific season, in this case, winter. There are, however, occasional exceptions. A mid-nineteenth-century kosode in the Nomura Collection has a design of cherry trees in four seasons around the hem (Figure 7). (For more on the theme of seasons in Japanese painting in relation to Kubota's work, see "Kubota as Imagist," p. 29.)

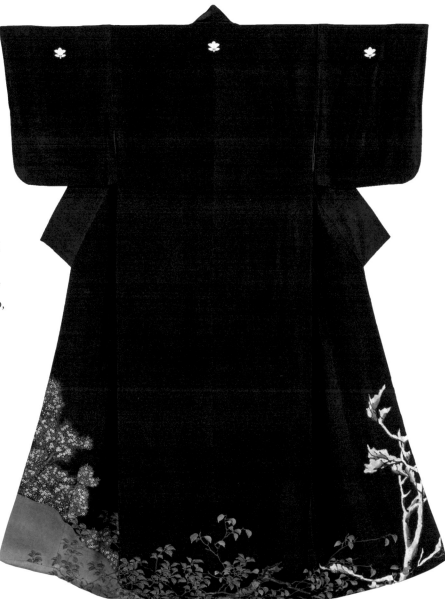

Figure 7
Kosode with Cherry Trees in Four Seasons
Edo period, mid-19th century
Yūzen dyeing and embroidery on silk crepe (*chirimen*)
Center back: 63¼ in. (161 cm)
National Museum of Japanese History, Nomura Collection

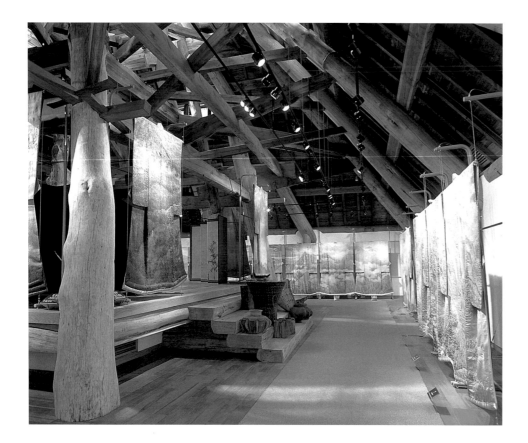

Figure 8
Installation view of Symphony of Light at the Itchiku Kubota Art Museum.
The suspension system for individual kimono can be seen on the right.

Presentation: Kubota's initial version of Symphony of Light was a series of kimono of the four seasons, the oceans, and the universe (although only Winter, Autumn, and portions of both The Oceans and The Universe were completed before his death).[15] Although the imagery on each kimono can be viewed as complete in itself, all the kimono in a series were intended to be viewed together as a single work of art, with the imagery continuing from garment to garment. Unlike kimono designed to be worn, these are intended only to be seen from the back with the front edges held out to the sides. They do not move in space; it is the viewer who moves (see "Kubota as Imagist," p. 28). Kubota even designed special stands for the kimono to line them up in the same plane before the viewer (Figure 8).

The late Momoyama to early Edo period (late sixteenth–late seventeenth century) was a time of great interest in fashion by all classes, but especially wealthy merchants. This period saw the popularity of paintings on folding screens (*byōbu-e*) displaying several kimono draped over a lacquer rack. *Tagasode* screens (literally, whose sleeves?; a reference to an unseen beautiful woman) have literary associations that reach back to the Heian period; they were also the model for the tsujigahana and other silk fragments affixed in kimono form by the textile collector Nomura Shōjirō (1879–1943) to two-panel gold-leafed folding screens now in the National Museum of Japanese History (see Figure 2; *Kosode on Screen*, p. 120; and *Two Kosode on Screen*, p. 133). Tagasode screens were an opportunity to display the latest kosode designs as well as exotic, imported fabrics such as painted or printed cottons from India and Southeast Asia. Several genre paintings of the same period depict clothing hung on strings or kimono racks to shield the outdoor gatherings of the well-to-do from public view (and show off their fashionable kosode in the process). Some tagasode screens show robes displayed with the top pole of the rack apparently "through" the sleeves, making the garment hang from the back across the shoulders.[16] This is also seen in examples created by Nomura, including the *Kosode on Screen* mentioned above.

It is not known if Kubota was familiar with the Nomura screens, although it is possible, because they were displayed at the Kyoto National Museum in 1934, at the Tokyo National Museum in 1973, and several other times in Japan.[17] He certainly was aware of actual tagasode screens, as evidenced by a photograph of the artist sitting in front of one,

looking at tsujigahana fragments.[18] In addition, numerous examples of these genre screens are found in Japanese museums and publications. Although not a perfect visual model for Kubota (who undoubtedly had other models; see introduction to Symphony of Light, p. 38), tagasode screens as well as genre paintings set a precedent for the presentation of kimono in a two-dimensional format. (For a discussion of Symphony of Light in the context of Japanese folding-screen and sliding-door paintings, see "Kubota as Imagist," p. 32.)

Kubota's vision to create Symphony of Light as a compositionally linked series of images, literally continuing from one robe to the next, is one of his greatest innovations—unique in twentieth-century kimono art. Among Kubota's fellow kimono craftsmen in Japan, few have combined the four seasons on one garment and none has conceived of a series of robes as a continuous surface. Among the exceptions in the former category are yūzen-dyed pieces by two Living National Treasures: *Flowers of the Four Seasons* (1932) by Ueno Tameji (1901–1960) and *Fragrance of the Four Seasons* (1959) by Moriguchi Kakō (1909–2008).[19] At least two fiber artists in the West who use the kimono form, both Americans working in wool, have produced kimono representing the four seasons, one for each season. The works can be viewed as a group of four or displayed individually, but each kimono is a complete, self-contained entity with the design confined to the parameters of the garment. *Spring*, *Summer*, *Fall*, and *Winter* from art knitter Nicki Hitz Edson's Landscape Kimono series (1986–88) was shown in the exhibition *Kimono Inspiration* (1996) at the Textile Museum in Washington, D.C. Also in that seminal exhibition was the tapestry-woven *Snow Kimono* (1984) by Danielle Ray, a single work from a four-season series.[20] Kubota's concept is unique: Symphony of Light expands beyond the single garment and its decoration to an extended surface that moves through time and space, flowing from robe to robe in a horizontal panorama. (The installation aspect of his work is explored more fully in "Kubota as Imagist," pp. 32–33.)

KIMONO REDEFINED: ITCHIKU KUBOTA

Kubota's willingness to "modernize" and his ability to innovate are both firmly entwined with his deeply Japanese spiritual connection to nature and his intimate knowledge of traditional Japanese painting and dyeing techniques. All of these influences are evident in his landscapes, which are created using centuries-old techniques, modern materials, and newly invented dyeing methods. By presenting his work as a series of compositionally linked images in Symphony of Light, as a means of expressing his painterly concerns with light and color in landscape, Kubota has indeed redefined the kimono for the twenty-first century. His son Satoshi, as Itchiku Kubota II and director of Itchiku Kōbō, the artist's atelier, currently continues Itchiku's vision with his brothers and the atelier staff.

KUBOTA AS IMAGIST

Reinventing Pictorial Icons in Kimono Form

HOLLIS GOODALL

Itchiku Kubota spent his life evoking visual and emotional experience through works on fabric. The overarching theme of his work is beauty: beauty in nature, in color, in light, and in human invention. Trained in *nihonga*, a Japanese painting style that uses traditional materials for the pigments and ground, Kubota also would have surveyed the principles of Japanese art through history, with its ebb and flow of aesthetic influences from China and the West, balanced by Japan's native aesthetics and symbology. Though he was fascinated with tradition, Kubota's art was most affected by his own life-changing experiences: being awestruck by the beauty of a *tsujigahana* textile fragment at the Tokyo National Museum; or balancing the pain of each day of his three-year imprisonment in a Siberian prisoner-of-war camp by observing the spectacular sunsets of that region. These personal revelations, and his visceral response to nature, light, and color, are reflected in each kimono.

SYMPHONY OF LIGHT

The kimono, as discussed in "The Kimono Redefined" (see p. 16), was conceived by artists as a decorative covering that complemented the movement of the body wrapped within it. Sweeping diagonal designs, pictorial narratives, quotations from literature, and myriad other images expressed the wearer's taste and interests. In the eighteenth and nineteenth centuries particularly, prominent artists received commissions from patrons to transform a woman of elegance and sophistication into a moving painting (see Sakai Hōitsu's *Kosode with Plum Tree and Flowering Plants*, p. 21), using the kimono simply as a new format for pictorial art. The kimono medium, however, also had a sculptural element in the cut of the garment, in the variations of the drape and reflectivity of the fabric, and in how the garment could take on three-dimensional volume when worn on the moving body or become a flat, pictorial format when displayed on a kimono rack. Kubota's costuming for theater and the kimono he created in his signature style for personal clients were scaled to the body; uniquely, however, most of Kubota's pictorial kimono extend well beyond life-size (see p. 23).

In his Symphony of Light and Mount Fuji series, Kubota took the extraordinary step of increasing the height of the kimono by approximately 20 to 40 percent. These oversize works no longer functioned as wearable art; they were now strictly a painting format, scaled to create a sense of the vastness of the sunset landscapes, or the immensity of Mount Fuji. The shape, the softness and drape of fabric, and the dimensional effects accomplished by using a ground of dense silk crepe (*chirimen*), or by puckering the surface with tie-dye (*shibori*), or by adding depth to it with embroidery—all these elements move the works beyond the confines of the standard, two-dimensional Japanese paper or silk painting surface. In making a continuous design within a group, as he did in the Symphony of Light series, Kubota experimented with a variation on the idea of the *fusuma-e*, paintings on the sliding-door panels (*fusuma*) that embellish temples, palaces, official residences, and the homes of the wealthy.

Paintings used to divide rooms or create areas of semi-privacy within a space are recorded within narrative picture scrolls dating back to the eleventh century, although it was not until the Muromachi period (1333–1573) that paintings on sliding-door panels became a fixture in architecture. By the late fifteenth and into the sixteenth century, fusuma-e compositions could seemingly expand the physical space of a room by

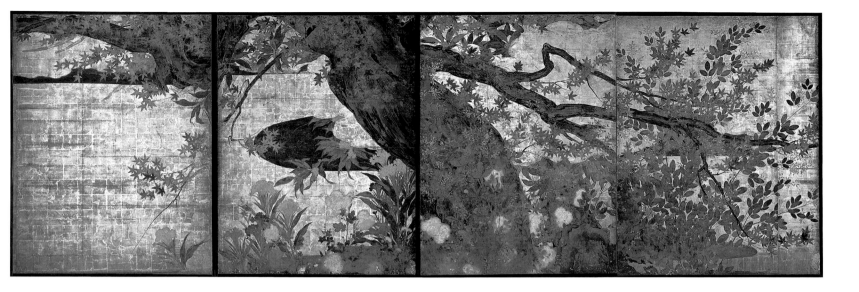

Figure 1
Hasegawa Tōhaku (1539–1610)
Maple Tree and Autumn Plants, c. 1593
Four sliding-door panels (*fusuma-e*); color and gold leaf on paper
Each: 68⅛ x 54⅞ in. (174.3 x 139.5 cm)
Chishakuin, Kyoto

employing deep-distance views or open space in the design. These paintings—often of ink, color, and gold—can dominate the room, and might even overwhelm the viewer with their magnificence. In garden-facing rooms of the sixteenth and seventeenth centuries, the spatiality of the exterior garden could be reflected in the fusuma-e, or could be complemented by them. *Maple Tree and Autumn Plants*, a set of fusuma-e by Hasegawa Tōhaku (1539–1610) in the Chishakuin temple in Kyoto, exemplifies this interplay of interior and exterior (Figure 1). In some works, Tōhaku, like Kubota, displayed a penetrating awareness of the beauty that he observed directly in nature. Tōhaku's *Maple Tree and Autumn Plants* and *Blossoming Cherry Trees* (also at Chishakuin) do not follow the popular, Chinese-inspired manner of strong outline and repeated angular forms. *Maple Tree* has no predominant geometric structures; it is based instead on the naturalistic, untamed growth patterns of a venerable old tree.

Standing in the room at Chishakuin, where Tōhaku's giant maple graces one wall of fusuma-e and the grand, blossoming cherry tree adorns the opposite wall, the viewer's first impression may be one of immensity. Branches splay across surfaces, seeming to reach into the viewer's space. The branches appear to be both well tended and natural; they are neither organized, like a bonsai, nor entirely chaotic, as one would find in a forest. Beyond each tree, clouds of gold conceal the background, abstracting it and holding the viewer's attention to the surface of the painting, following a manner popular during the late sixteenth century. The view from the room is channeled between the dense surfaces of these painted trees to the open space of Chishakuin's large garden with a pond, bounded by expertly composed rocks. Beyond the confines of the garden, in a "borrowed view" (see glossary), can be seen the tall trees that enclose the vista in the distance. As with many sixteenth-century fusuma-e, the garden itself became the fourth wall in the painted composition. The later Kyoto artist Maruyama Ōkyo (1733–1795) would actually calculate the angle of the view toward the garden from a single, stationary vantage point and use the same point of view to compose the landscape features within his fusuma-e, thus enhancing the illusion of being fully encircled by a garden space. Kubota instead varied the point of view throughout the series of kimono, so that observers, as they walked in front of the hanging display, would feel as if they were wandering through a landscape. (These changes in points of view are discussed in great depth beginning on p. 34.)

When all the kimono in the Symphony of Light series are displayed in a single room, the effect is that of an expanding and changing vista that both encloses the viewer and creates the illusion of seeing far beyond the confines of the room toward a distant horizon. At his own museum, Kubota constructed a grotto-like building within a beautifully designed garden compound, in sight of Mount Fuji. Before entering the exhibition hall and the virtual landscape that Kubota created with his display, visitors

first leave the road, then walk through the bucolic serenity of the garden. This shift from actual to virtual worlds parallels the entry into the hermitage-like environs of a temple surrounded by gardens and embellished with painted fusuma-e, such as Chishakuin.

The naturalistic aspect of Hasegawa Tōhaku's paintings at Chishakuin, as well as his insistence that the beauty in nature was sufficient unto itself and did not need to be heavily stylized in painting, is reminiscent of the art of the impressionists, with which Kubota was fascinated. The impressionists, who worked primarily in France during the late nineteenth century, were also thought to be governed more by the senses than by academic theory, and they were most concerned with the physical perception of light. They experimented with the theory that the eyes blended the colors that were variously reflected or refracted from surfaces, depending on the angle and intensity of light. Painting over a white base material that enhanced the clarity of their color palette, they would place strokes of pure color adjacent to one another, recording exactly what their eyes perceived without blending, in order to convey accurately the effects of light on a form. Even though the painter would split objects in a composition into bits of color, the viewer's eye would automatically meld the colors together, allowing for the perception of definite shapes and structures illuminated by light that came from a specific direction and had a particular quality. Artists of this group, most memorably Claude Monet (1840–1926), intently studied the effects of dawn light, midday sun, late afternoon slanted sunlight, and the tones of twilight, when the colors of the sky outshone those on the ground. More important for Kubota was that these artists had studied how the earth's orbit around the sun changed the quality of light from season to season. Monet and Kubota both considered color to be an emotive device as well, capable of evoking a subconscious response in the viewer.

The effects of seasonal light shift from kimono to kimono in Symphony of Light as the designs flow from autumn through winter and vary between decorative designs and naturalistic views. Sunlight comes from a higher angle in autumn-themed images, and it differs from the light given off as the sun stays close to the horizon, seen in Kubota's winter-themed kimono. The light also appears to change depending on the weather conditions: mist, snow, rising humidity, limpid clarity, or haze.

Kubota's Symphony of Light series guides the viewer through space and time like the narrative of a handscroll, evolving into a set of seasonal paintings executed on a grand scale. The treatment of the concept of time is not often found in pre-modern Western works. It is specific to historical East Asian painting, and can be seen in Japanese narrative handscrolls (emakimono)[1] and in pairs of seasonal paintings (shiki-e)[2] most commonly produced in Japan. Scrolls from the twelfth century showing continuous narrative sequences survive in Japan, but one work in particular from the thirteenth century resonates with the artistry of Kubota: the Ippen hijiri-e, dated 1299, by the artist En'i (fl. c. 1300) (Figure 2). In this set of twelve scrolls, the itinerant priest Ippen Shōnin[3] is seen throughout a continuous narrative, traveling through towns and countryside. Details of autumn leaves, snow, blossoming cherries, and annual events signify Ippen Shōnin's experience of the seasons in his journey. In ancient poetry, seasonal motifs were indicators of emotions such as melancholy or awe, and in the Ippen hijiri-e they similarly reveal the responses of the priest and his retinue to different events and circumstances during their long pilgrimage.

In the following centuries, with the increasing numbers of larger-scale paintings created to embellish rooms, the continuous figural narrative of the type seen in the Ippen

Figure 2
En'i (fl. c. 1300)
Shōkai at Sakurai, scroll two, section two of *Ippen hijiri-e, or Picture Scrolls of Itinerant Priest Ippen*, 1299
Set of twelve scrolls; ink and color on silk
Scroll two, section two: 14⅞ x 44¾ in. (37.7 x 113.5 cm)
Shōjōkōji, Fujisawa, Kanagawa prefecture

hijiri-e was replaced by more prominent seasonal features, including birds, blossoms, moonlight, snow, and annual events occurring as part of festivals that marked the time of year. Seasonal referents had been codified in poetry at least since the tenth century, by the poet Ki no Tsurayuki (872?–945). Shortly before the *Ippen hijiri-e* was painted, Fujiwara no Teika (1162–1241), a court poet and scholar who anthologized poetry for the emperor, wrote a series of verses redesignating the birds and flowers that were to represent each month, and the response that could be elicited by their presence. Teika's birds and flowers have consistently been used as time markers and emotive metaphors since the thirteenth century, not only in poetry but also in painting, textiles, lacquerware, ceramics, and *ikebana* (flower arrangements).

Tōhaku's paintings at Chishakuin express a simplified version of seasonal passage: cherry blossoms of spring are paired with maples of autumn to feature the high points of the year. A slightly more complex version of this theme is the commonly used triad of snow, moon, and flowers. Snow can represent either winter or early spring. It is quite often depicted on pine trees (see Cat. No. 17), symbols of long life and fortitude that show their strength by withstanding the weight of the massed snow. The moon, which glows as a large, pale orb in late summer and early autumn, is often paired with miscanthus grass, evoking the melancholy beauty of autumn. In early poetry, the word *flowers* referred to plum blossoms but later came to mean cherry blossoms, which bloom briefly from late March to early April. The blooming of cherry blossoms is a celebration of the height of spring, but their short-lived splendor also recalls life's impermanence. These are the seasonal beauties, which are further described by Teika in his reformulation of monthly motifs.

Typically, a seasonal folding-screen composition would begin on the right side with early spring, often heralded by Teika's metaphors of the willow and cherry blossoms. The artist would develop his theme, moving from right to left (the direction of traditional East Asian writing systems), including additional symbols of spring, and then early summer birds and flowers, such as wisteria with skylarks, and Chinese pinks with cormorants. The artist would move into autumn, depicting bush clover with wild geese. Grasses and chrysanthemums or maples of late autumn would eventually give way to winter snow on pines or blossoming plum trees paired with mandarin ducks. This iconic theme of seasonal progression struck a universal chord in the Japanese viewer: it provided comforting familiarity and extolled the beauty of nature in Japan, at the same time revealing the inevitable cycle of birth, aging, death, and rebirth. Screens such as this, therefore, not only inspired an array of emotions but were also a metaphor for the poignancy of the cycle of life, an idea central to traditional Japanese aesthetics that reflects a strong connection to the Buddhist belief in the karmic cycle and the impermanence of all things.

Cherry blossoms, maple leaves, snow on pines, and the summer moon were the orthodox symbols of the seasons through the twentieth century in Japan. However, an interest in seasonal imagery from outside the mainstream Japanese canon was stimulated by imported Western books in the eighteenth century and the ensuing growth of empirical science. For some artists, this new knowledge encouraged them to look beyond the iconic set of seasonal symbols. A pair of six-panel screens by Yamaguchi Soken (1759–1818), *Flowers and Plants of the Four Seasons* (Figure 3), features an array of

Figure 3
Yamaguchi Soken (1759–1818)
Flowers and Plants of the Four Seasons
Pair of six-panel screens; ink and color on gold leaf
Each overall: 60¼ x 100⅟₁₆ in. (154.3 x 254.1 cm)
Los Angeles County Museum of Art, gift of Jerry Louise and Robert Johnson, M.82.149.2a-b

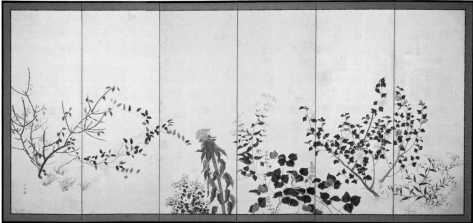

flora, probably selected from Soken's sketchbooks of plants in their yearly cycles. On the right screen (pictured above), unconventional plants representing spring and summer include magnolia, thistle, peony, daylily, reeds, and water lilies; on the left screen (pictured below), the plants of autumn and winter are knotweed, rose of Sharon, Japanese arrowroot, boneset, cockscomb, wild chrysanthemum, bittersweet, and sumac. Although all four seasons still display their finery in these screens, the artist looked beyond the accepted poetic formulas, reinterpreting the theme through botanical study and empirical science. In Kubota's Symphony of Light series, not only are seasons progressing from left to right across the kimono (rather than the traditional right to left), but the seasonal referents come from both within the traditional Japanese canon and beyond it, in the environment that he observed through travel.

Artists were encouraged to travel abroad in the early Meiji period (1868–1912), and they left Japan to study and sightsee mainly in Europe, North America, and South Asia. Foreign travel expanded their vision of how seasons progressed around the globe. After spending a number of years studying, recording the battles of the Sino-Japanese (1894–95) or Russo-Japanese (1904–5) wars, or documenting the Manchurian occupation (1931–45) and later the Pacific War (1937–45), artists portrayed the passing of the seasons with a new vocabulary based on their experiences abroad. Kubota's intensive study of seasonal passage during his imprisonment in Siberia during World War II is just such an example of this new vocabulary. In that barren but stunning topography, light (which would fascinate Kubota in the impressionists' paintings) and the change in the sun's angle to the earth became indicators of seasonal change.

Japanese artists had used light as a subject in pictorial art for centuries. Two hundred years before Kubota's time, the literati artist Yosa Buson (1716–1784), in his *Cormorant Fishing at Night* (Figure 4), studied the glow of the fire's light through the enveloping darkness. Buson employed the calligraphic techniques of a literati artist; he restricted himself to ink (*sumi*) and light colors and used the brush in the vertical manner prescribed for writing, the method best suited to expressing one's individual and intellectual qualities through stylized use of ink. He had an absorbing interest, however, in the representation of empirically observed moments in time. While the subtleties of changing daylight would not be captured until nineteenth-century artists exploited the effects of color, Buson was among the earliest artists in Japan to observe the changes produced by light.

The famous landscape print artists of the nineteenth century, Utagawa Hiroshige (1797–1858) and Katsushika Hokusai (1760–1849), are noted for their compositions and for their ability to tell stories through anecdotal genre details. However, both artists also assiduously studied the effects of light passing over the landscape, evident in Hiroshige's *Dawn at Kanda Myojin Shrine* (Figure 5) and Hokusai's *South Wind, Clear Dawn* (Figure 6). Each would use brighter colors to highlight areas of a landscape still struck by sunlight, leaving other areas in the cool green or blue shadows of approaching twilight.

Among nihonga painters and *shin-hanga* (see glossary) printmakers, especially those practicing in the first half of the twentieth century, light and atmosphere were of central concern. For example, Yokoyama Taikan (1868–1958), in his pair of six-panel screens *Sacred Mountain in Morning Sun* from 1927, records on the left-hand screen Mount Fuji at sunrise, the slopes reflecting gold between the cool white of the snow at the cone and the lifting clouds. On the right-hand screen, the sun rises through haze beyond mist-shrouded mountains (Figure 7).

Higashiyama Kaii (1908–1999), like Taikan, was enraptured by light and atmosphere. He created works that approach the effect of Kubota's Symphony of Light series; although there are no clear links between the two artists, Higashiyama and Kubota were both well known, and each must have seen the other's work. From 1974 to 1975, Higashiyama composed a series of paintings, *Mountain Clouds* (Figure 8) and *Sound of Waves* (Figure 9), on walls and fusuma-e of the Mieidō, a subtemple of Tōshōdaiji in Nara.[4] Higashiyama's composition emphasizes the rows of mountains, their slopes silhouetted by mists.

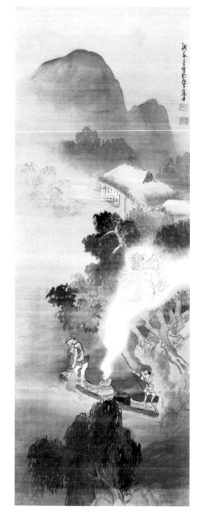

RIGHT
Figure 4
Yosa Buson (1716–1784)
Cormorant Fishing at Night
Hanging scroll; ink and
light color on silk
51⅛ x 18⅝ in.
(130.2 x 47.2 cm)
Itsuo Art Museum, Osaka

BELOW
Figure 5
Utagawa Hiroshige
(1797–1858)
*Dawn at Kanda Myojin
Shrine*, number ten from
the series One Hundred
Famous Views of Edo,
September 1857
Color woodblock print
Image and sheet: 14¼ x
9¼ in. (36.2 x 23.5 cm)
Los Angeles County
Museum of Art, gift
of Arthur and Fran
Sherwood, M.2007.152.19

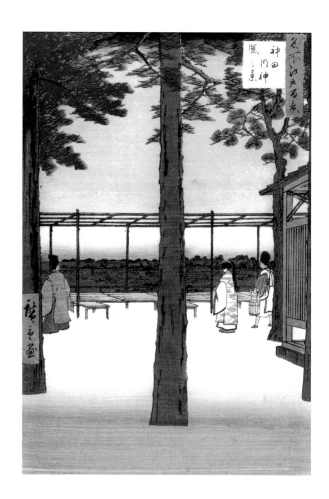

RIGHT
Figure 6
Katsushika Hokusai (1760–1849)
South Wind, Clear Dawn, from the series
Thirty-six Views of Mount Fuji, *c.* 1830–31
Color woodblock print
Image and sheet: 10 x 14⅜ in. (25.4 x 36.5 cm)
Los Angeles County Museum of Art, gift of the
Frederick R. Weisman Company, M.81.91.1

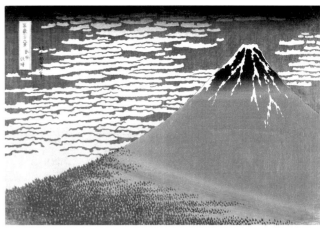

BELOW
Figure 7
Yokoyama Taikan (1868–1958)
Sacred Mountain in Morning Sun, 1927
Pair of six-panel screens; color on paper
Each: 89½ x 178⅛ in. (209.5 x 452.4 cm)
Imperial Household Agency, Museum of
the Imperial Collections

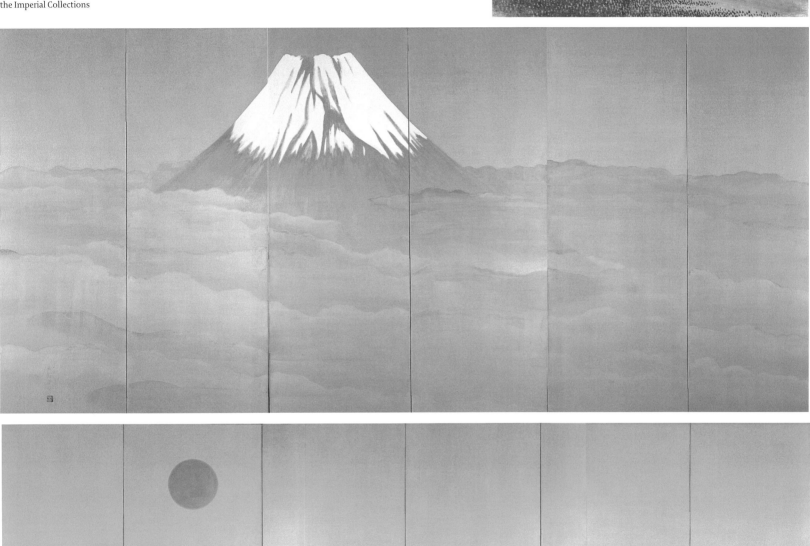

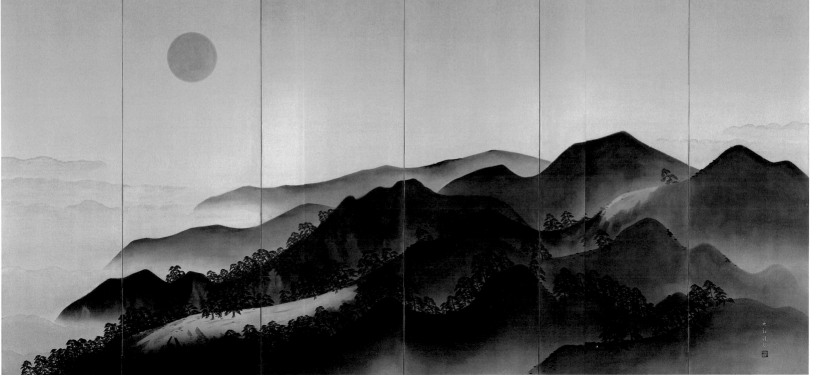

The mountain pines veiled by mist in Kubota's Symphony of Light series (Cat. Nos. 11–15, 17, 18) are related to this work, and to more stylized precursors in Higashiyama's oeuvre from the 1960s, such as *Autumn Leaves in a Ravine* (Figure 10). Kubota, however, would also insert patternized, cone-shaped conifers (like those found in *Autumn Leaves*) beside roughly drawn barren trees and grasses taken directly from nature sketches (Cat. Nos. 11–14), without regard to maintaining a single aesthetic; in the process, he created further visual interest.

Rather than studying light in *Sound of Waves*, Higashiyama keenly observed the colors within the water's varying depths near shore, the flow of the tides and the movement of the waves, and how the sea collides with the vertical faces of boulders. Even though the room in which it is installed is large in scale, the composition nonetheless envelopes the viewer (Figure 11). Four kimono in Kubota's Symphony of Light series (Cat. Nos. 21–24) convey a similar study of reflections in water.

Although the scale and the composition of mountains and waves in Higashiyama's work recall Kubota's Symphony of Light, their differences are equally remarkable. The sculptural qualities of the kimono have already been mentioned as an essential difference between Kubota's work and two-dimensional painting formats. Kubota's scheme also displays constantly changing viewpoints and stylistic mannerisms, which must have added interest to the exhaustive work involved in completing each kimono.

Kubota was inventive as an artist partly because he was willing to experiment with styles and materials. He combined and alternated Japanese-style (*wayō*) and Chinese-style (*karayō*) motifs; Japanese, Chinese, or Western manners of expressing perspective and distance; historical and contemporary techniques; color and dye usage; and purely decorative or semi-naturalistic schemes with fully realistic pictorial designs. In the delicate ink-painted motifs embedded in clouds on kimono such as *Beni* and *Shoujoutou* (Cat. Nos. 1, 6) are direct quotes from Momoyama period (1573–1615) tsujigahana textile motifs, including *aoi* leaves (see glossary), bush clover, wisteria, and others. Here, however, they are mixed with the stylized floral design known as *hōsōge*,[5] which was employed most often in embellishments on Buddhist icons or sutras, and on woven silk fabrics (either imported from China or derived from those imported silks) for aristocratic or religious use.

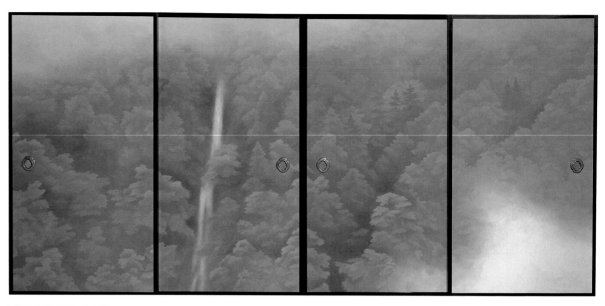

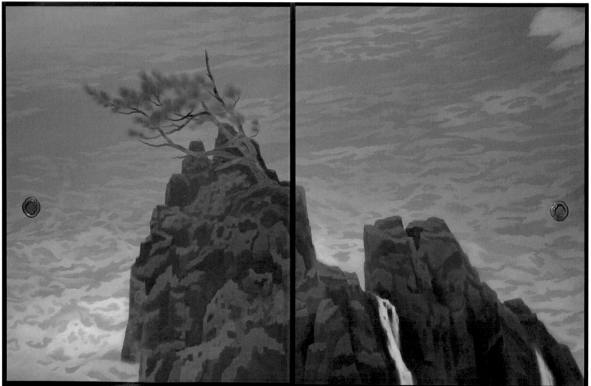

TOP
Figure 8
Higashiyama Kaii (1908–1999)
Mountain Clouds (detail), 1975
Sliding-door panels (*fusuma-e*); color on paper
67¾ x 148¼ in. (172 x 376.4 cm)
Mieidō, Tōshōdaiji, Nara

ABOVE
Figure 9
Higashiyama Kaii (1908–1999)
Sound of Waves (detail), 1975
Sliding-door panels (*fusuma-e*); color on paper
67¾ x 516½ in. (172 x 1311.9 cm)
Mieidō, Tōshōdaiji, Nara

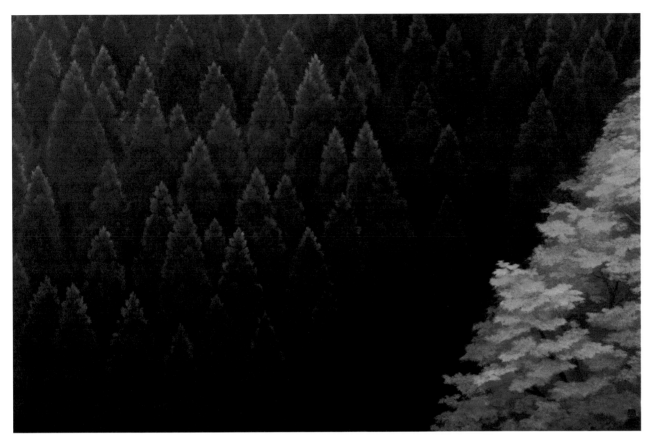

Figure 10
Higashiyama Kaii (1908–1999)
Autumn Leaves in a Ravine, 1968
Color on paper
34⅞ x 51⅛ in. (88.5 x 130 cm)
Hyōgō Prefectural Museum

Figure 11
Higashiyama Kaii's *Mountain Clouds* and
Sound of Waves installed in the Mieidō
subtemple of Tōshōdaiji, Nara.

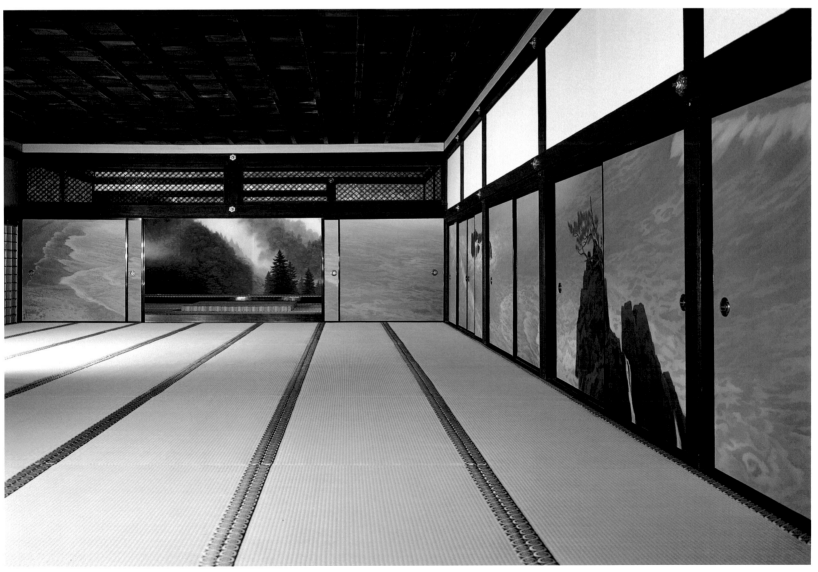

In Kubota's winter landscapes, pine trees covered with snow are quoted directly from naturalistic models developed by Maruyama Ōkyo, such as those seen in *Landscape in Snow* (Figure 12), and continued by Ōkyo's followers into the twentieth century. Ōkyo's technique of washing the outer edges of an unpainted area with gray to suggest snow on a blank silk or paper ground—called "outside shading" (*sotoguma*)—appears in Kubota's *Ei* and *Yuu* (Cat. Nos. 17, 33).

Beginning almost immediately with *Hi* (Cat. No. 2), Kubota selects fabric and color treatments that convey an impression of reflectivity. He sets a low horizon line pictorially.[6] Water in the lower half of the kimono (from the hipline down) is conveyed as undefined horizontal bands of underwater current. Atop the water, indicating wavelets, are lighter-colored shibori strips. Above these wavelets, purple and yellow light-infused clouds stretch broadly over a scintillating orange sky. Small hills at the lower left of the skirt reflect the topography of the region around Kyoto and Nara and are rendered in a wayō or *yamato-e* style, a signifier of native Japanese taste since the thirteenth century.[7] Kubota consciously applies this and other features of wayō (including flattened, asymmetrical compositions and abstracted natural forms treated as patterns), as well as traditional motifs such as those seen in tsujigahana, throughout the Symphony of Light series.

Perspective gradually evolves from *Kyou* (Cat. No. 3) to *Hiwacha* (Cat. No. 4), with wavelets appearing in the glow of light on *Hiwacha* to define a now-raised horizon line. This evolution is completed in *Aihatoba* (Cat. No. 5), with a conversion of perspective from a low horizon line and vaguely defined one-point perspective to a raised horizon line (nearly at the top of the shoulder). The raised viewpoint, or "bird's-eye view," is another signifier of yamato-e style. As the perspective is raised, the landforms are abstracted and flattened, with heavy outlines and decorative motifs throughout. Kubota has maintained a semi-realistic manner for depictions of water and maple leaves closer to the foreground.

In *Kougaki* (Cat. No. 8), it is clear that the interwoven landforms of the previous three kimono (which mask a distant view) have also camouflaged the return of the composition to a lowered horizon, now revealed in the mid-back area. The mid- and background hills, richly ink-painted with motifs, contrast with the patterned, semi-naturalistic, foliage-covered foreground hills. Colors range from the fantastic and purely decorative to the more natural, such as those seen on autumn hillsides. The horizon continues on the same plane in *Benigara* (Cat. No. 9), as oversize, exaggerated motifs begin to wind their way in,

Figure 12
Maruyama Ōkyo (1733–1795)
Landscape in Snow, 1784
One of a pair of six-panel screens; ink and light color on paper
Overall: 64 x 140 in. (162.6 x 355.6 cm)
Los Angeles County Museum of Art, Mr. and Mrs. Allan C. Balch Fund,
M.58.9.1

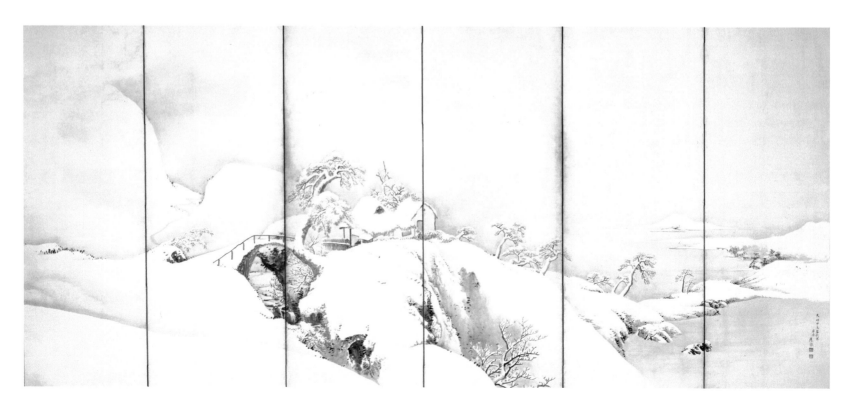

dominate the center, and then diminish from the foreground at the right. In *Kakimurasaki* (Cat. No. 10), smaller ink-painted motifs and patterned trees appear, replacing the magnified features of *Benigara*.

Perspective is again changed to a bird's-eye view in *Jo* (Cat. No. 11), while the landscape elements form a complex blend that range from semi-naturalistic trees to boldly and variously scaled ink-painted decorative motifs. In *Ryou* and *Kou* (Cat. Nos. 12, 13), mountains obscure the horizon once again; motifs, transitioning toward the background, are replaced in the foreground by colored and ink-painted trees and plants rendered in a more naturalistic style. Employing a device long used in East Asian painting, Kubota uses mist to disguise the transitions between foreground and middle ground, and middle ground to background. The cone-shaped conifers similar to Higashiyama's *Autumn Leaves in a Ravine* are prominent in *Hin* (Cat. No. 14).

Resituating the point of view in *Hou* (Cat. No. 15), Kubota brings a third perspective type, of Chinese origin, into *Kou* (Cat. No. 16) and *Ei* (Cat. No. 17). In Chinese ink painting, a standard method for expressing depth of field is to establish a set of three viewpoints. For example, in a vertical scroll, the viewer first looks down on the foreground; mist or water forms a transition, and the viewer then looks straight outward, toward the middle ground; mist or water again forms a transition, and the viewer looks upward, toward the background. This manner of conveying perspective is most clearly displayed in *Kou*. As the viewer looks down (near the edge of the kimono skirt) at the tops of foothills, sunlight plays across mist, creating a transition against which the outline of the hills in the middle ground is silhouetted; past the clouds, the viewer looks upward to the distant, snow-dusted mountains at the shoulder line. The three-viewpoint perspective continues in the brightly lit snow scene of *Ei*, becoming indistinct again in the transitional design of *Sei* (Cat. No. 18).

From *Shou* (Cat. No. 19) to *Kyoku* (Cat. No. 24), Kubota changes the subject matter to the grandeur of the open sky at sunset and its reflections upon a vast body of water. He returns to a Western perspective, lowering the horizon, while the colors express the complexities of reflected light as well as the effects of light's penetration through the clouds. In *Byou*, *Bou*, and *Kyoku* (Cat. Nos. 21, 22, 24), the colors of Monet's Water Lilies paintings, which intrigued Kubota, emerge in the water and in the reflection of the darkly roiling sky.

Snow, both covering the land and falling through the air like a scrim that alters the view of the setting, becomes the topic of the remaining kimono in Symphony of Light, up to and including the climactic final work. Beginning with *Ryou* (Cat. No. 25), Kubota returns to the winter landscape, expressing for the first time reflections on ice and the complex layers of color that can be perceived in that glass-like surface. In *Kan*, *Jo*, and *Jou* (Cat. Nos. 27–29), taupe, pink, and mauve tones create an impression of what lies beyond the curtain of snow, which is brilliantly expressed with shibori applied with varying levels of density. Abstract decorativeness returns in *Shi* (Cat. No. 30) as ink-painted or reserved motifs appear, unrelated to the landscape, scattered along a snowy ridge. This juxtaposition of motifs and naturalistic landscape elements is further pronounced in *Kan* (Cat. No. 31), in which Kubota has used *Mi-dots* (a painting technique used to indicate foliage, developed in the eleventh century by the Chinese artist Mi Fu) to accent tree-like forms over another snowy ridge. Blank silk around the tops of the tree forms subtly distinguishes them from the more distant middle ground, while mottled dyeing effects are employed to advantage by Kubota to evoke layer upon layer of falling snow. On *Rei* and *Yuu* (Cat. Nos. 32, 33), pictorial snowy-mountain landscapes are applied over very densely creped fabric, accomplished by complex and varying use of shibori tie-dye. The flow of the creped and puckering lines and the arrangement of complementary motifs emphasize the presence of topographical volume.

Baku (Cat. No. 34), while continuing the winter narrative on its lower section, breaks the pattern of contiguous flow in its upper portion: a sunlit blue sky releases the series from the heavy weather of preceding kimono. The mixture of scale and perspective on this final kimono, with its images of waves crashing against giant rocks beyond snowy mountains, jolts the viewer and brings the series to an unexpected and magnificent conclusion.

MOUNT FUJI

In his five-kimono series on Mount Fuji, Kubota focused on the essentials of this specific landscape's spectacular light and color. The mountain's history, its place in Japanese culture and the Japanese psyche, and the numerous paintings of Fuji in Japan all may have affected the way Kubota interpreted his subject, although his first priority was to suggest effects of sunset and varying seasons on the mountain's slopes.

Mount Fuji, an intermittently active volcano, is virtually a symbol of Japan; in pre-modern times it was considered by many to be the country's protector. Fuji's eruptions in the second century BC, in 864, and in 1707 reinforced the conviction that the mountain held great power. Fuji also has a long history of sacred and spiritual connections. It has been seen by many over the centuries as the axis mundi, the pillar reaching from earth to heaven, the birthplace of the sun and moon, yin and yang, and of humanity.

Since earliest times, Mount Fuji has been noted as one of Japan's spectacular sights and famous places (*meisho*). An early subject in poetry, Fuji was also recorded in the *Ippen hijiri-e* (1299), which included the first extant paintings of famous places (*meisho-e*). In the *Ippen hijiri-e*, Mount Fuji is shown for the first time in a surviving narrative scroll as the "gateway" to eastern Japan. The depiction in scroll six, section two shows *torii*[8] gates near the base of the mountain that mark the site as the habitat of *kami* (an animistic spirit of Shinto belief).

In much of Asia, mandala were limited to depictions of the cosmos. In Japan, however, mandala also included paintings of native sacred sites, and among the best known of these is the *Fuji Mandala* (Figure 13), dated to the Muromachi period. While citing Fuji as meisho was intended to inspire poetic references (to the mountain's sublime beauty, as a scene of romantic passion, or as a distant and lonely point during a sojourn from the capital in Kyoto), the *Fuji Mandala* reflects beliefs, prevalent since the Heian period (794–1185), that the mountain was inhabited by a deity of pure water and volcanoes. The three Buddhist deities depicted on Fuji's schematized tri-lobed cone suggest a link between the mountain deity and the Buddha of the Future (Miroku), the Buddha of the Western Paradise (Amida), and the Buddha of Medicine (Yakushi).

In the twentieth century, Fuji became a symbol for nationalists during the Pacific War. Yokoyama Taikan was a nationalist as well as a celebrated artist; he depicted Fuji in numerous painting formats, in all seasons and, like Kubota, in all types of light. In Taikan's earliest versions of the Mount Fuji theme, from the 1910s and 1920s, he elongated the cone of the mountain in an archaic manner reminiscent of the Muromachi-era mandala (see Figure 7). Gradation of tone lent a more naturalistic feel to the atmosphere and light of these paintings, although the mountain's shape was stylized. In the 1940s, during World War II, when Taikan painted innumerable portraits of the mountain, his observations of Fuji resulted in much more consistently realistic renderings, with the slope of the mountain flattened and the cone irregular in shape.

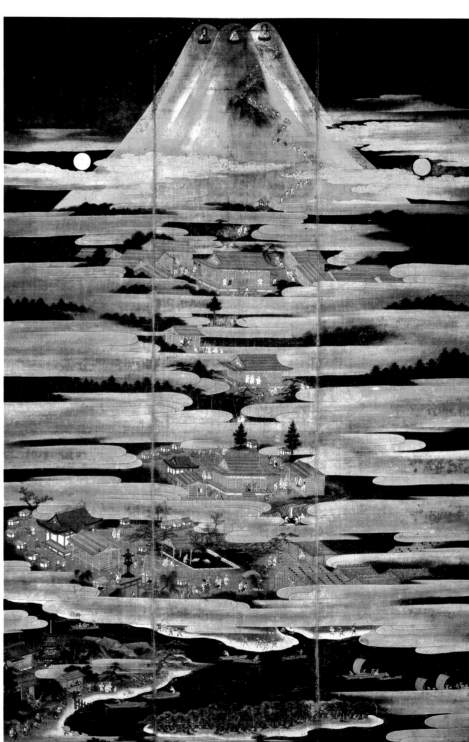

Figure 13
Fuji Mandala
Muromachi period, 1392–1573
Color on silk
71⅛ x 46½ in. (180.6 x 118.2 cm)
Fujisan Hongū Sengen Shrine, Shizuoka prefecture

It is fascinating to see how Kubota's interpretation of Mount Fuji varies. He has chosen not to explore any of the views of Fuji that once helped define its location for meisho paintings: the land spit of Miho no Matsubara, the famous temple of Seikenji, or Lake Kawaguchi. The first kimono, *Ohn/Fuji and Woodland* (Cat. No. 41), shows the archetypal view of Mount Fuji from a distance, its cone seemingly disembodied from its base. Exquisitely subtle shifts of color suggest topography in the conifer tree patterning on the skirt, and soft clouds rise beyond the peak, where they are touched by gold leaf.

In the remaining four kimono, Kubota reverts to the manner of Taikan's paintings of Mount Fuji from the 1910s and 1920s: the cone is either stylized, as if to make it a symbolic form, or given emphatic faceting that suggests angled light. After his naturalistic approach to Fuji on the first kimono, Kubota becomes more exultant, mixing exuberant coloration with elaborate pattern and texture on the second and third, *Ohn/Fuji, Glittering in Gold* (Cat. No. 42) and *Ohn/Fuji and Burning Clouds* (Cat. No. 43), as if to convey a sense of the effects of sunset in autumnal hues or amid the efflorescence of spring. In *Ohn/Fuji and Burning Clouds*, Mount Fuji is depicted as it would appear if viewed from the northeast (from Lake Yamanaka), although Kubota has made the angle of the slope more acute than it is in reality.

In the fourth kimono of the series, *Ohn/Burning Fuji* (Cat. No. 44), where the sunlight on the mountain takes on the color of faded red fabric, Kubota references early modern painting in his inclusion of flocks of plovers passing near the mountain's cone. The birds, in white reserve, are not naturalistic but rather call to mind a motif developed by Ogata Kōrin (1658–1716), a seminal painter and designer whose style is still quoted in Japanese decorative arts. Cloud forms and coloration on this kimono are Kubota's own, and suggest the smoky quality of air in the autumn leaf-burning season.

On the final kimono, *Ohn/Fuji Standing in a Sunset Glow* (Cat. No. 45), the bleeding of pastel color through an over-layer of white suggests the melting of ice at the summit. As the mountain awakens underneath its blanket of ice, color and energy pour out in all directions around a central flow of tsujigahana motifs across a yellow ground. Kubota's treatment of the cone gives the illusion of flying over the mouth of the volcano. This work captures the saturation of clouds by light as they gather around the mountain, leaving its base in cool darkness.

Kubota's worldly opulence in his approach to kimono design is a foil for the spiritual insight he displays in his deep understanding of light and its effects. His aesthetic follows the idea of "Japaneseness" in art expounded by Okakura Kakuzō (1863–1913) in contrasting Western and East Asian art. Okakura's contention was that in East Asia, the realism of the depicted surface in art was insignificant when compared with the effective portrayal of the energy and spirit of the object. Through vibrant color, texture, and a personal style in pictorial form, Kubota reaches within his subjects to evoke the spirit that moves them.

SYMPHONY OF LIGHT

THE FOUR SEASONS (CAT. NOS. 1–34)
THE UNIVERSE (CAT. NOS. 35–40)

DALE CAROLYN GLUCKMAN

Kubota's magnum opus is unquestionably the Symphony of Light series. The original concept was inspired, at least in part, by a visit in early 1981 to the Canadian Rocky Mountains, during which Kubota "was particularly concerned with the effects of natural light: not that which divides darkness from day, but that which plunges everything into endlessly changing color."[1] It was this effect that he wanted to capture in his work. The first five pieces of the Symphony series were completed later that year and exhibited in twenty-one cities in Japan in 1982. In 1983, they were exhibited at the Musée Cernuschi, Paris. By 1995, Kubota had produced thirty works[2] and considered creating a series of seventy-five pieces; ultimately, he increased this to eighty kimono.

According to Takamura Fumihiko, public relations manager for the Itchiku Kubota Art Museum, Kubota decided that Symphony of Light would be composed of The Four Seasons (which incorporated The Oceans[3]) and The Universe. This was to encompass Kubota's concept of the world and the universe: "the Universe section shows lava burning briskly in the core of Mount Fuji, which expresses the burning passion of Kubota's creative power. The artist stood in awe of nature…he was struck by the power and beauty of nature. Symphony of Light is Itchiku's homage to Nature and all things under the sun."[4] At the time of Kubota's death in 2003, thirty-four works with the themes of Autumn and Winter had been completed for The Four Seasons series (Cat. Nos. 1–34), as well as five for The Universe series (Cat. Nos. 35–39). One additional work for The Universe was produced by the Kubota atelier in 2006 (Cat. No. 40); no pieces have been added to The Four Seasons to date. Kubota's vision of the relationship of The Four Seasons and The Universe series is clarified by a pyramid-shaped diagram (echoing Mount Fuji) that shows the works in The Universe placed above those of The Four Seasons (Figure 1). The Oceans (Cat. Nos. 20–25) is incorporated into the Winter segment of The Four Seasons, but not shown in Figure 1.

A close examination of the kimono in The Four Seasons shows that, on each robe, Kubota has included ink-drawn flowers derived from sixteenth-century *tsujigahana*-style textiles. A surviving example in the Nomura Collection illustrates the clustering of flowers, first formed with stitch resist (*nuishime shibori*) and then outlined and filled with ink-drawn flowers typical of tsujigahana (Figure 2). Kubota's unique blend of tradition and innovation can be recognized as he incorporates the dense clusters of small, ink-painted flowers onto his semiabstract landscape essays on light and color (Figure 3).

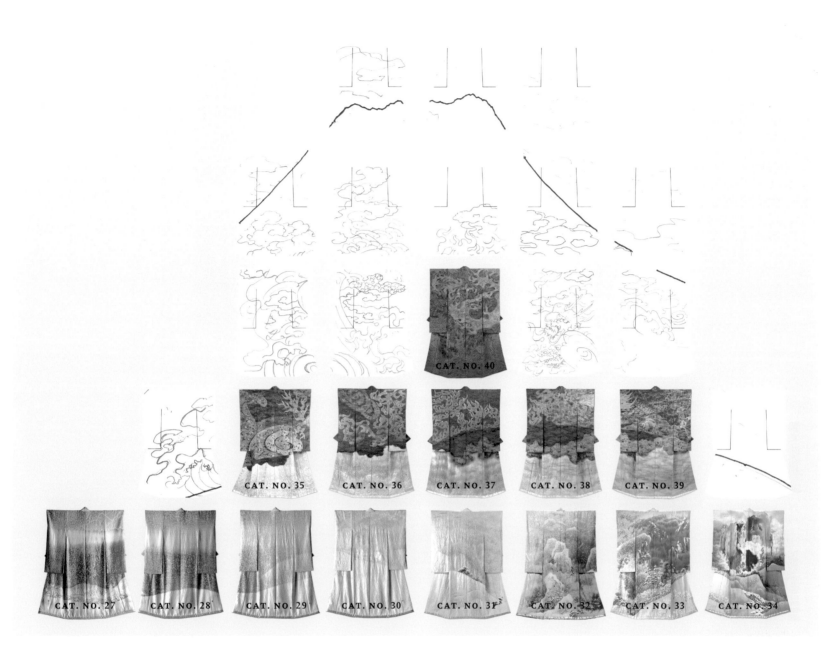

CAT. NO. 40

CAT. NO. 35 CAT. NO. 36 CAT. NO. 37 CAT. NO. 38 CAT. NO. 39

CAT. NO. 27 CAT. NO. 28 CAT. NO. 29 CAT. NO. 30 CAT. NO. 31 CAT. NO. 32 CAT. NO. 33 CAT. NO. 34

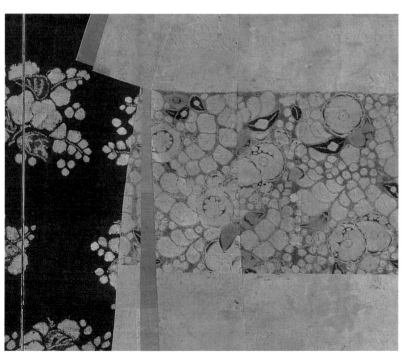

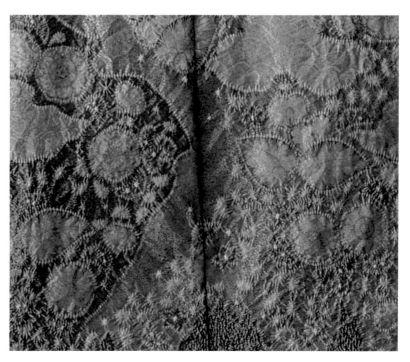

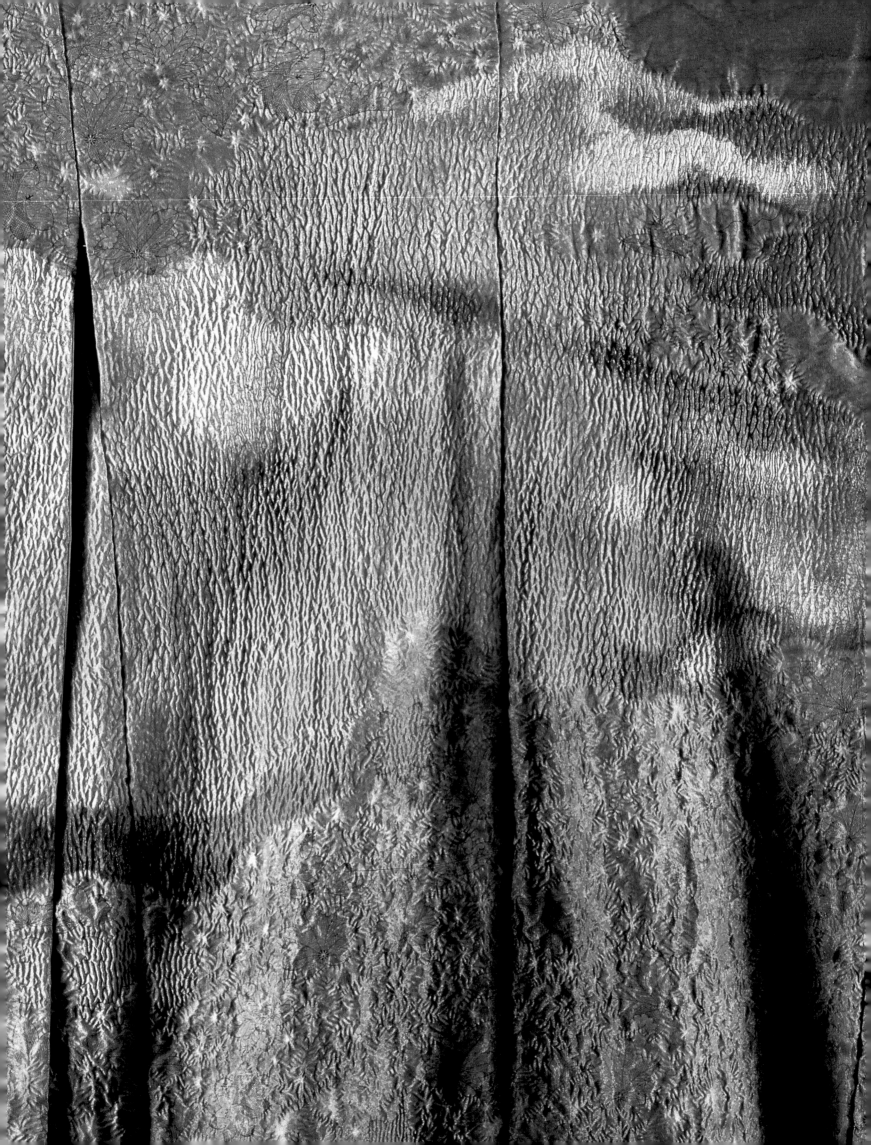

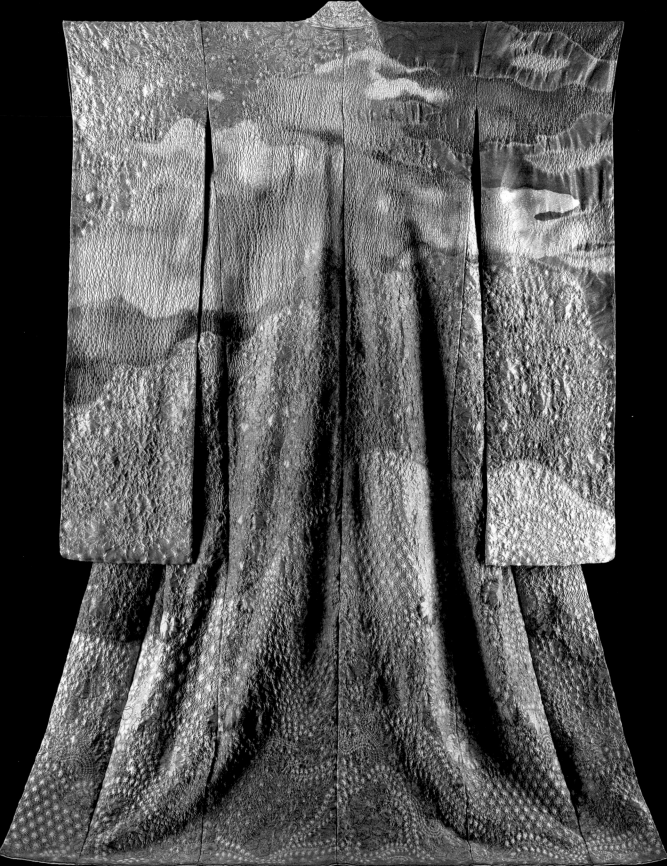

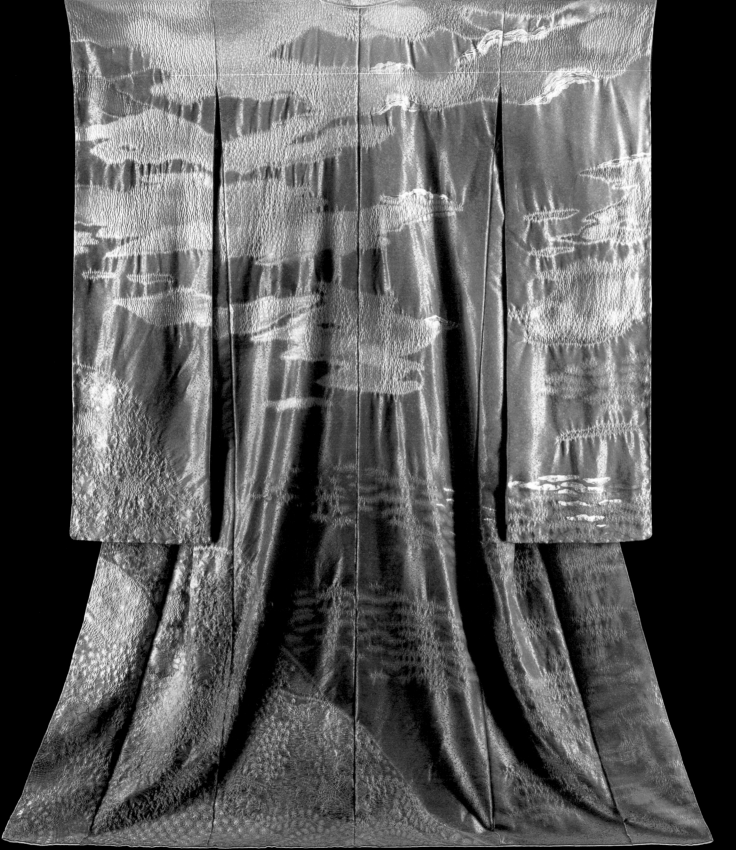

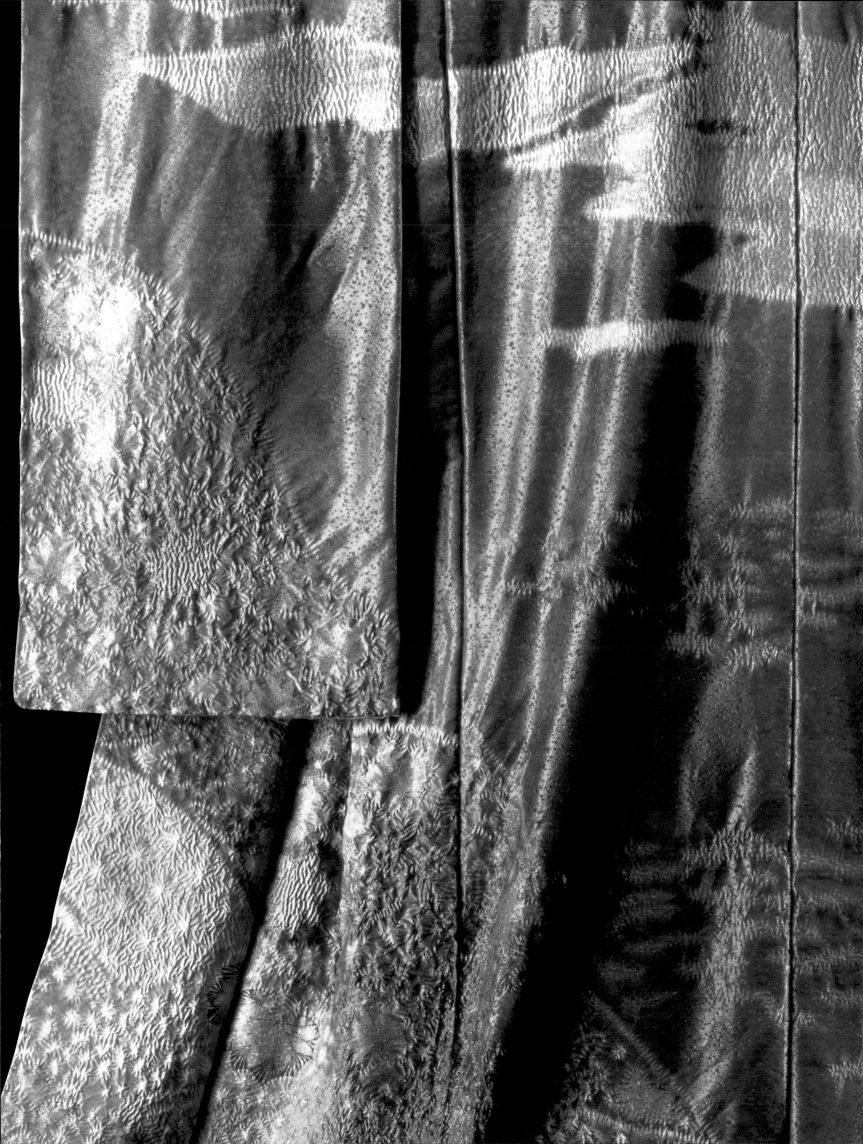

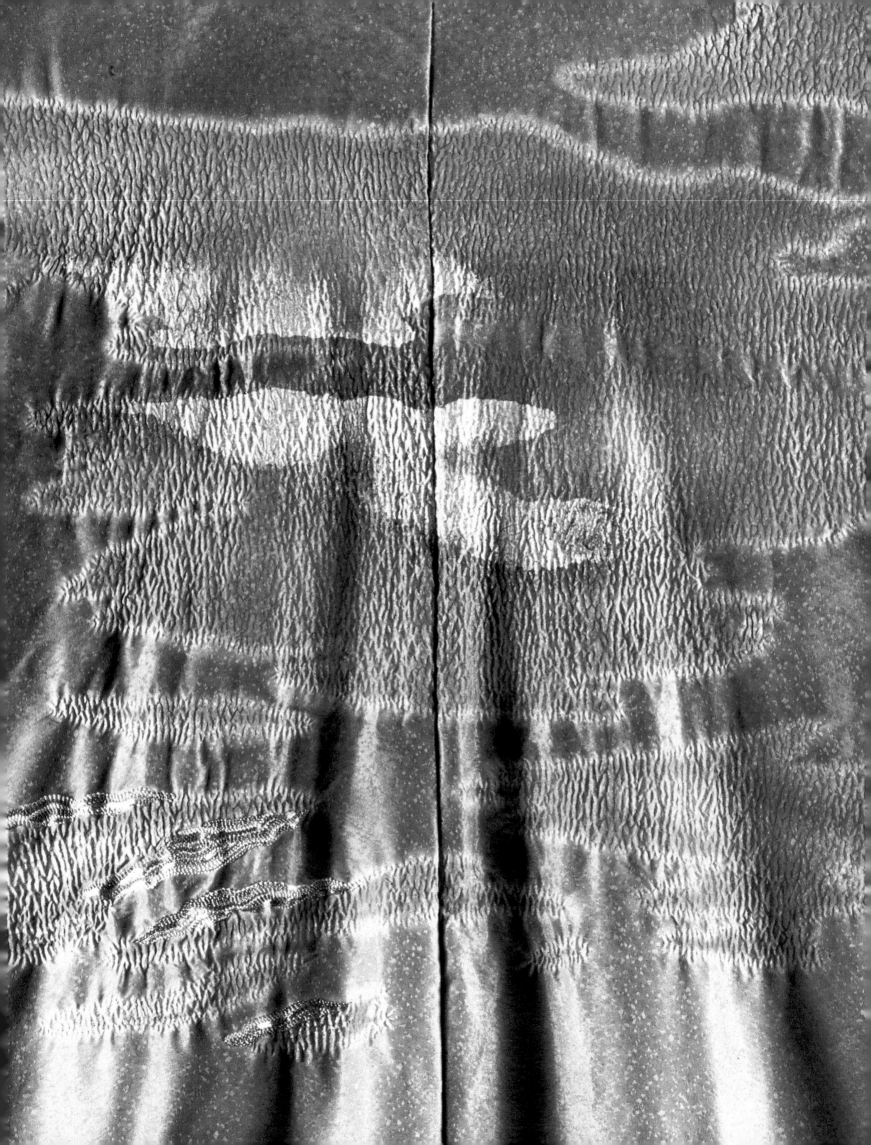

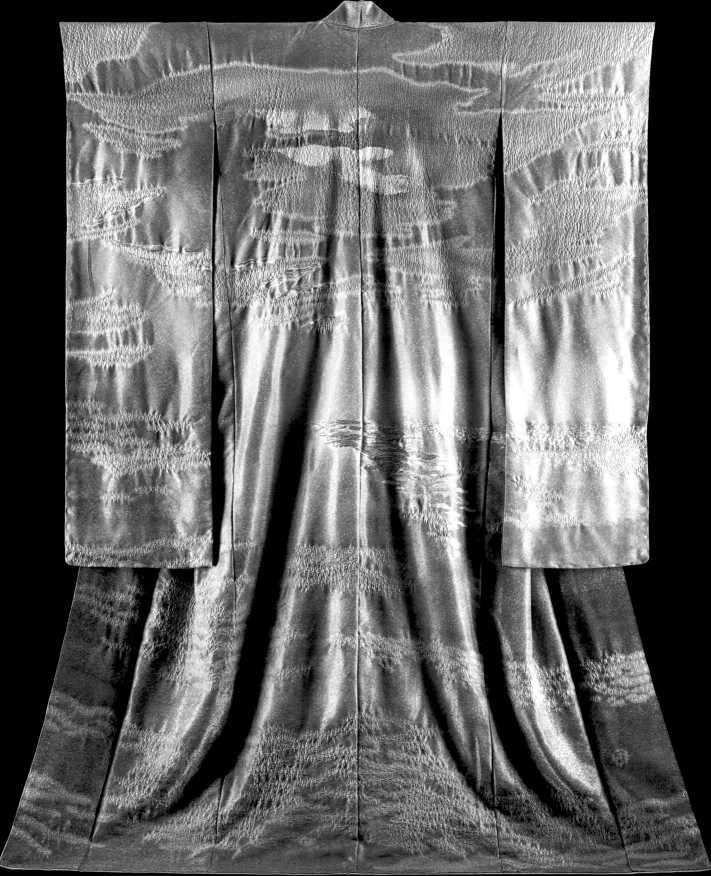

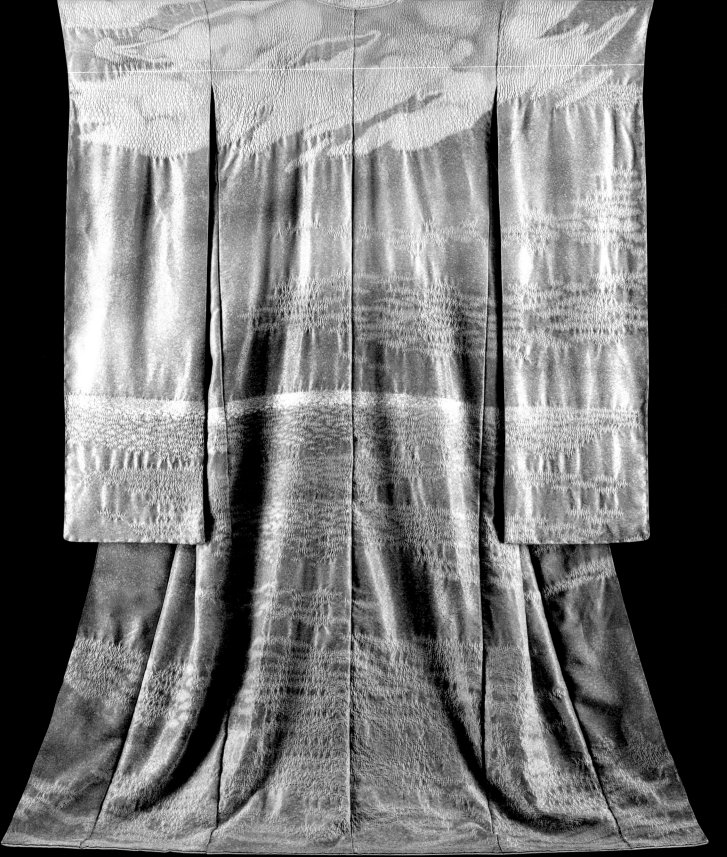

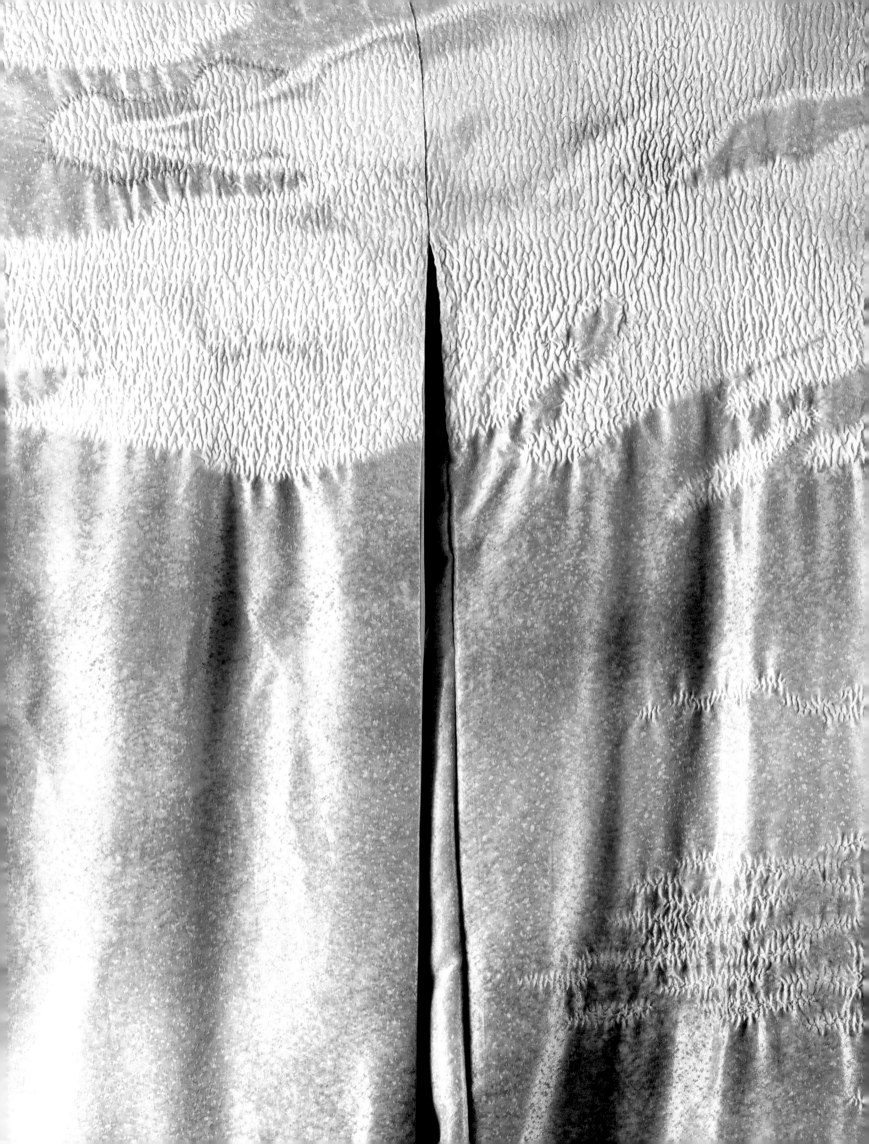

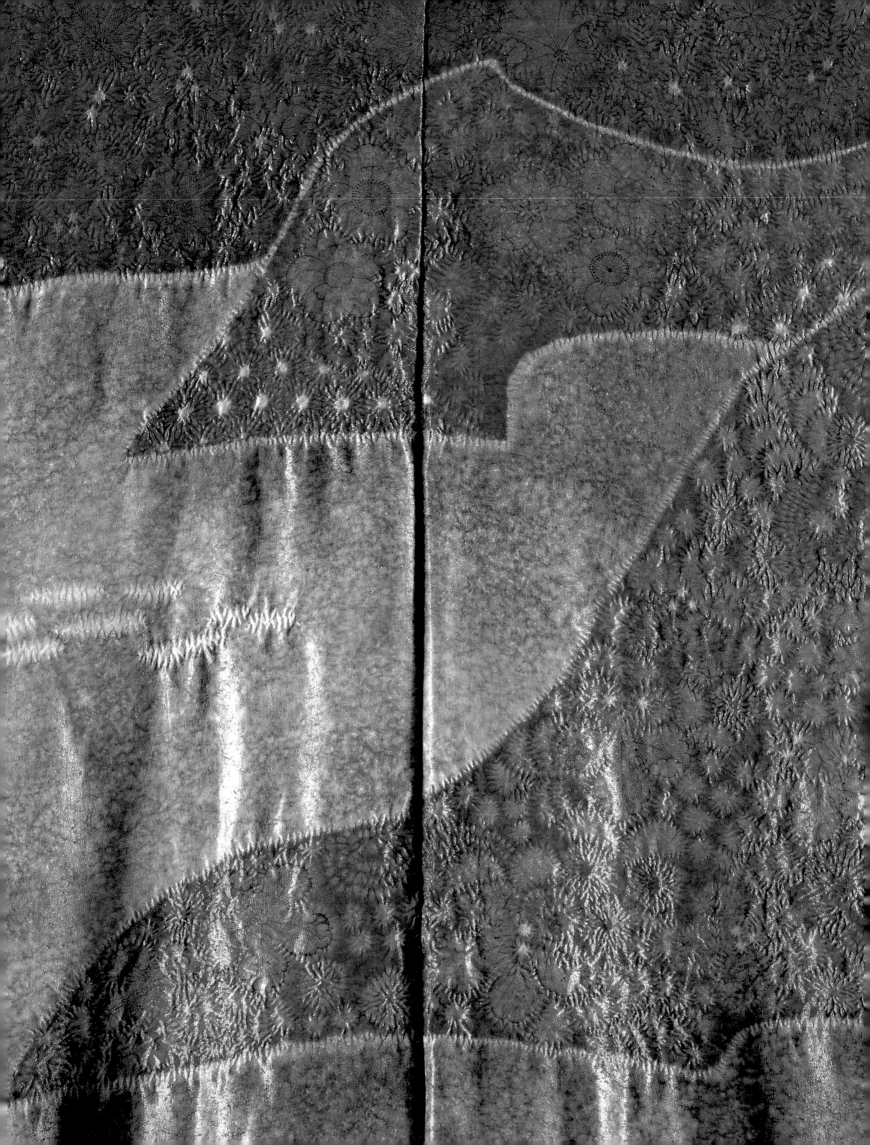

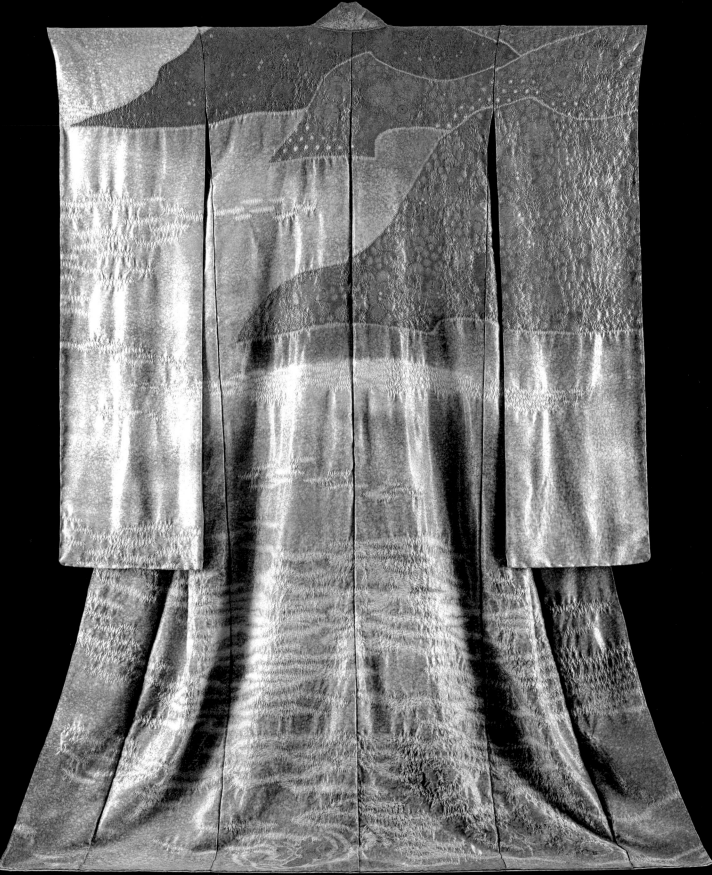

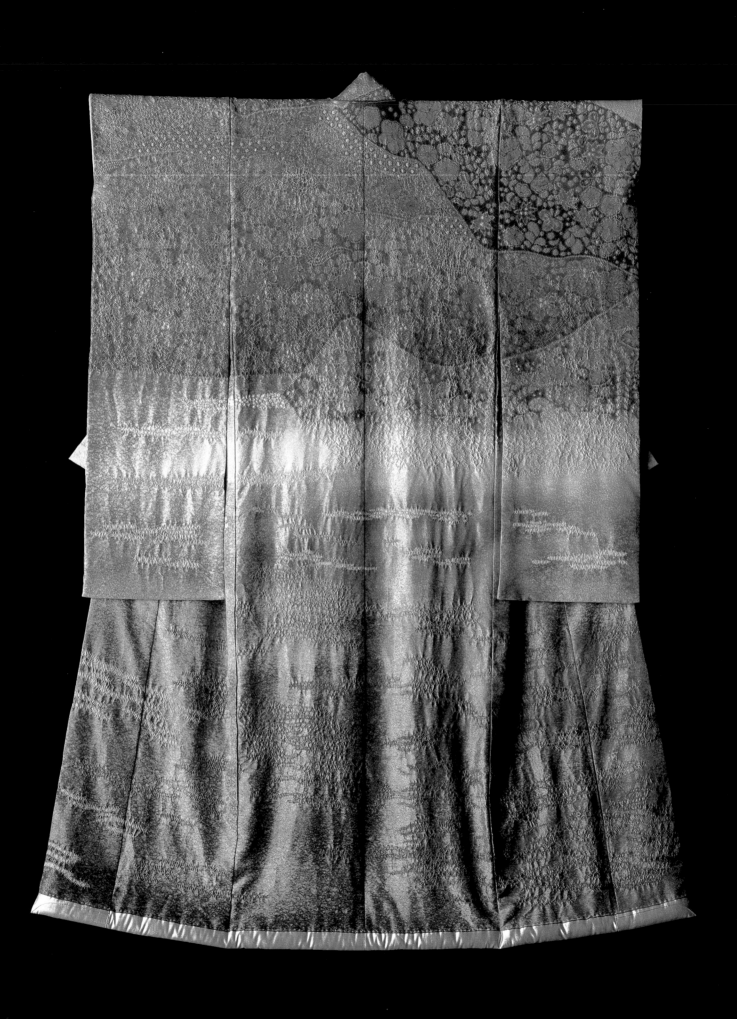

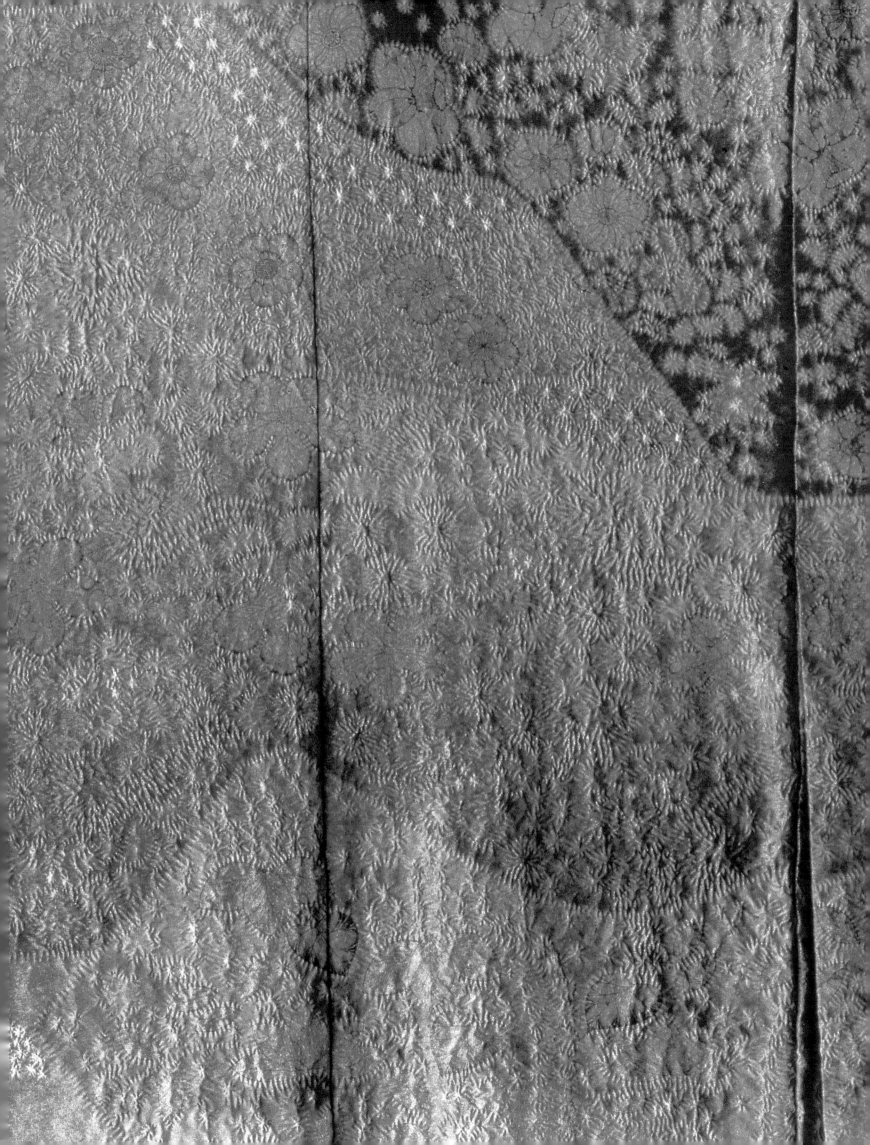

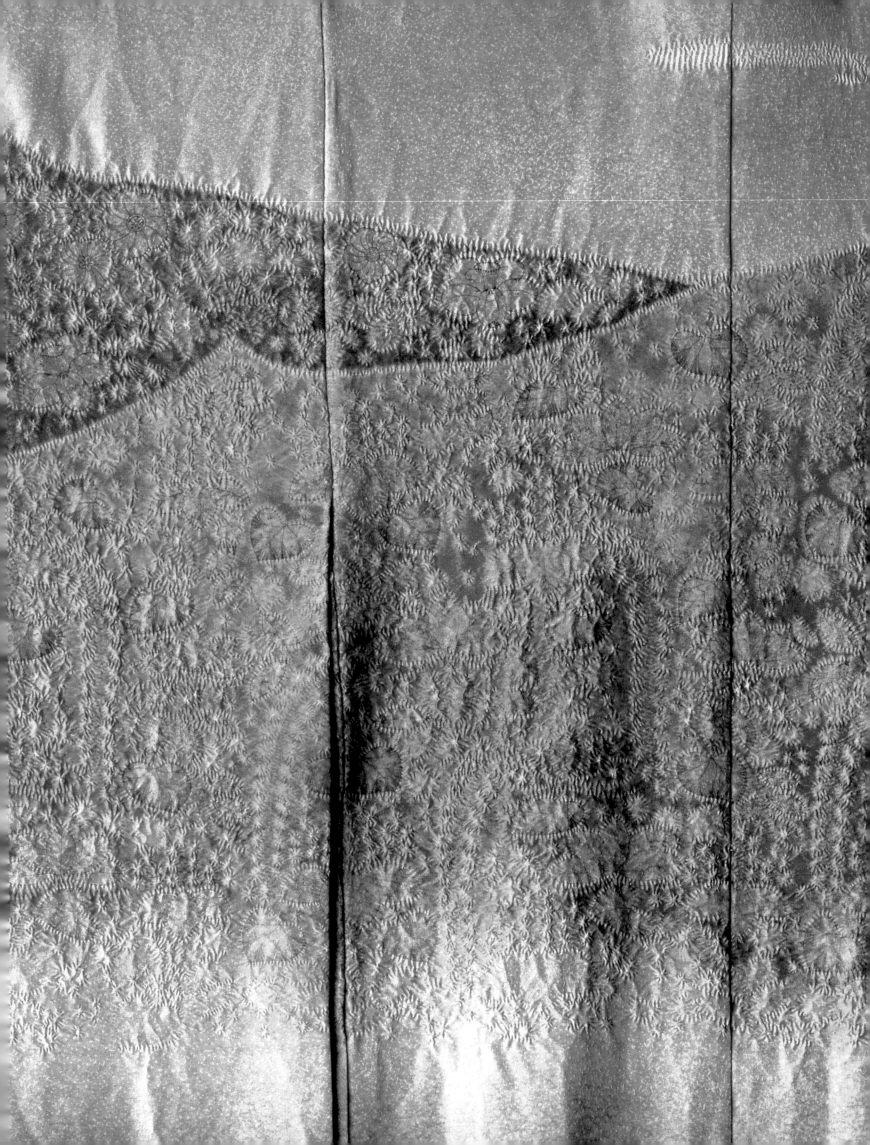

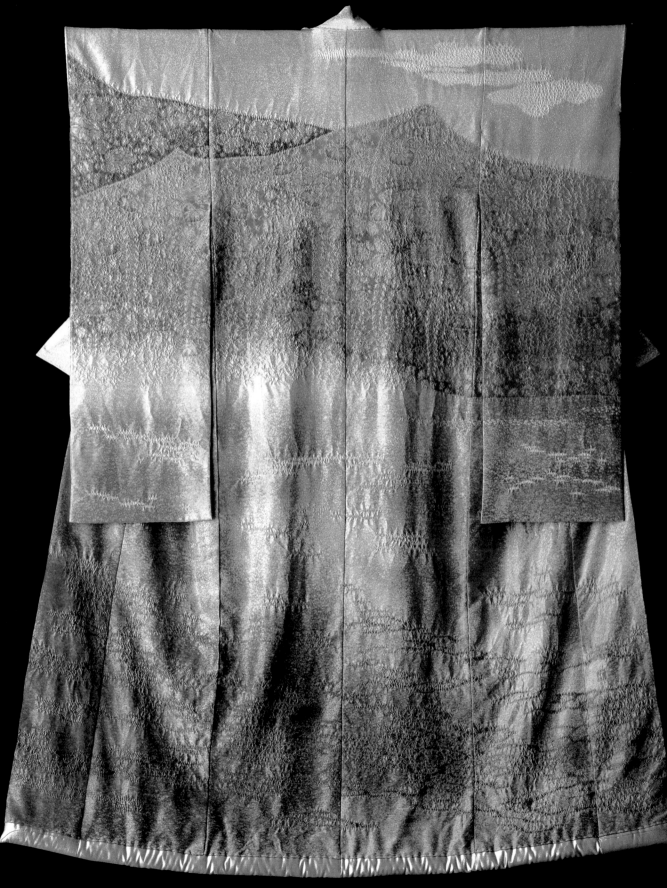

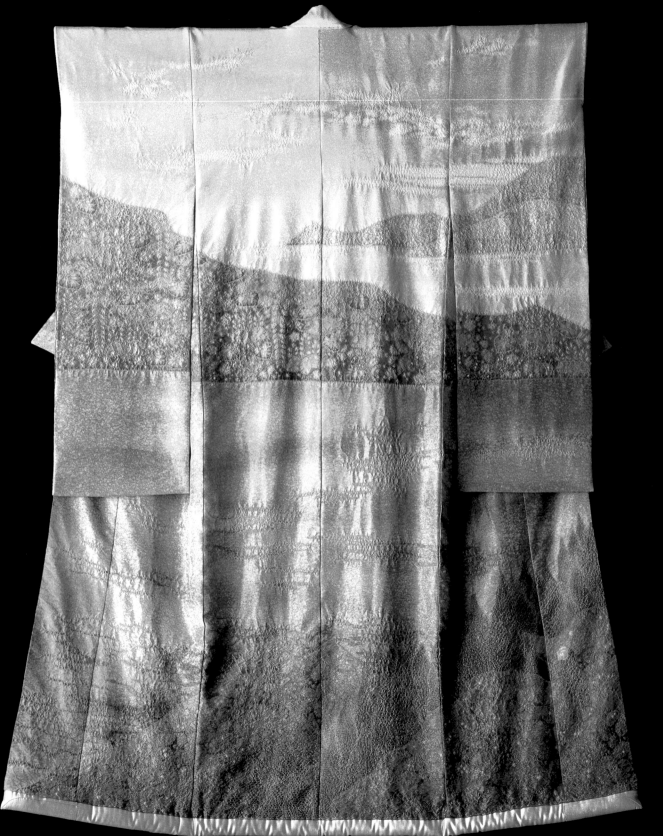

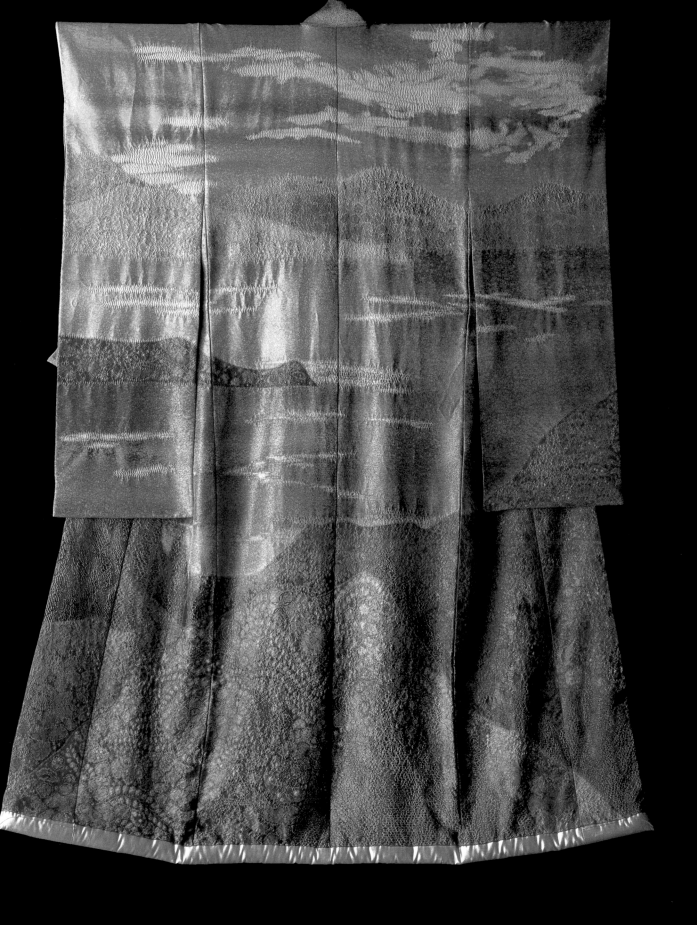

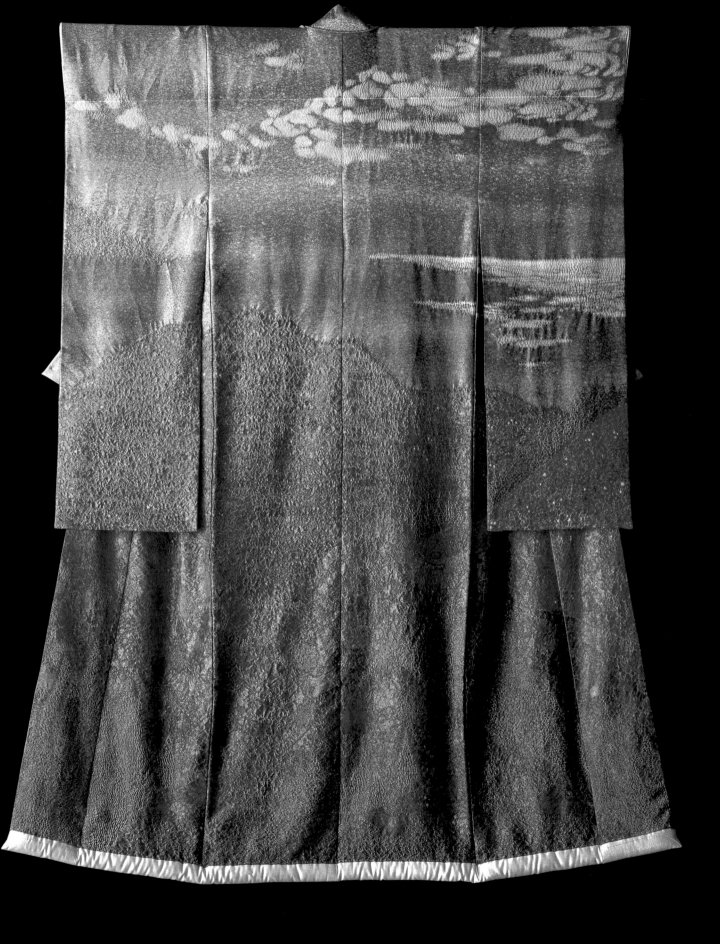

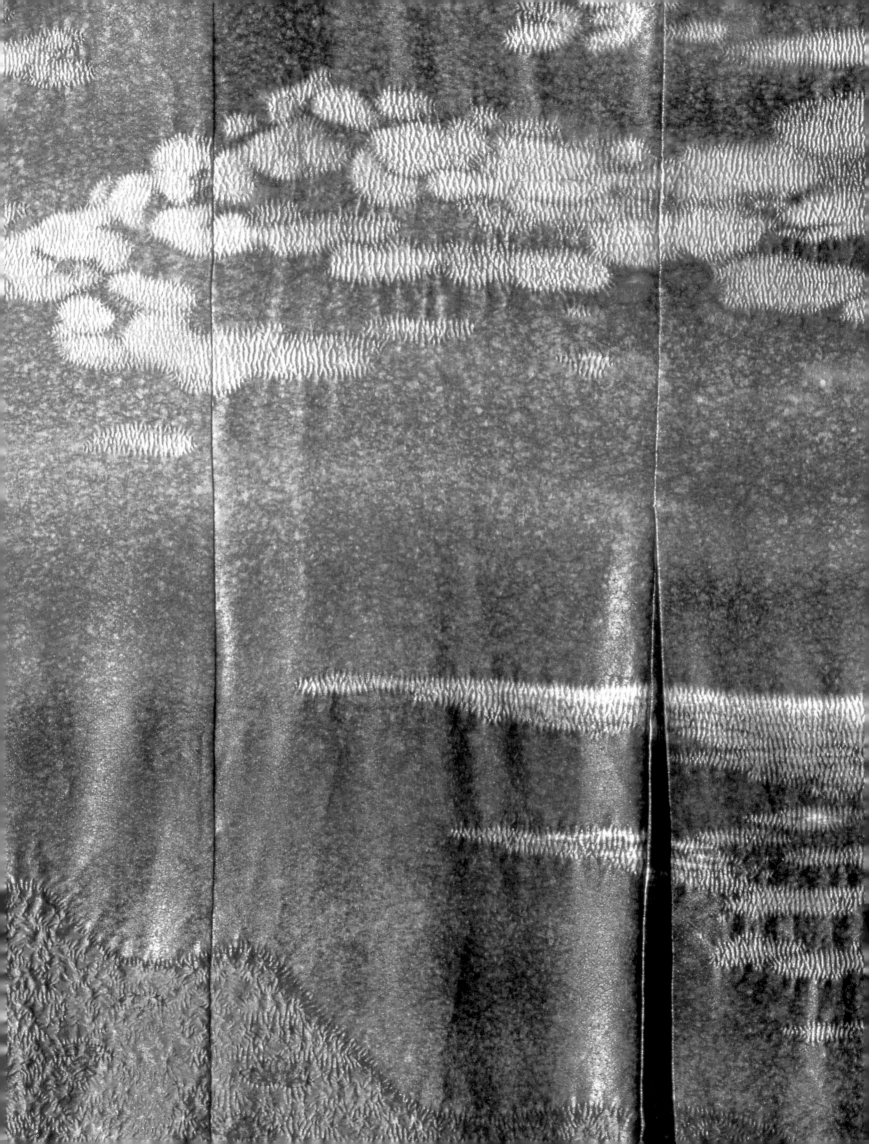

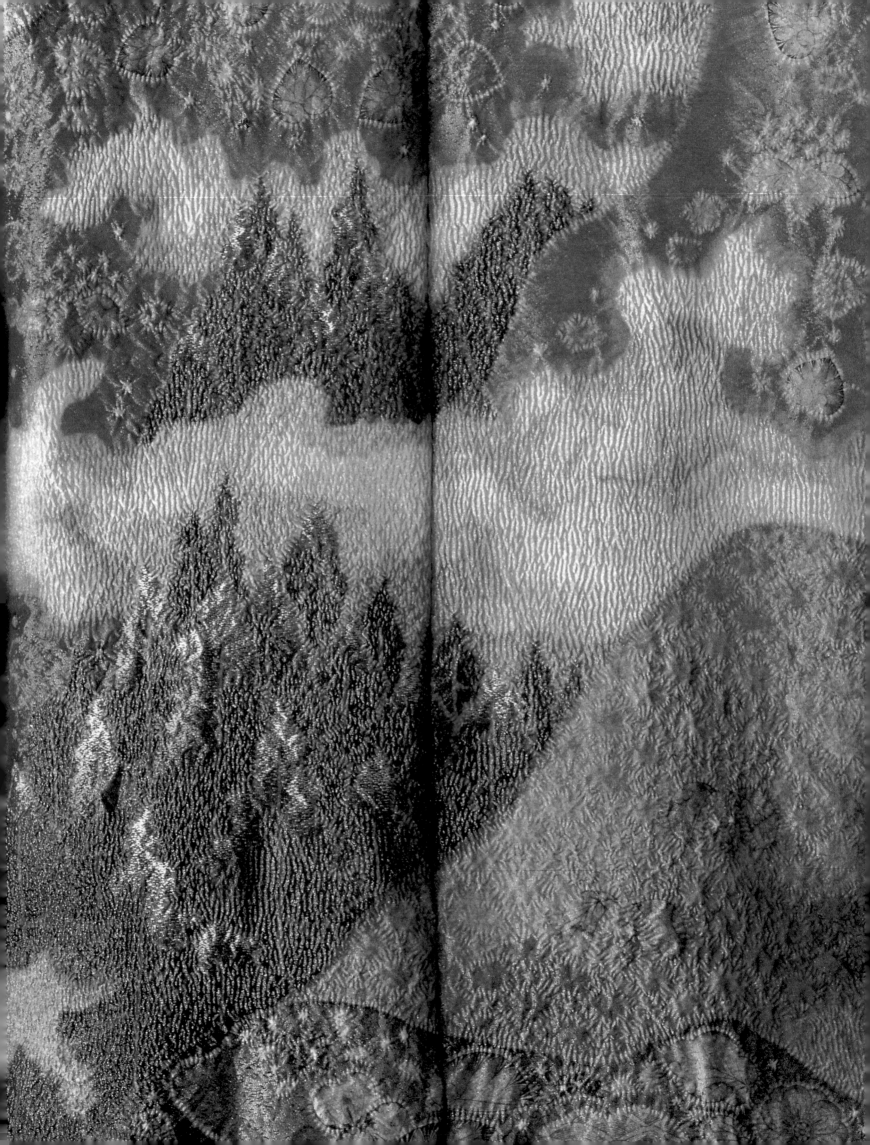

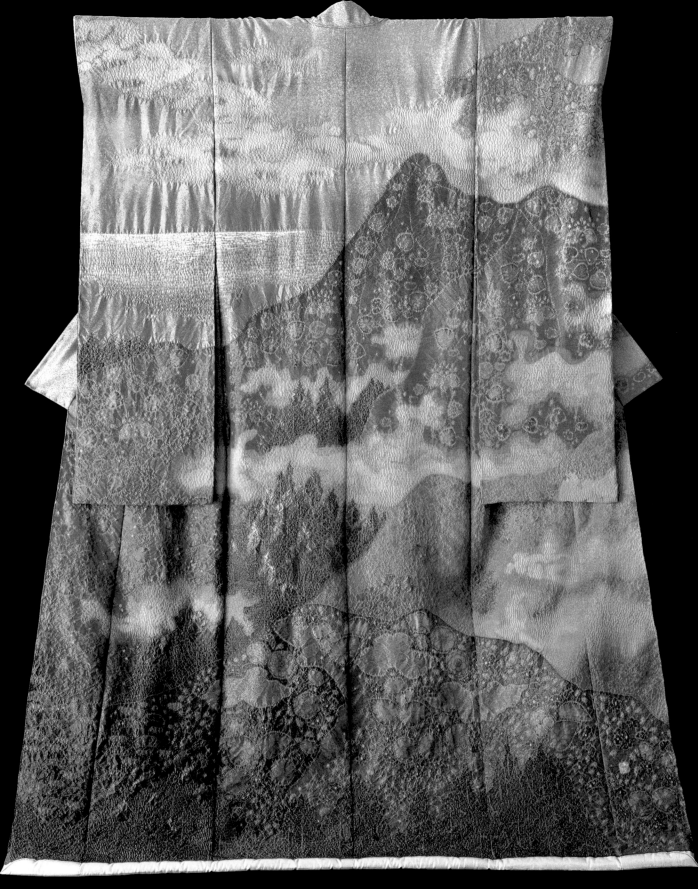

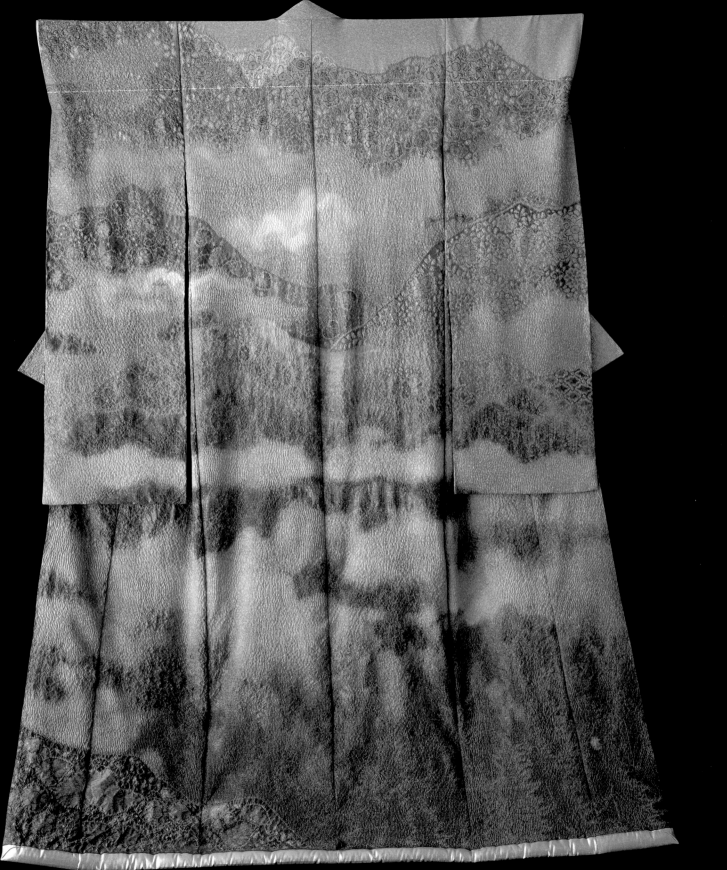

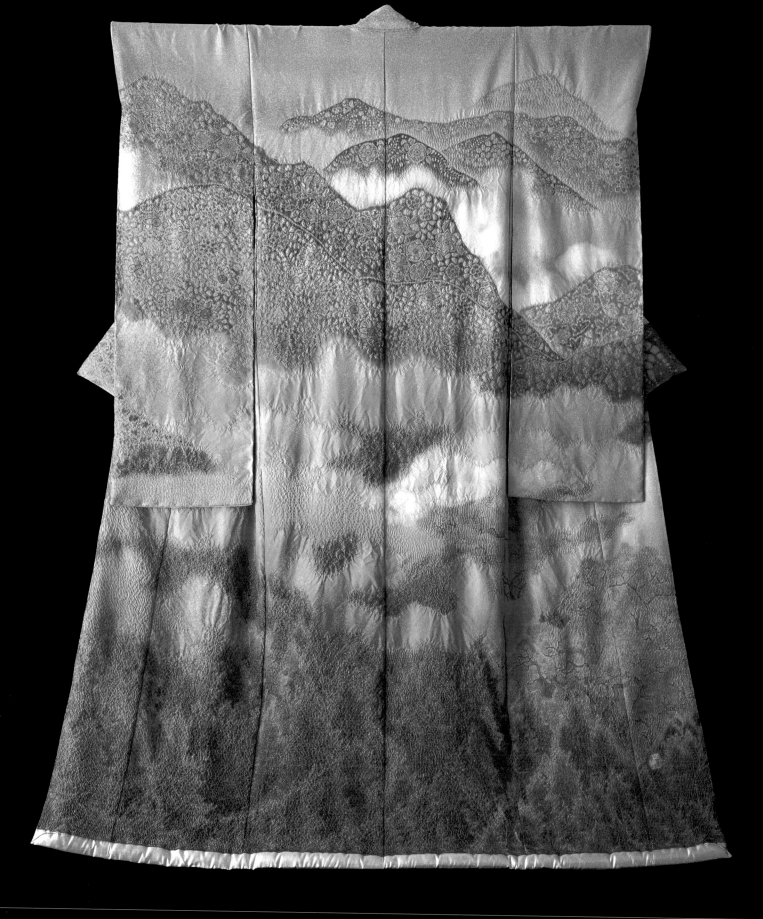

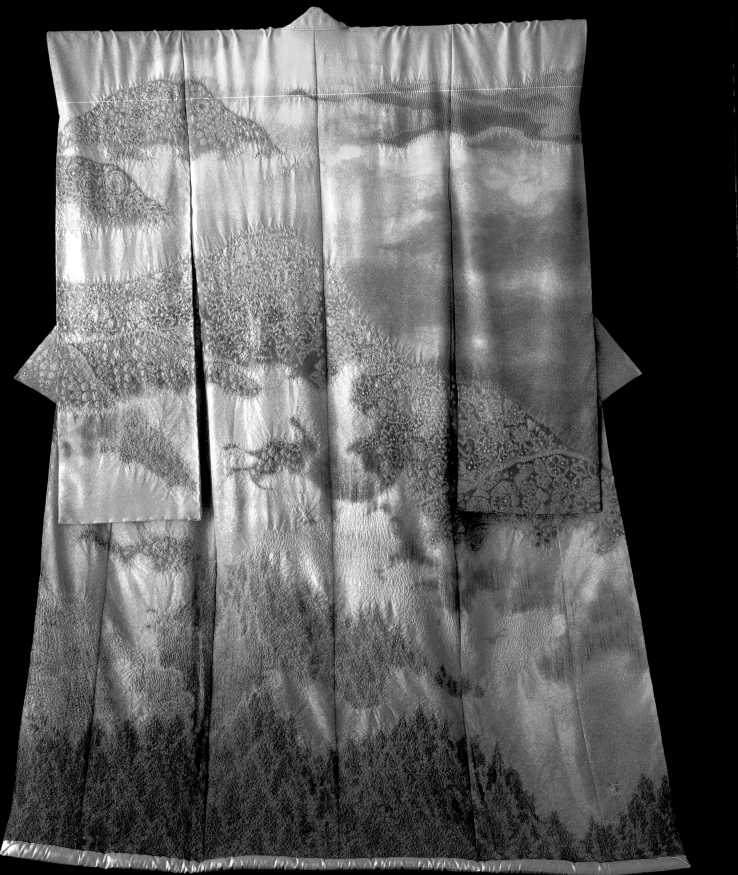

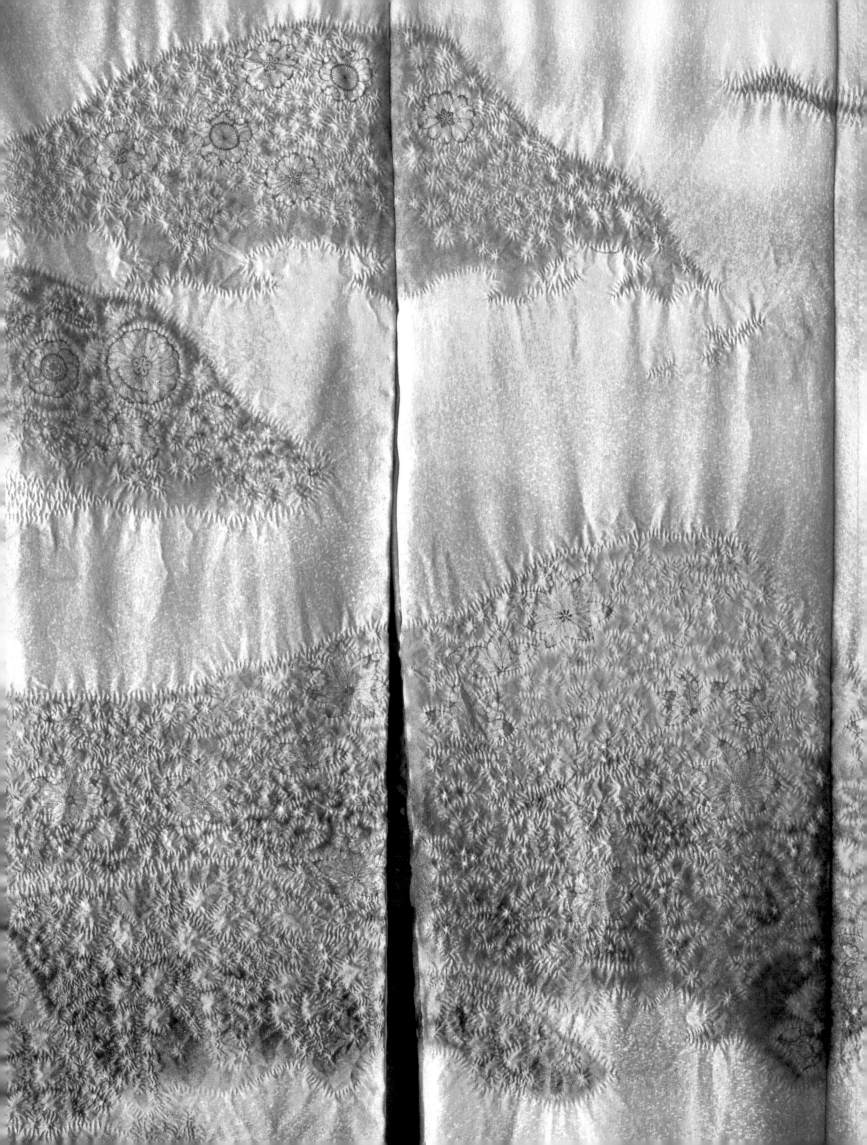

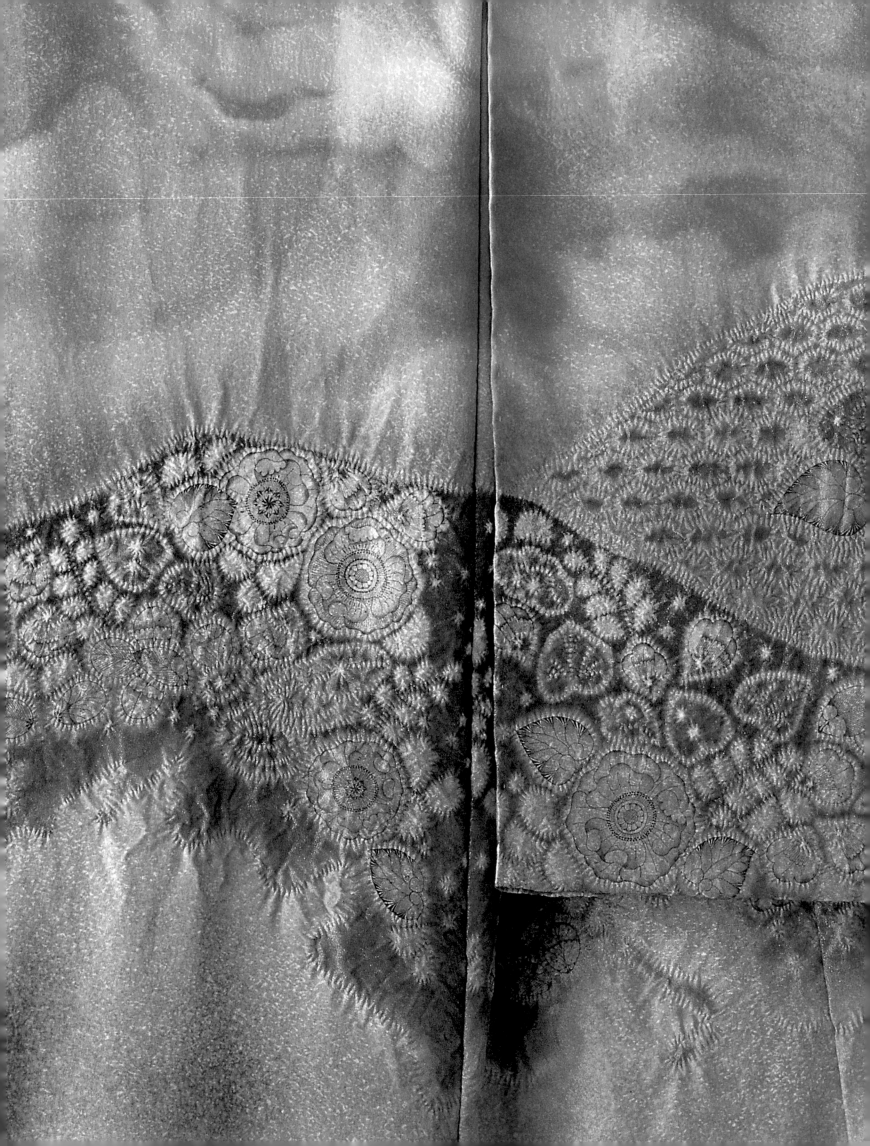

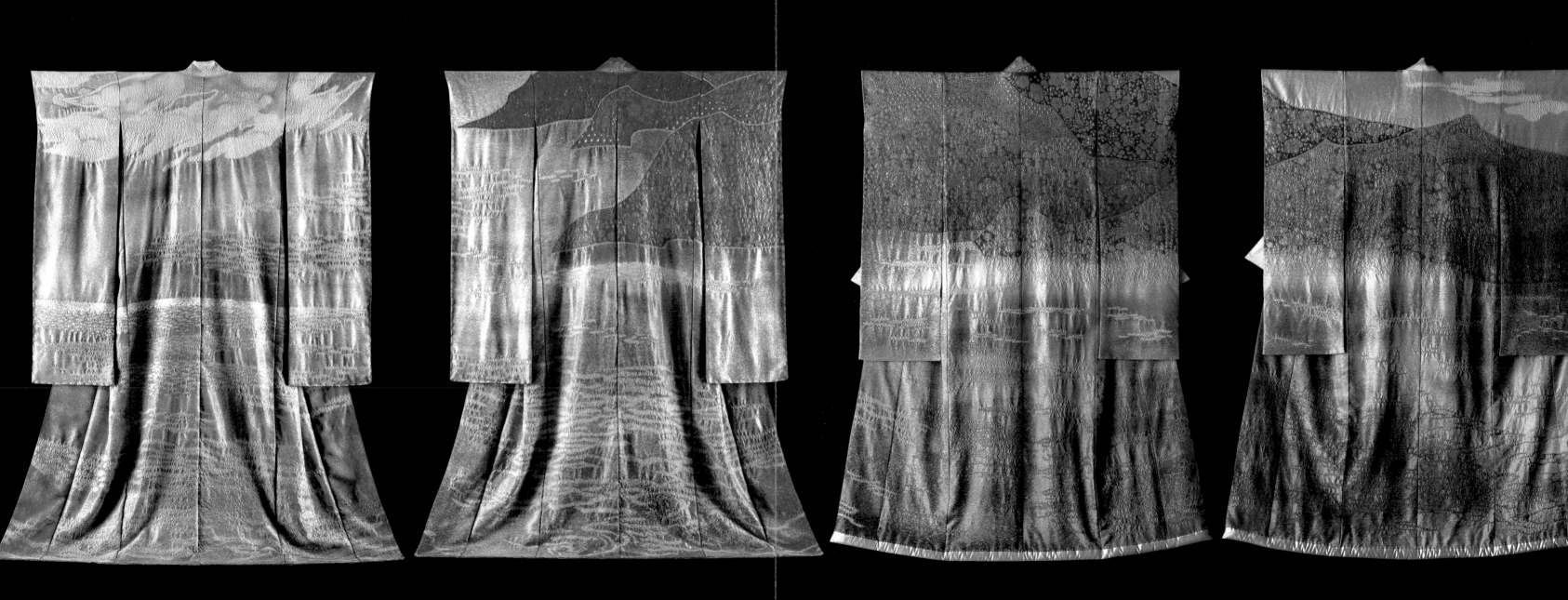

OPENING PAGES The continuity of pictorial imagery from *Yuu* to *Baku* (Cat. Nos. 33–34; see also pp. 111, 112).
THESE PAGES The continuity of pictorial imagery from *Hiwacha* to *Jo* (Cat. Nos. 4–11; see also pp. 46–61).

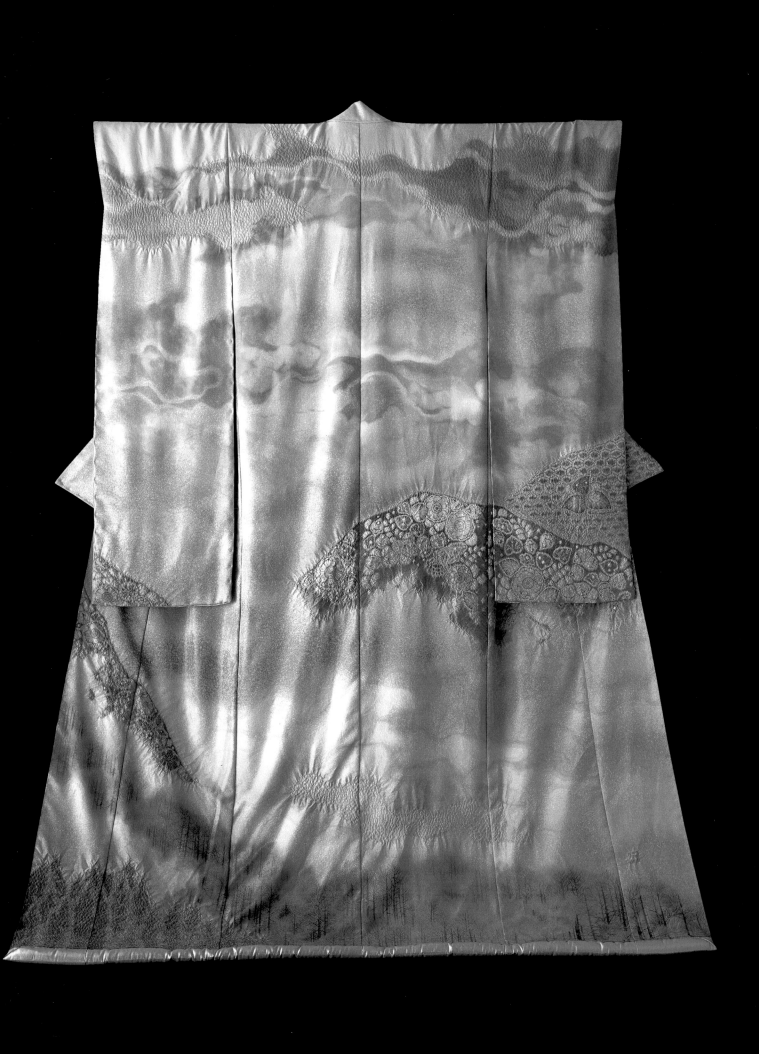
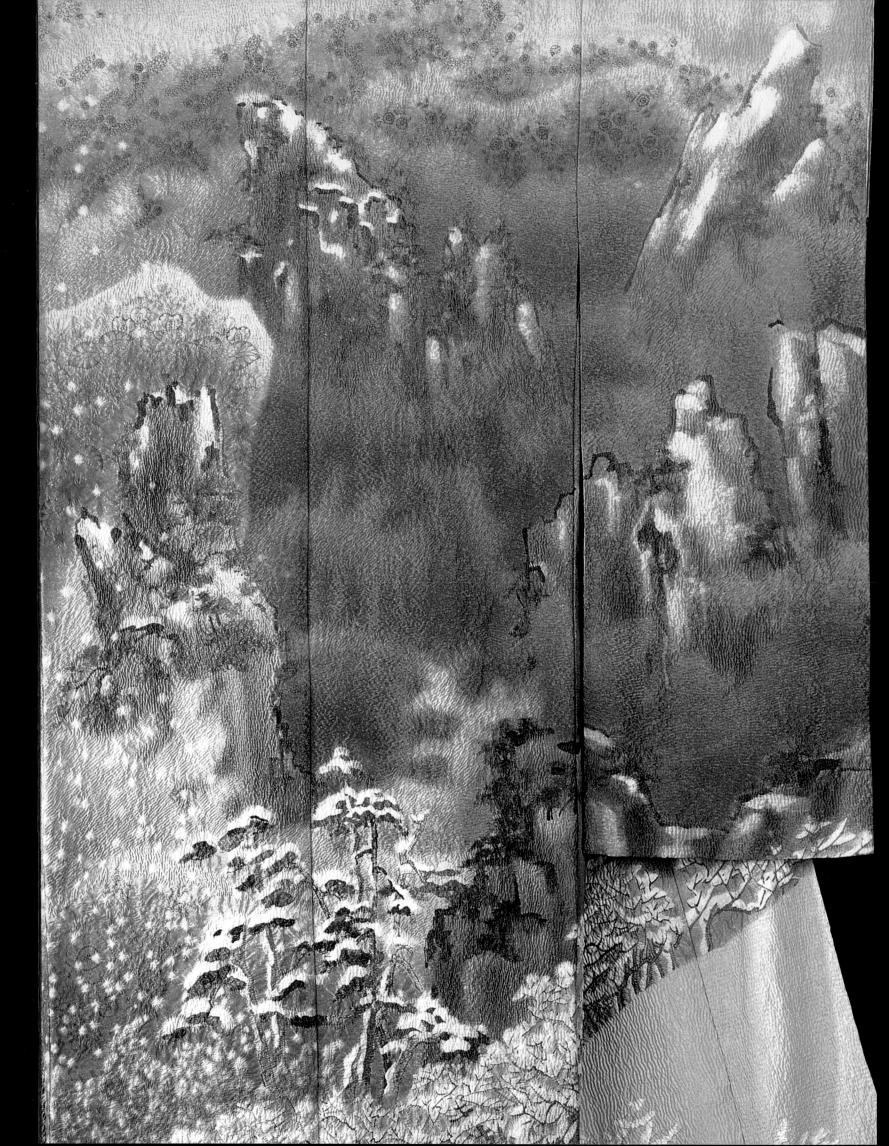

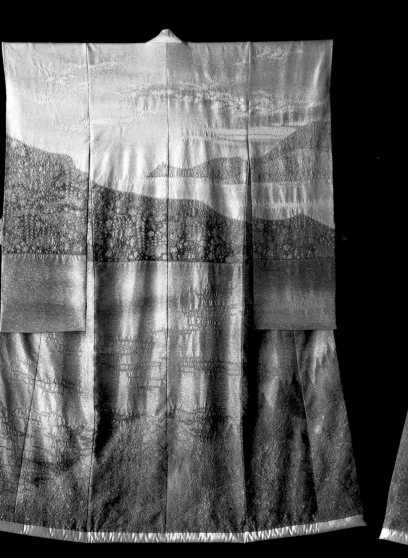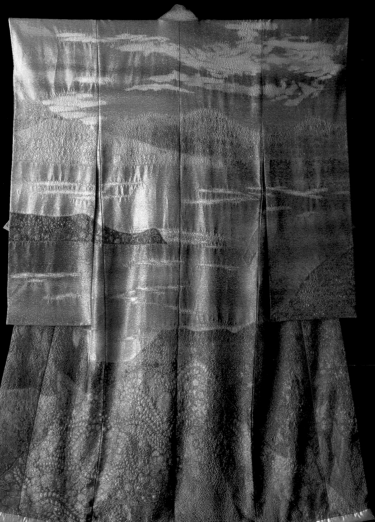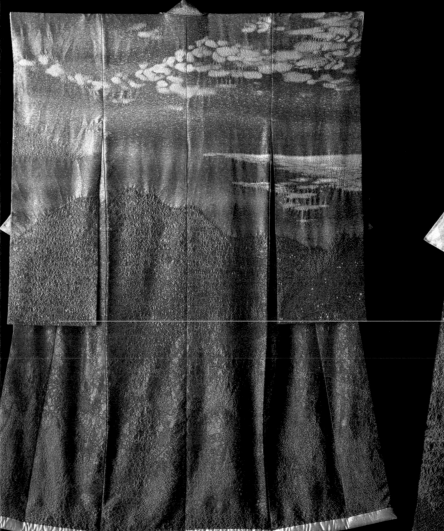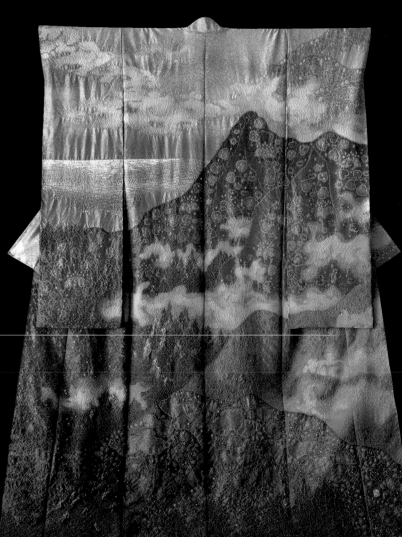

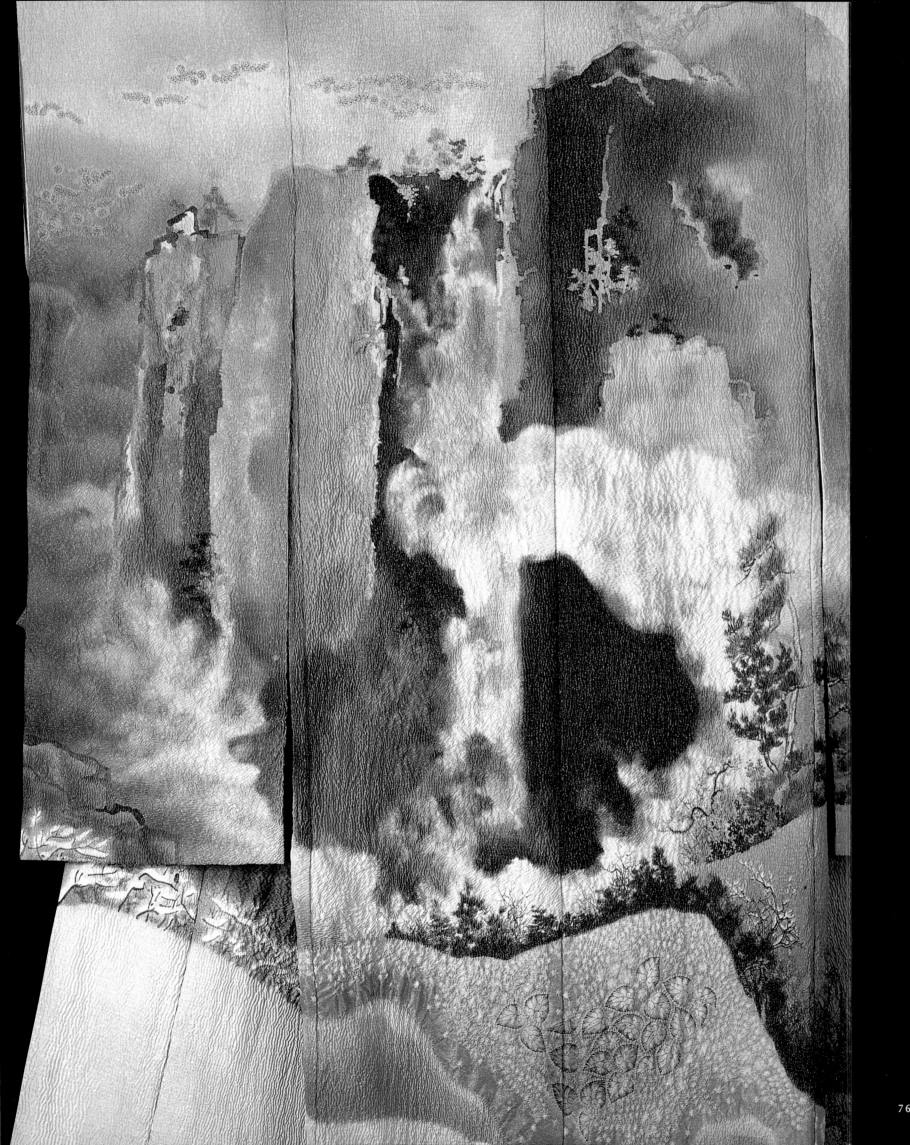
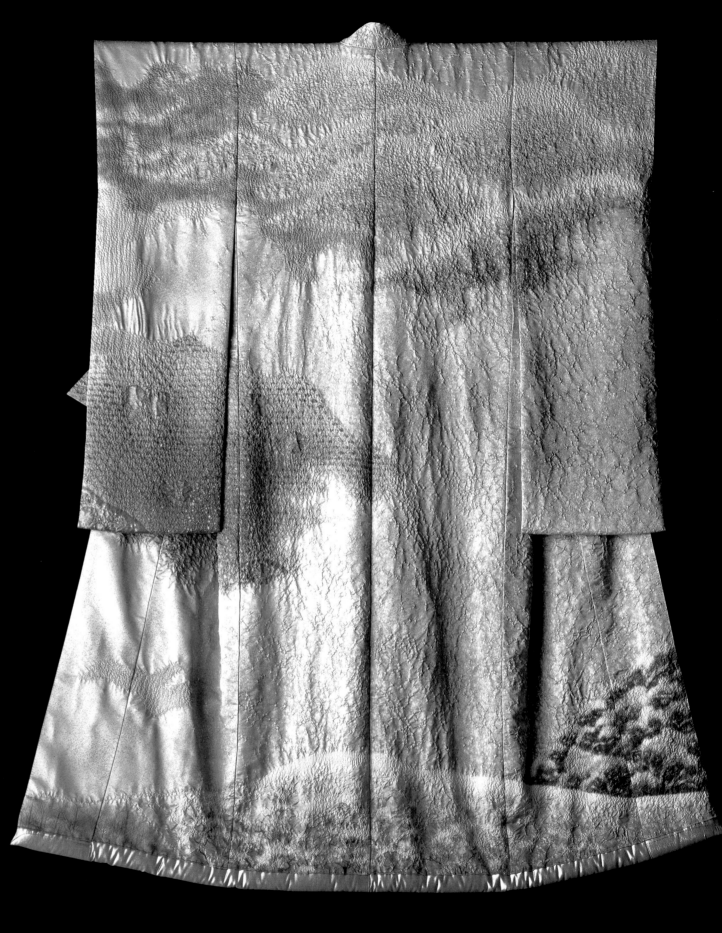

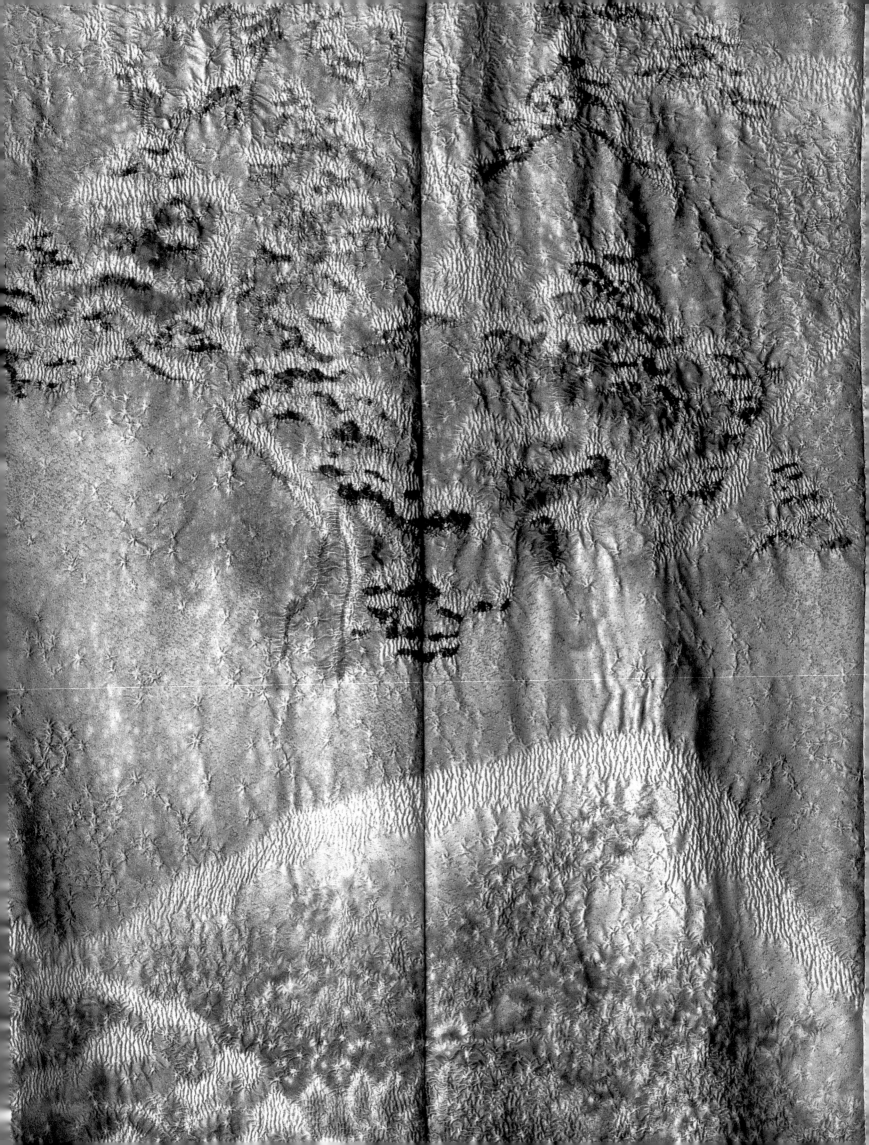

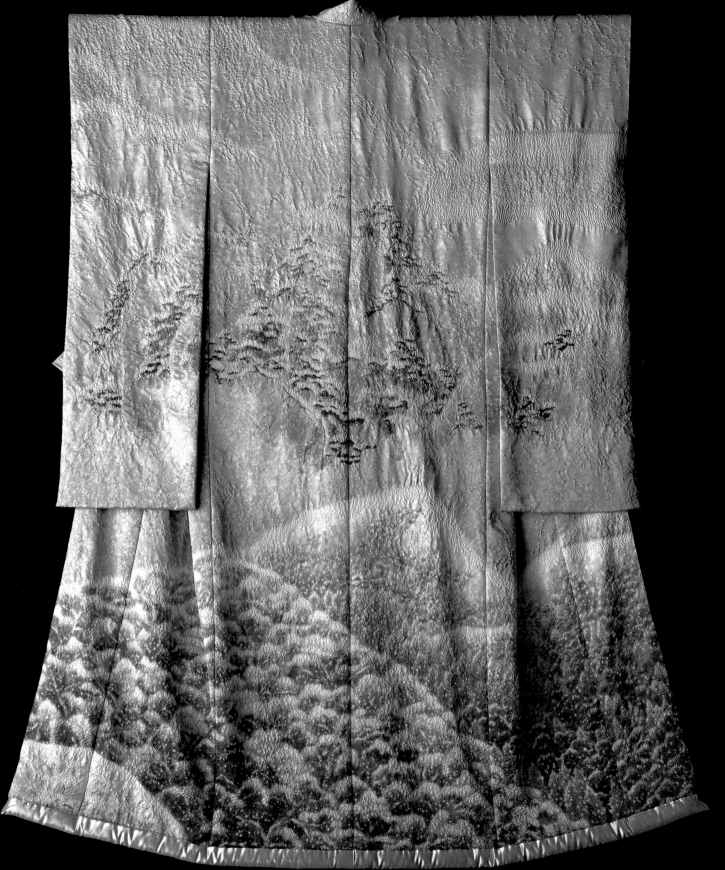

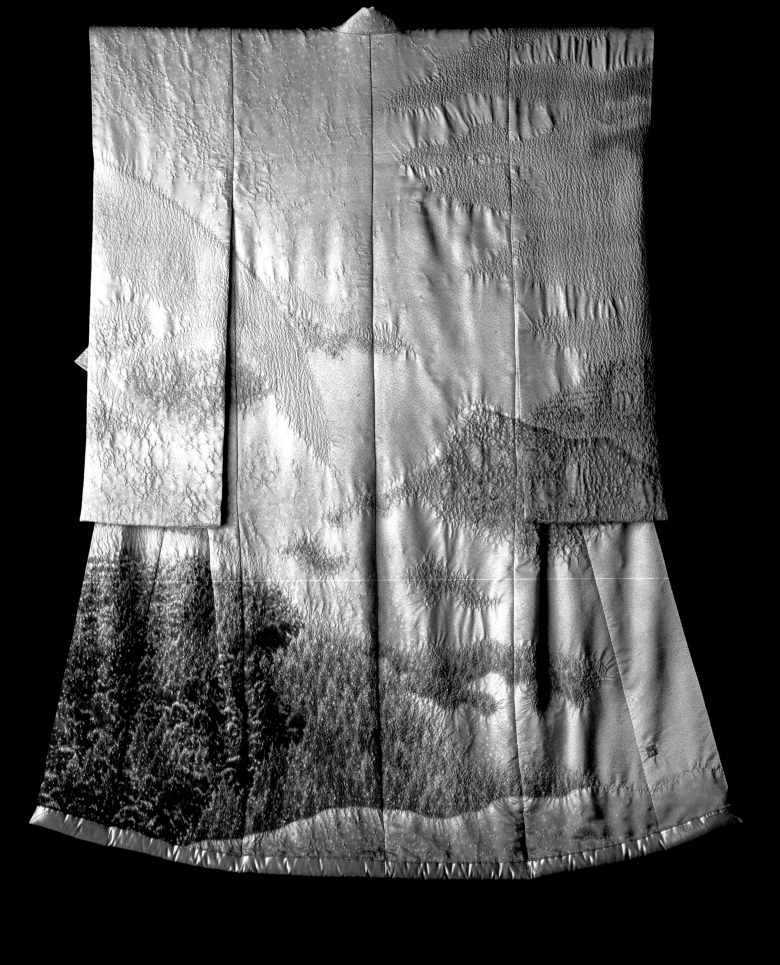

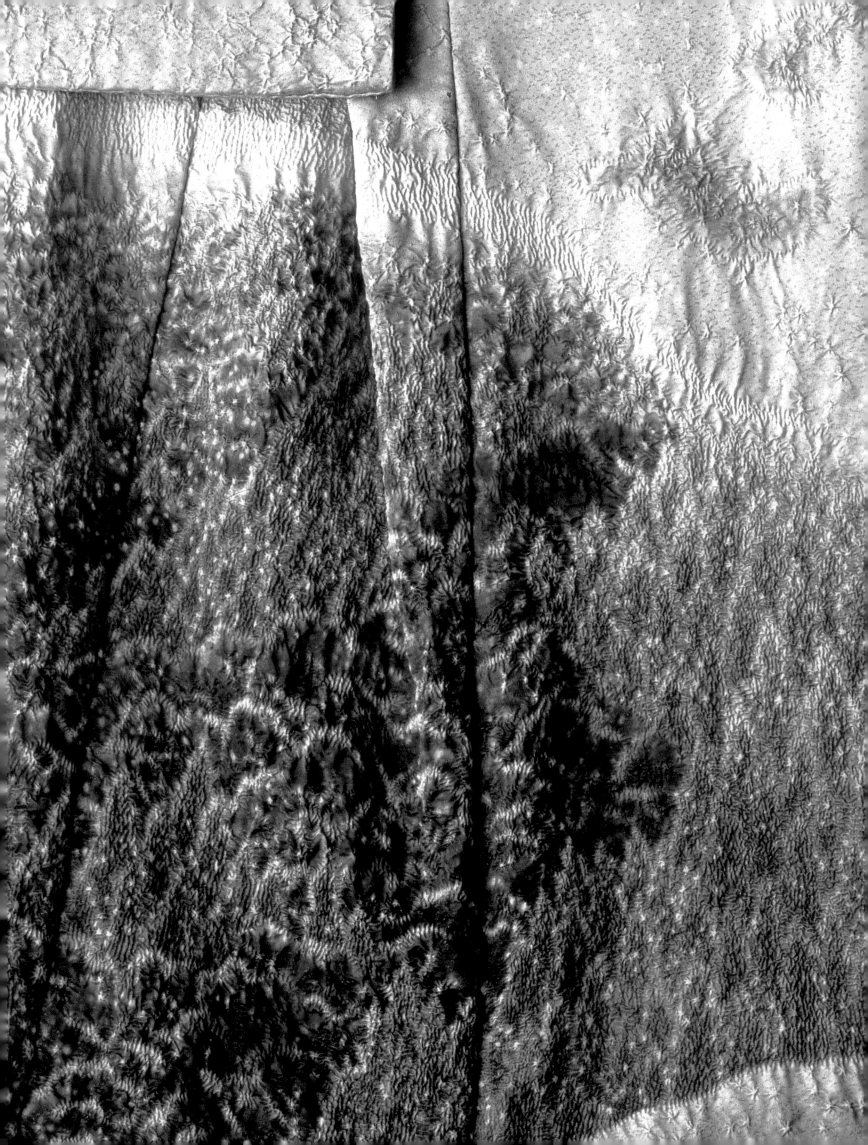

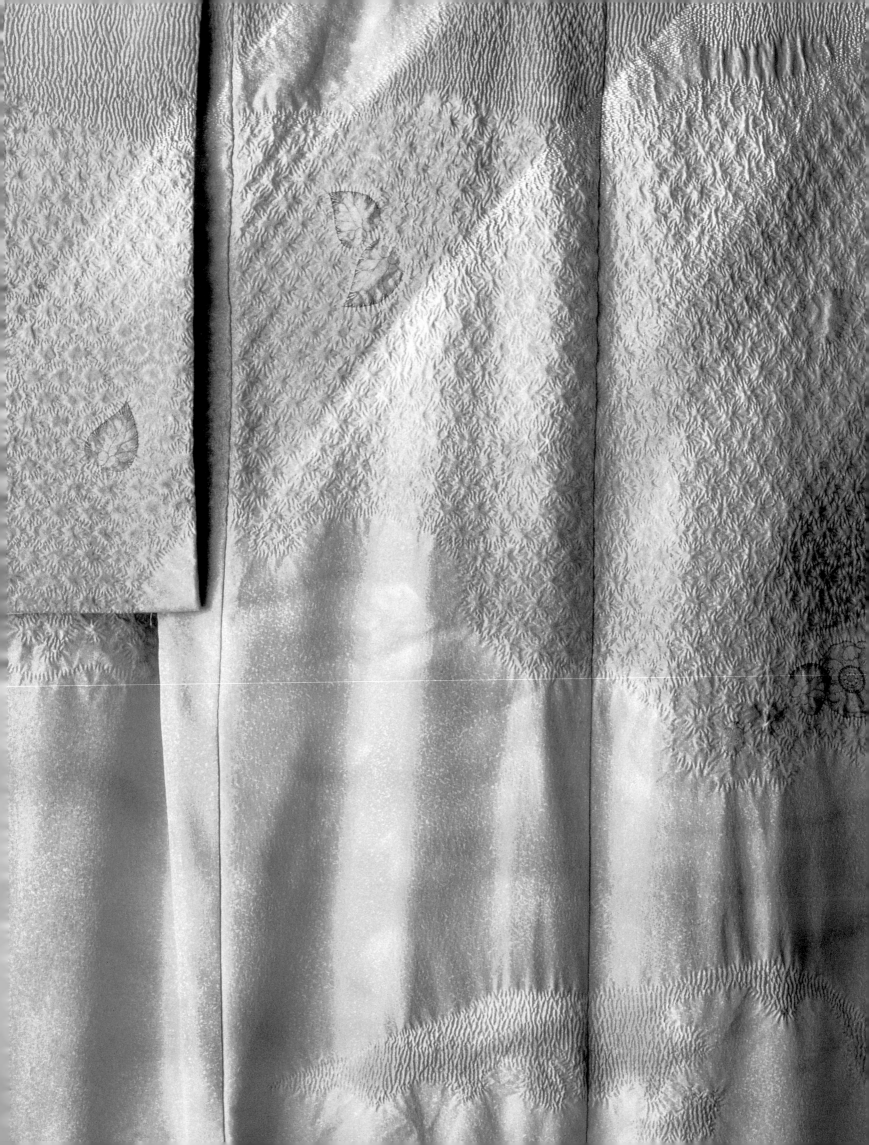

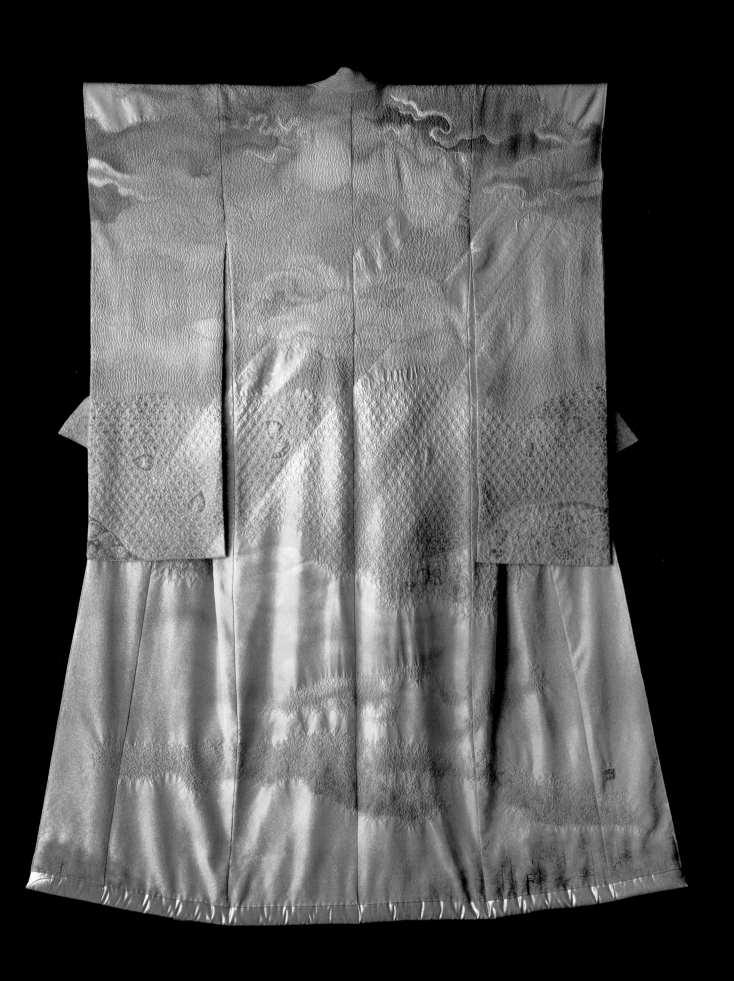

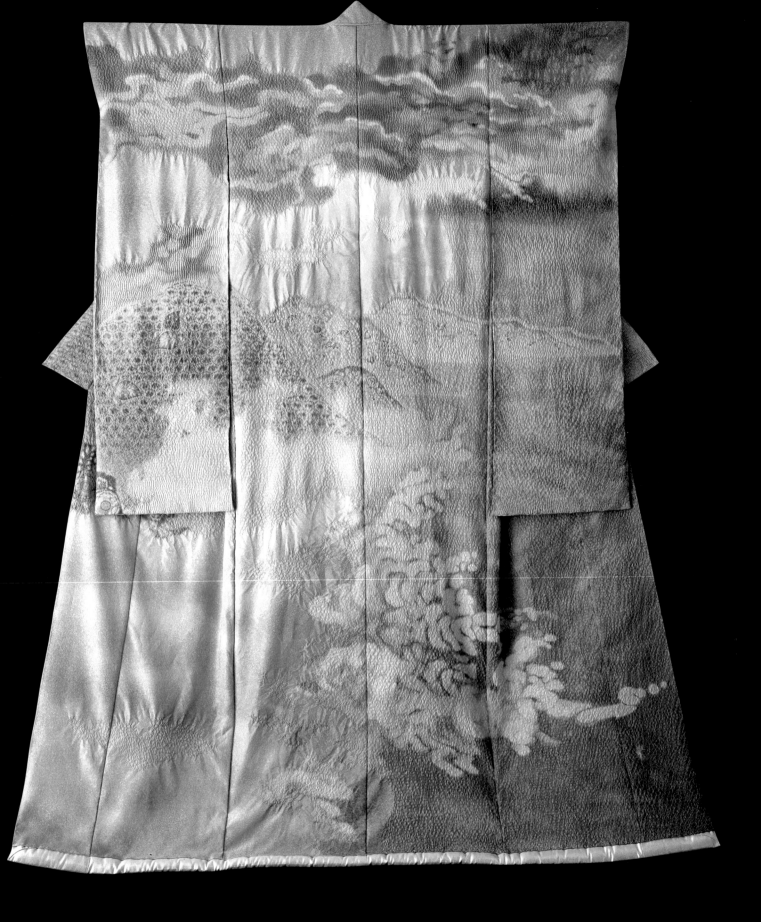

CAT. NO. 20 AI / OBLITERATION (1987)

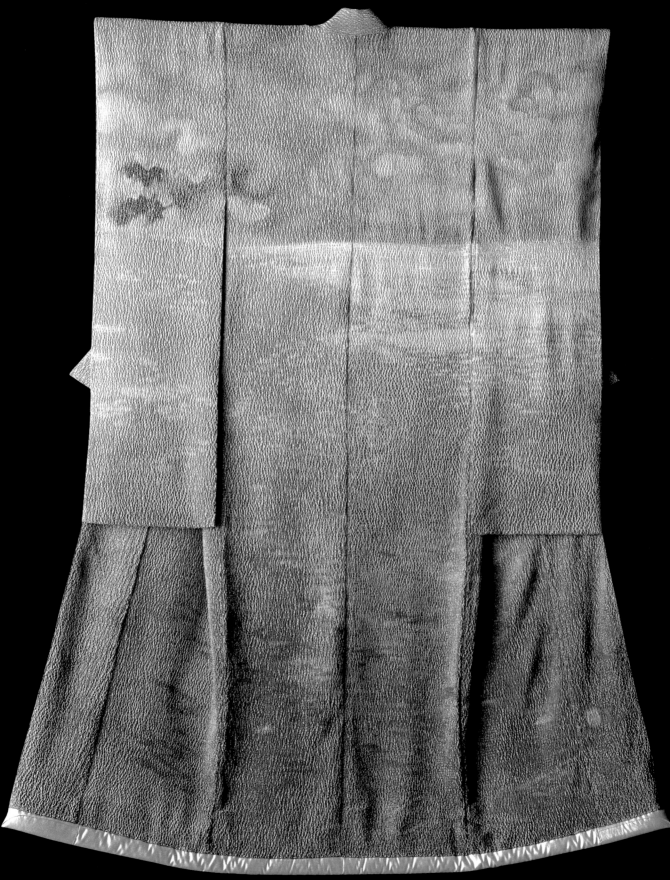

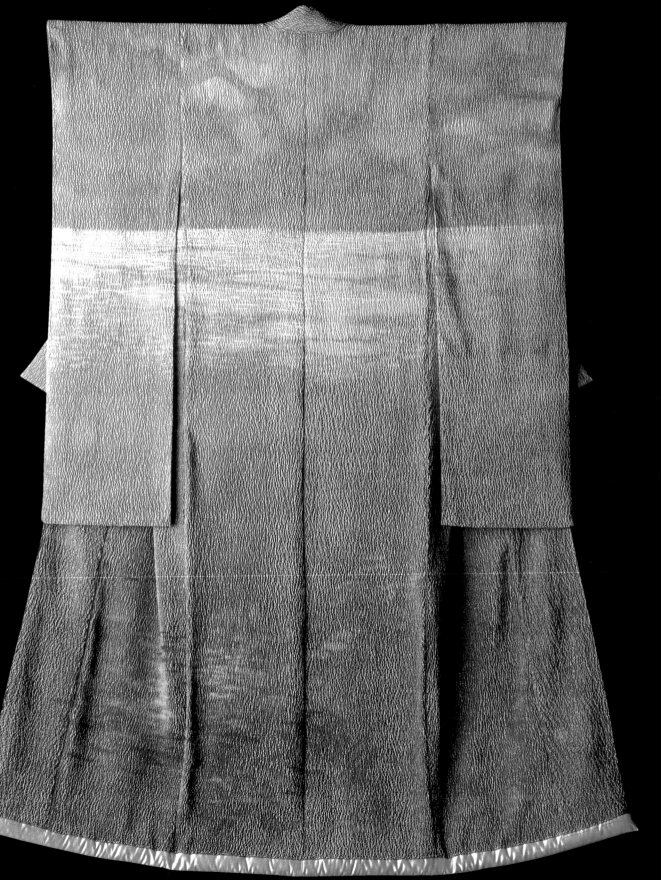

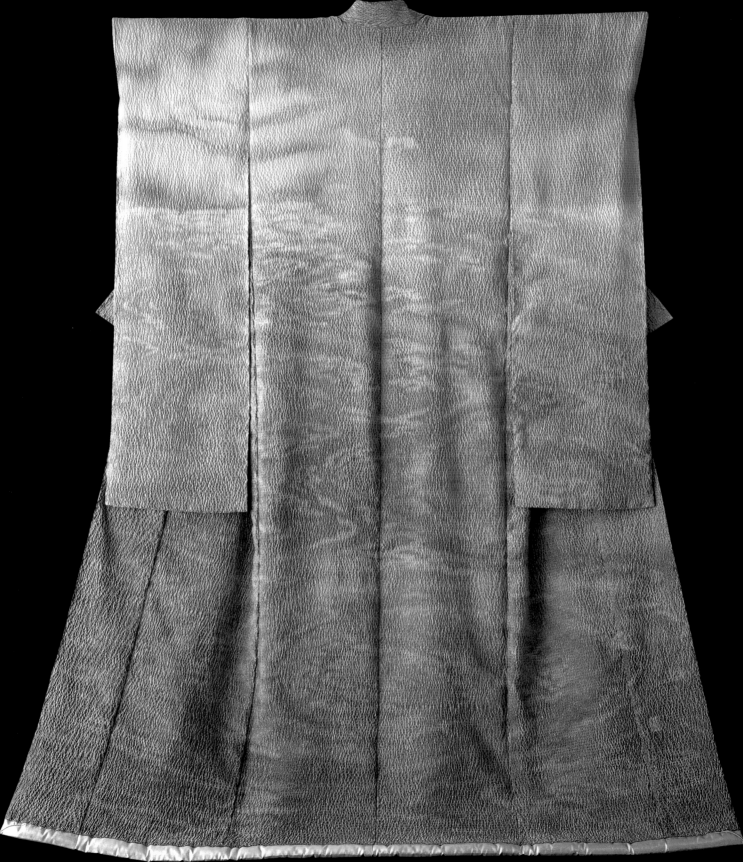

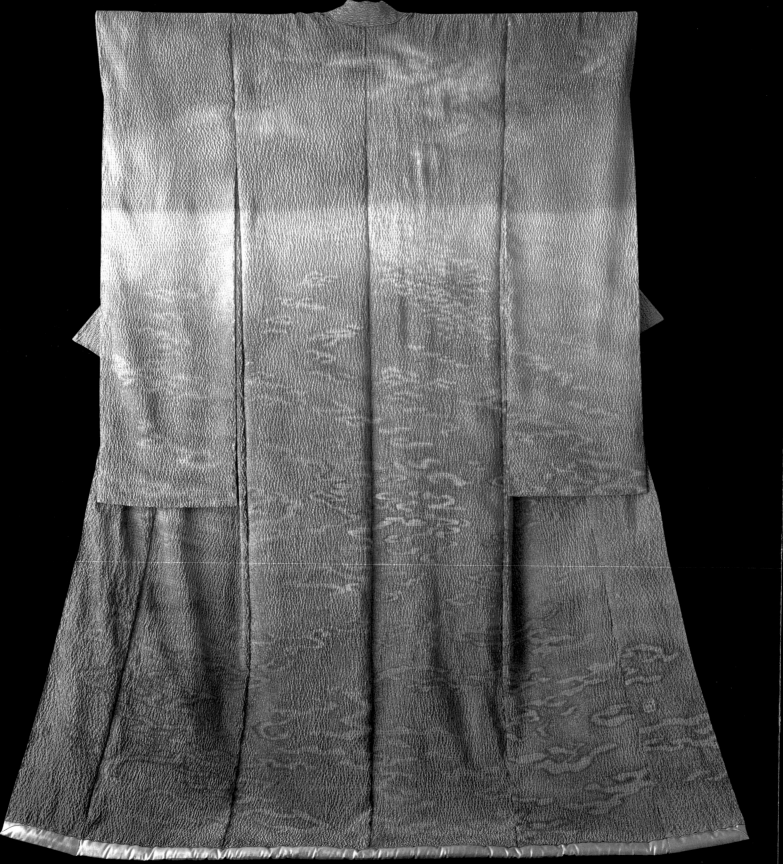

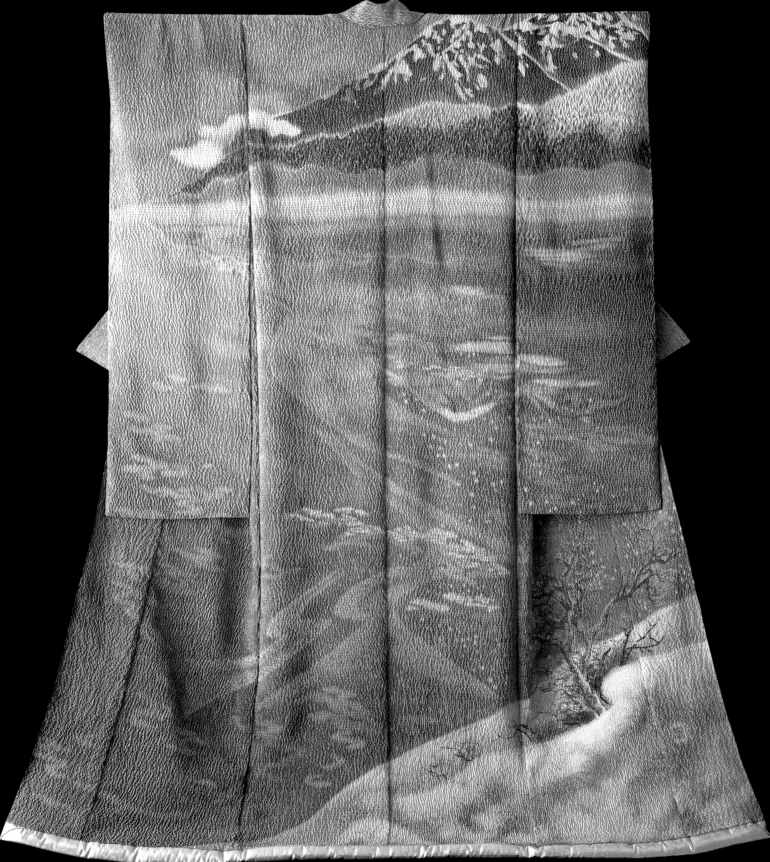

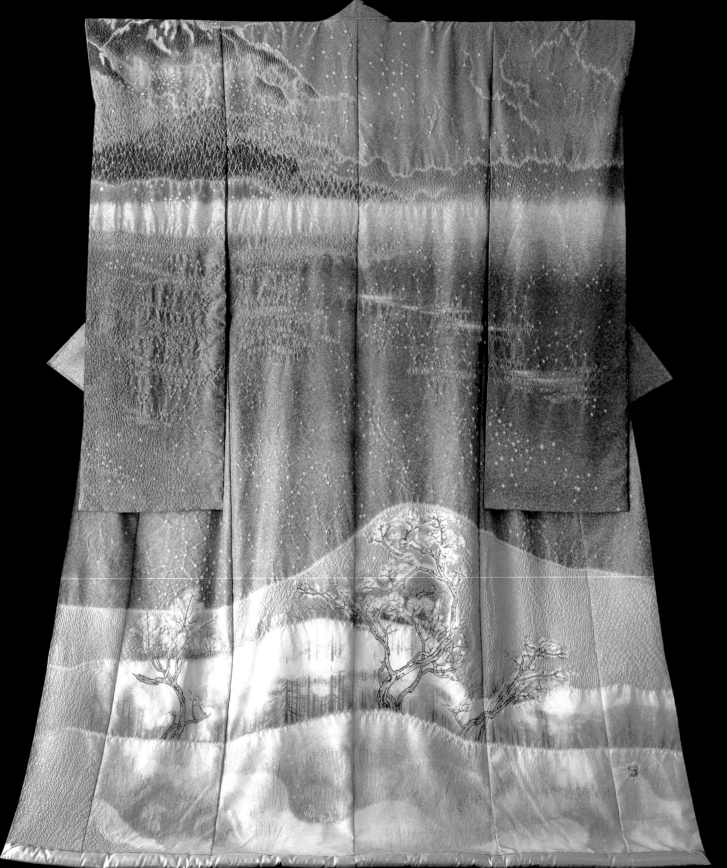

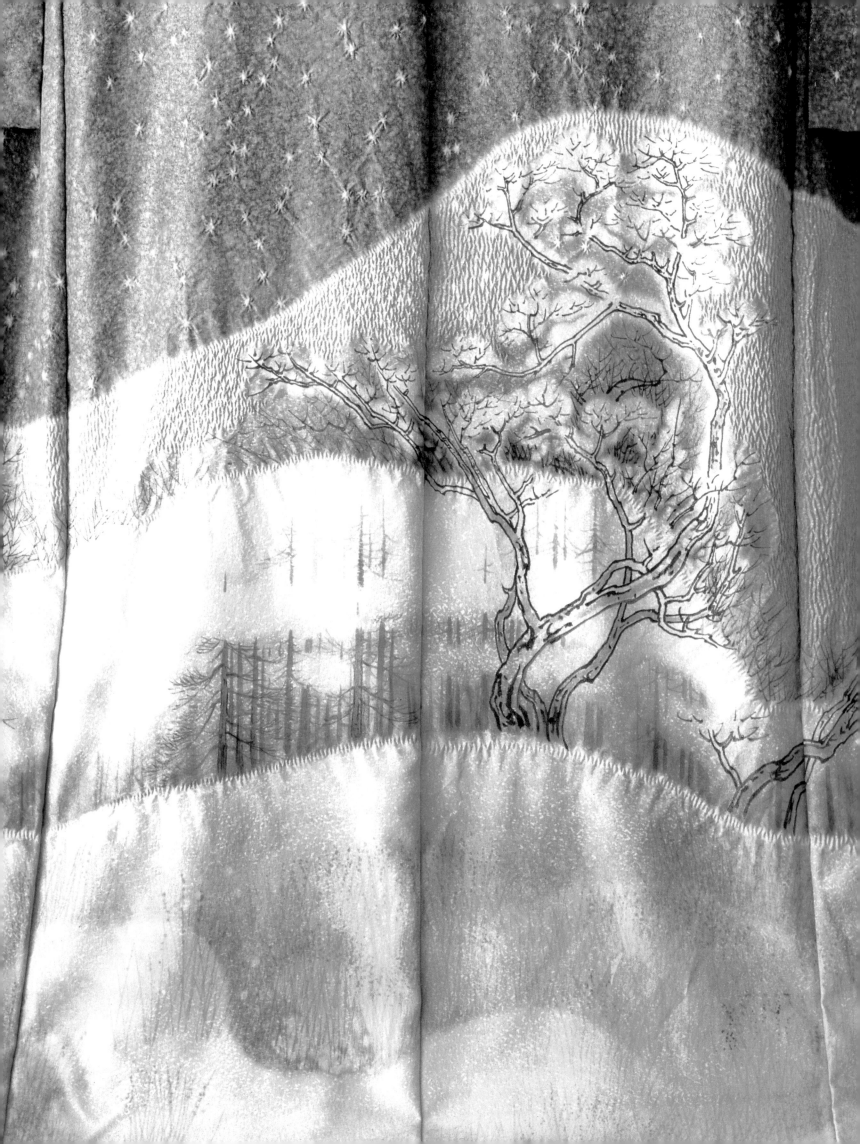

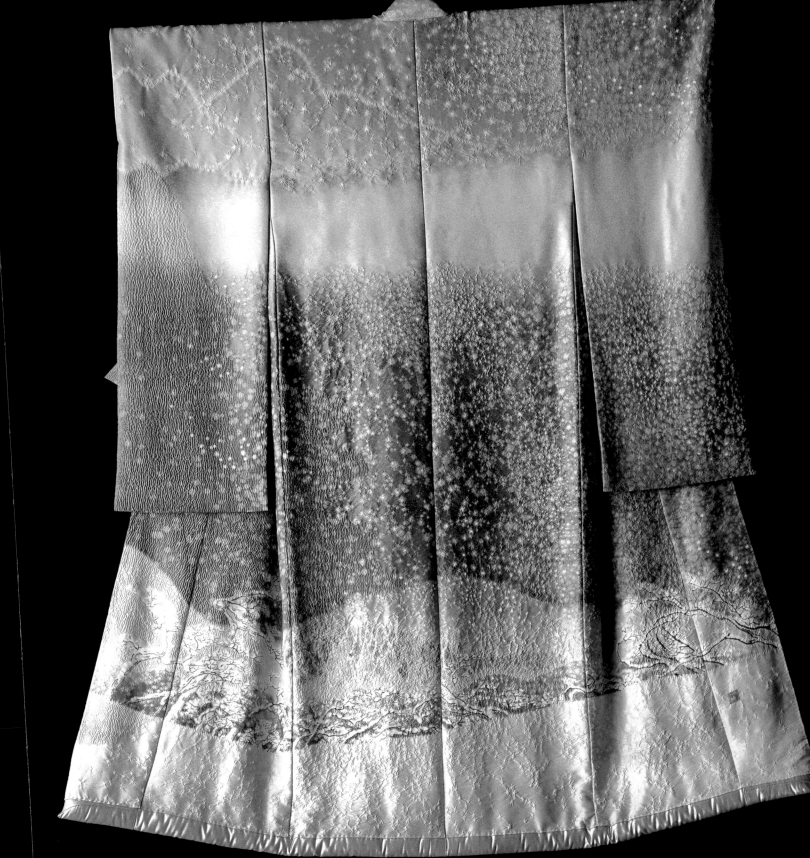

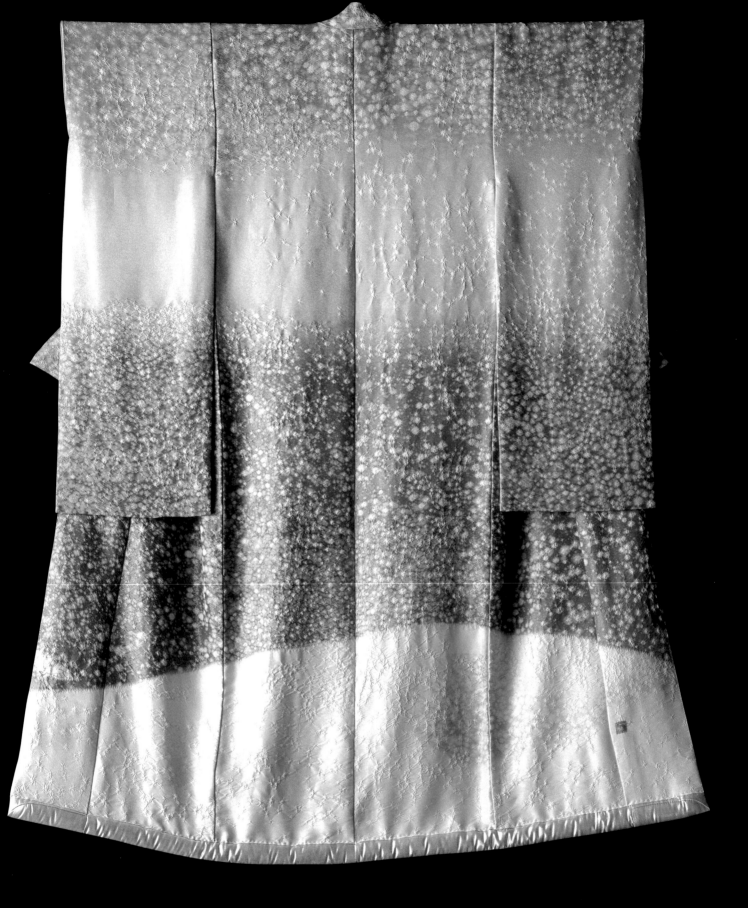

CAT. NO. 28 JO / ENDLESS SNOW (1988)

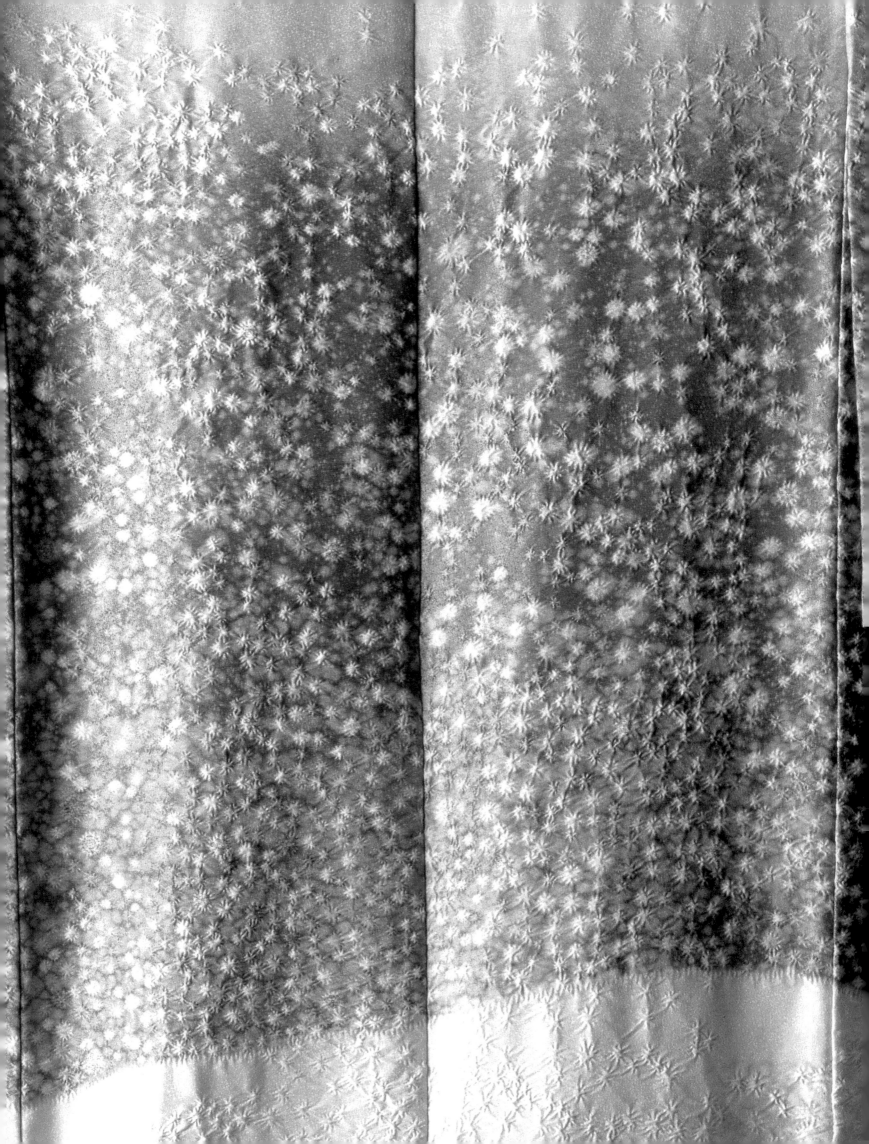

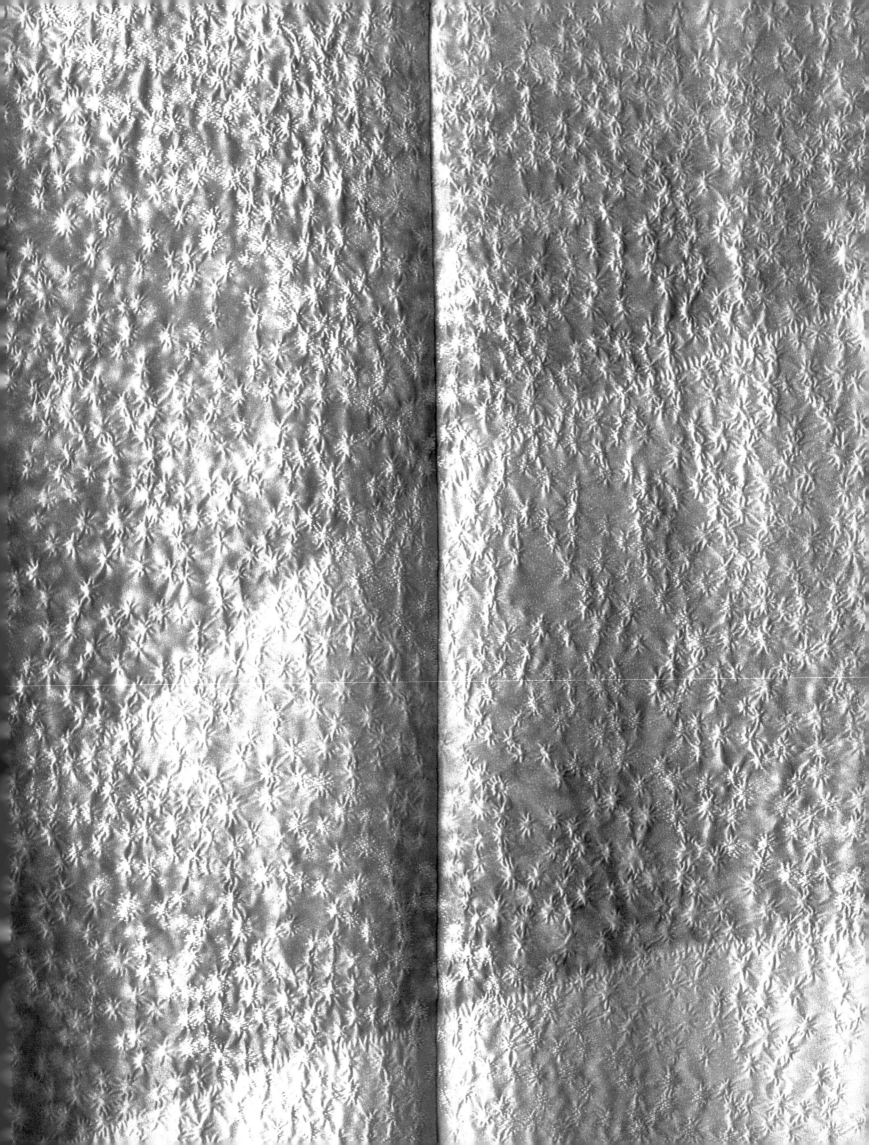

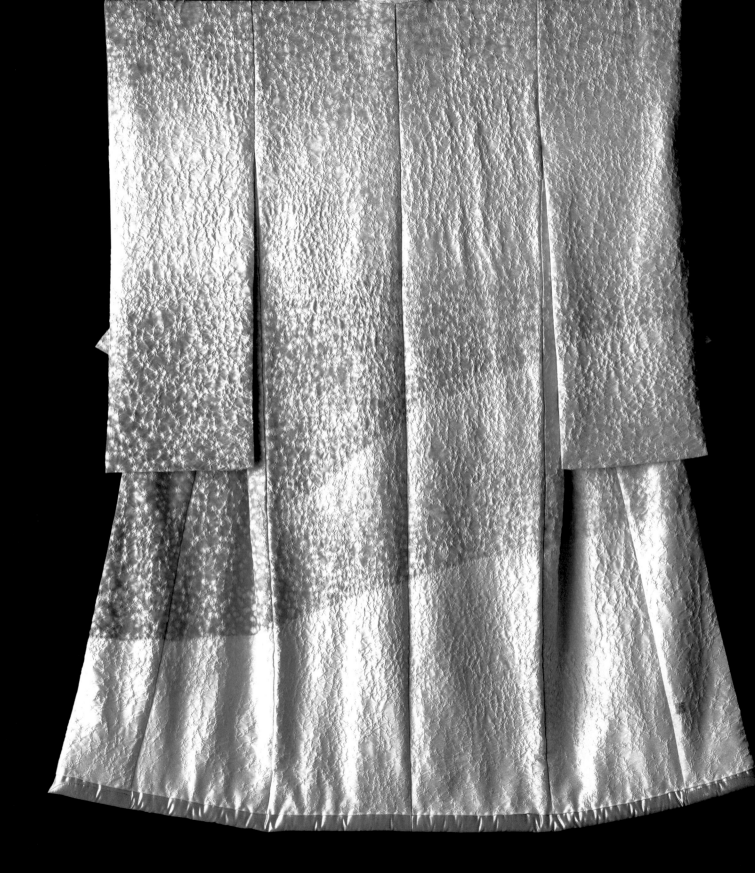

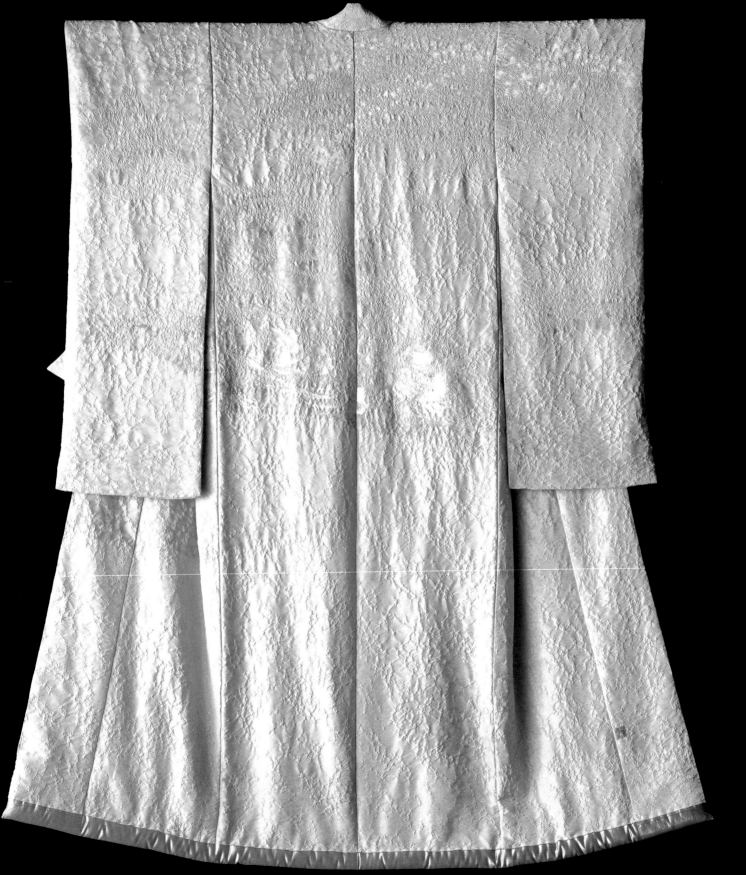

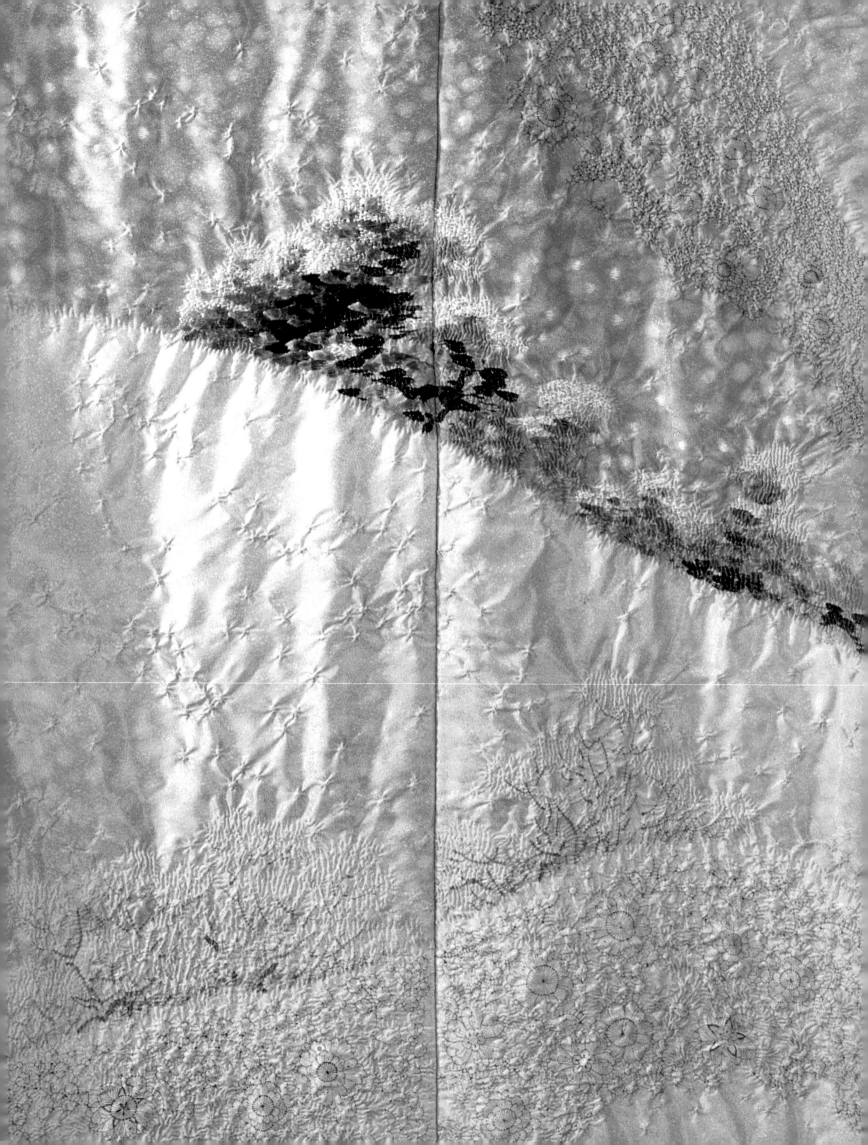

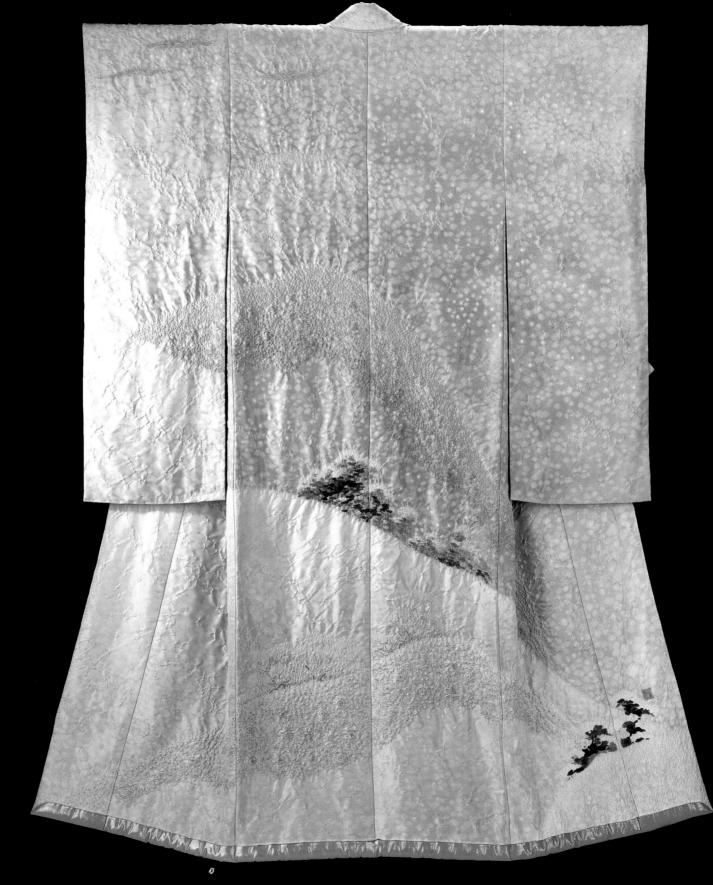

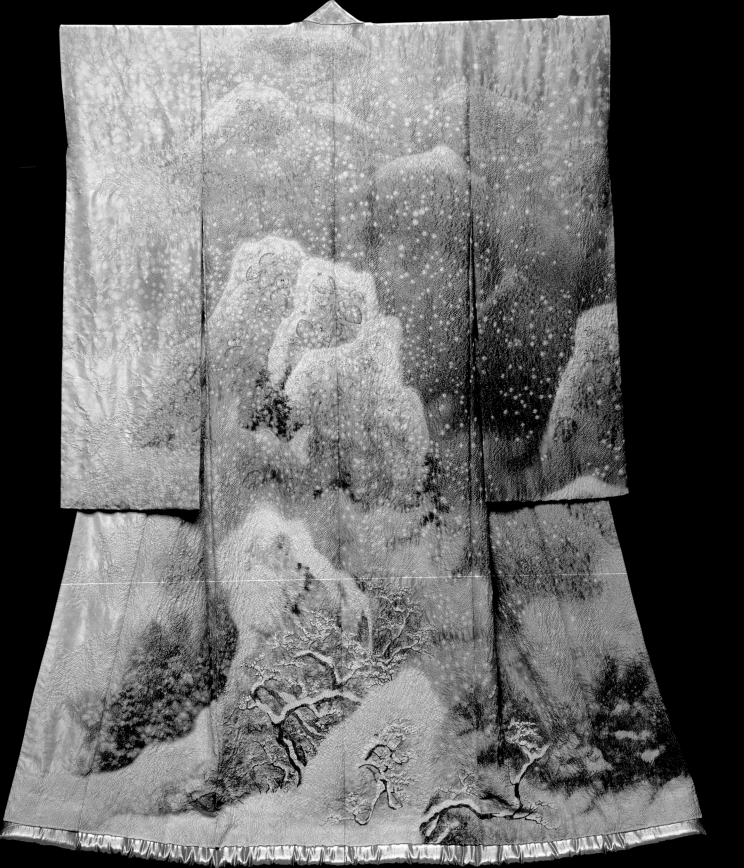

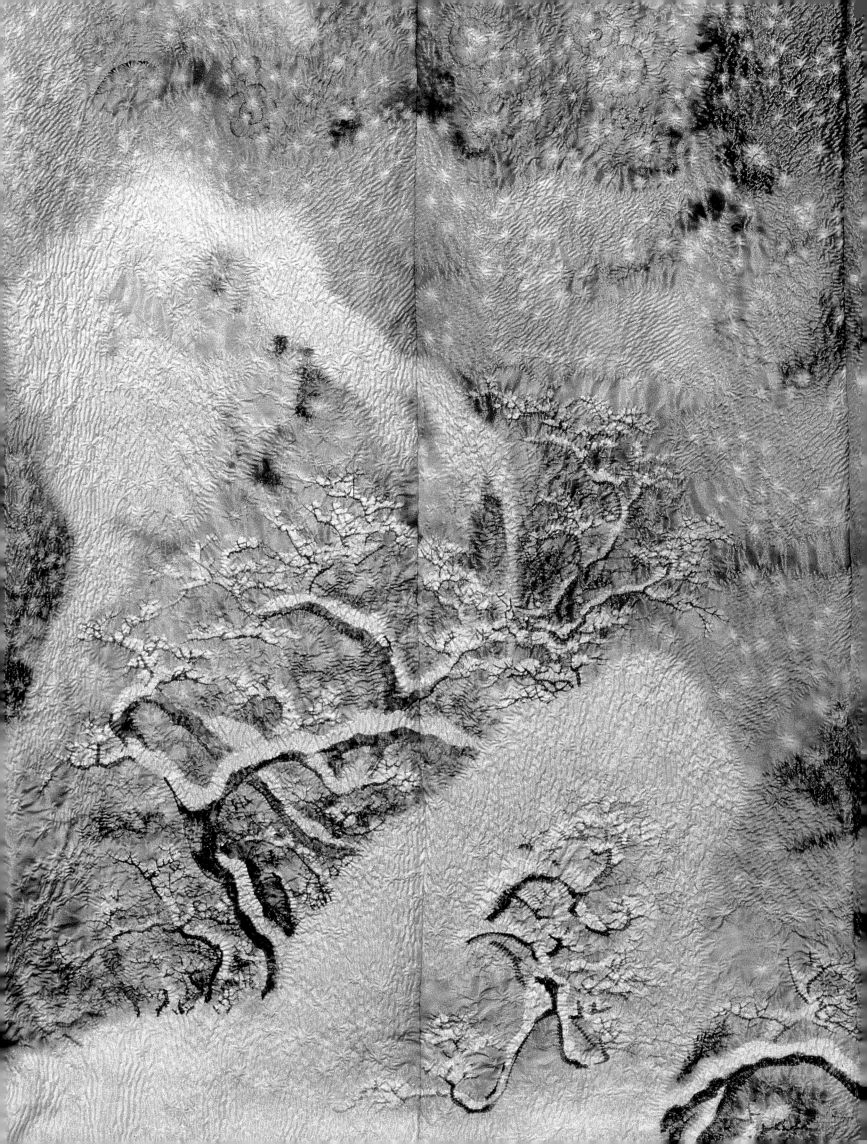

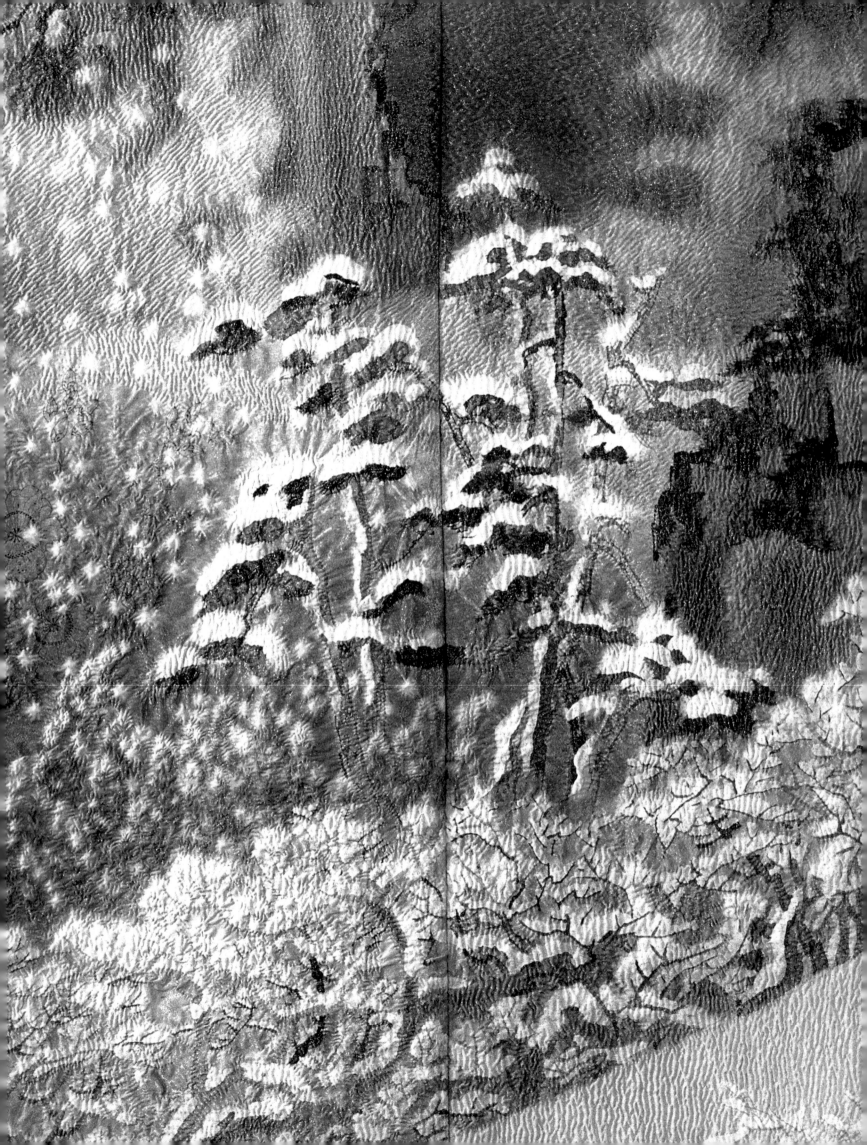

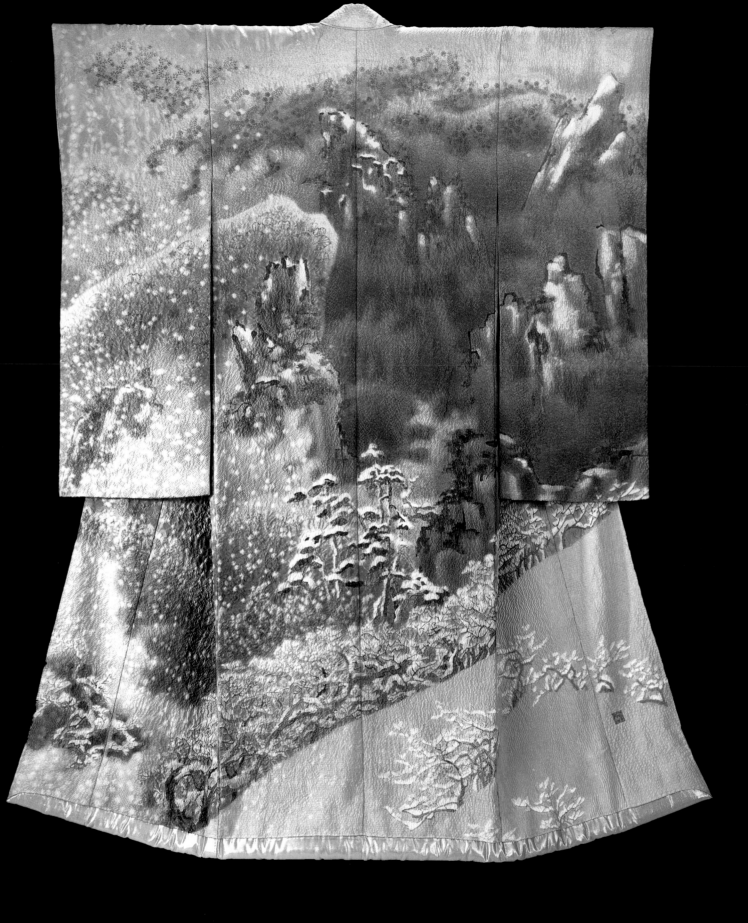

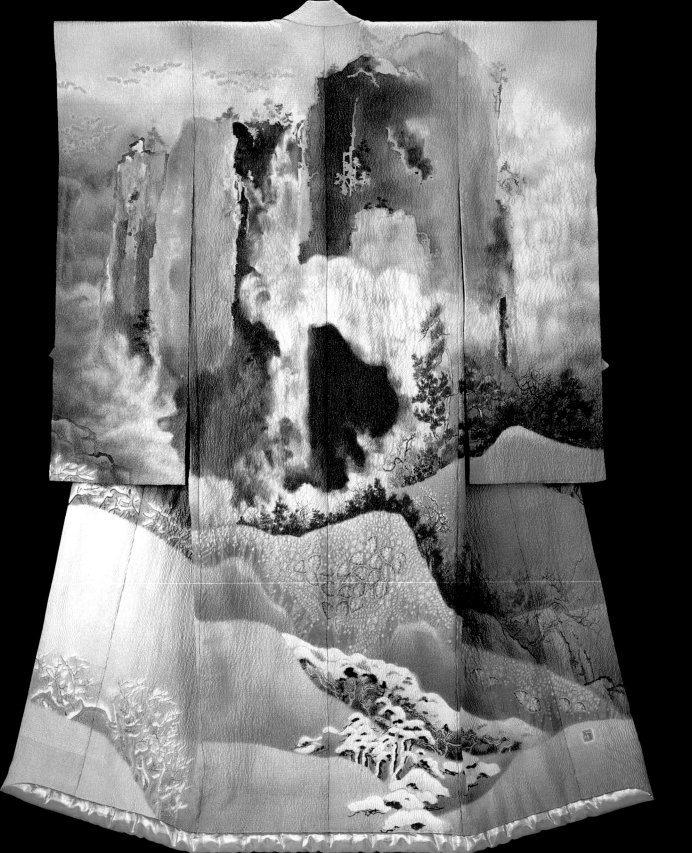

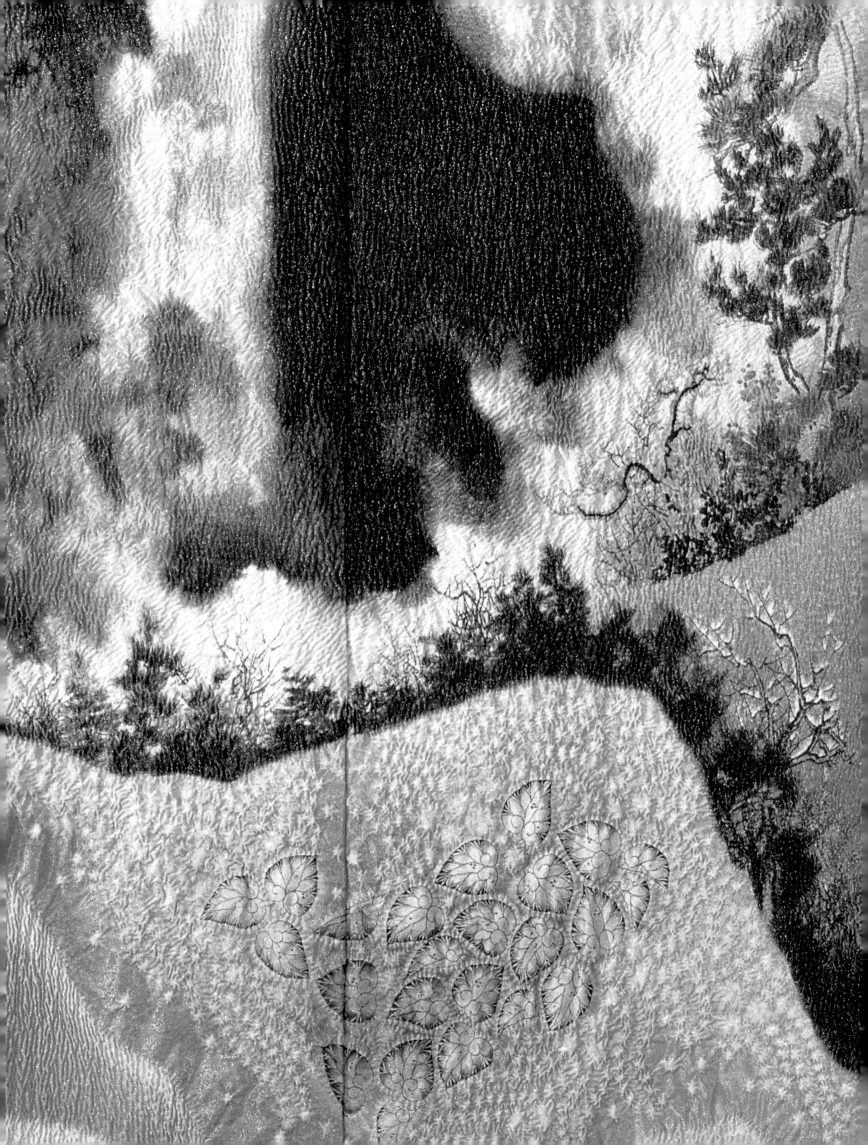

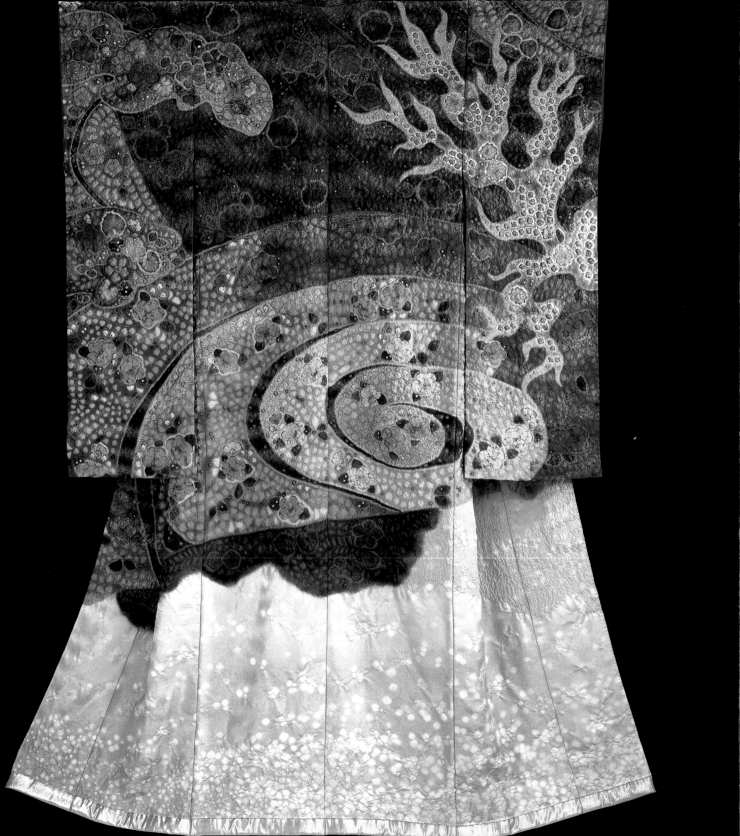

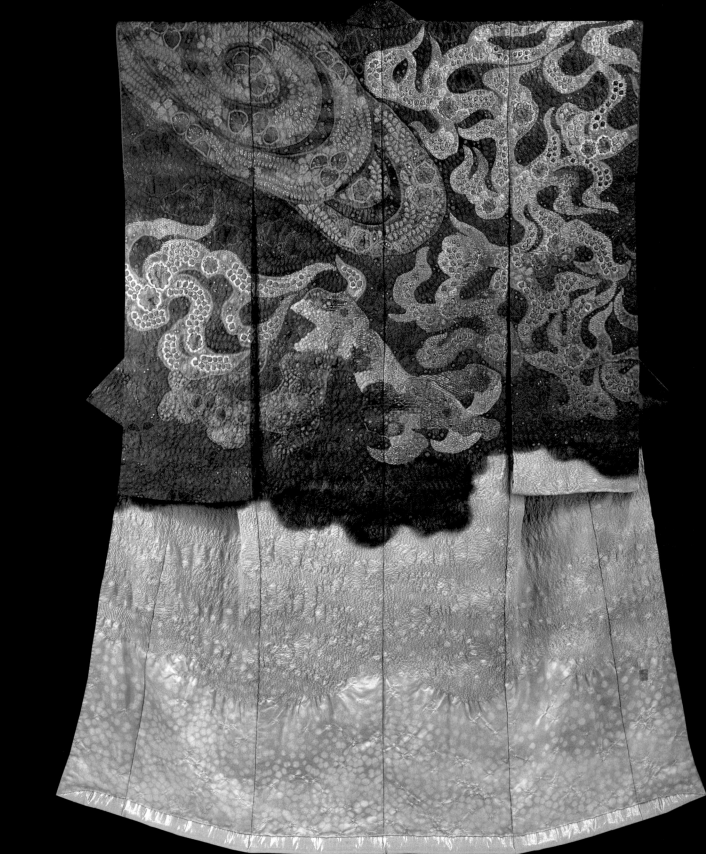

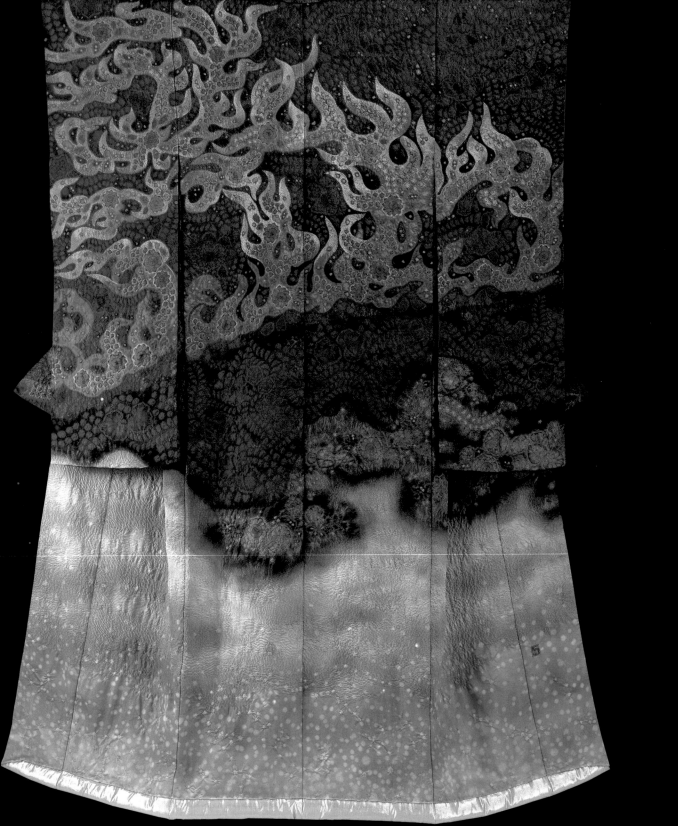

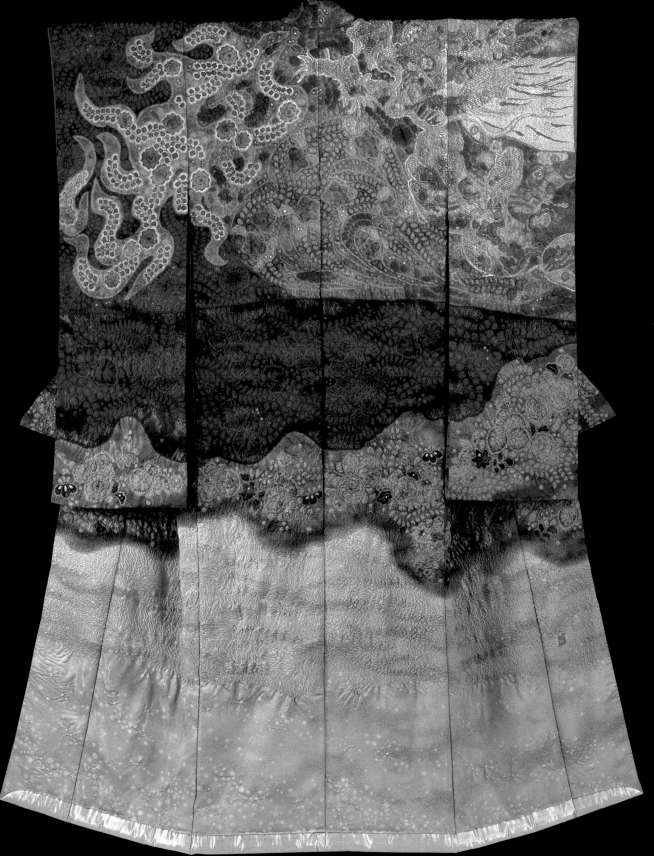

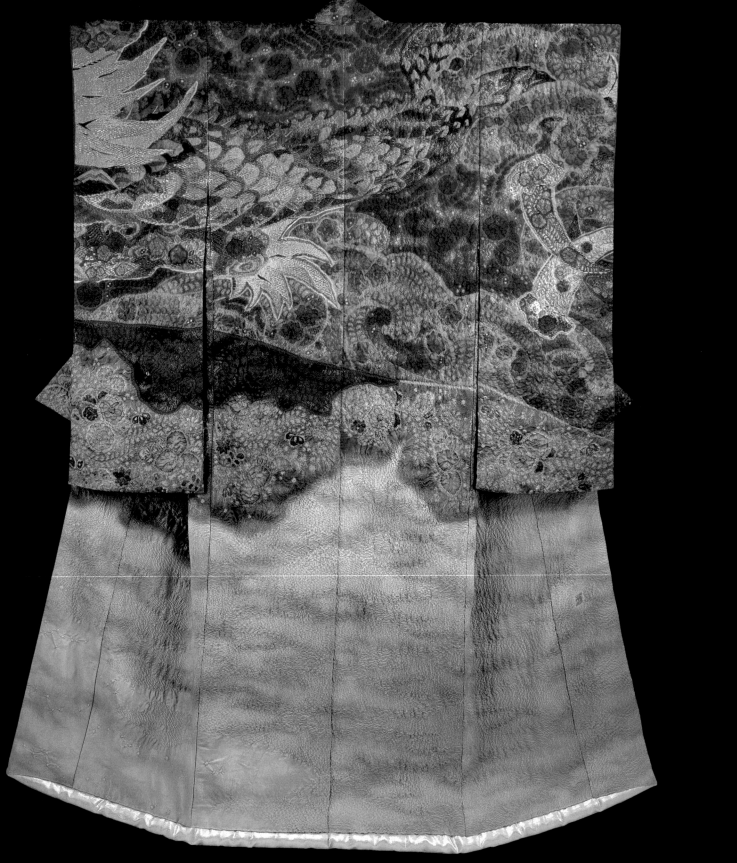

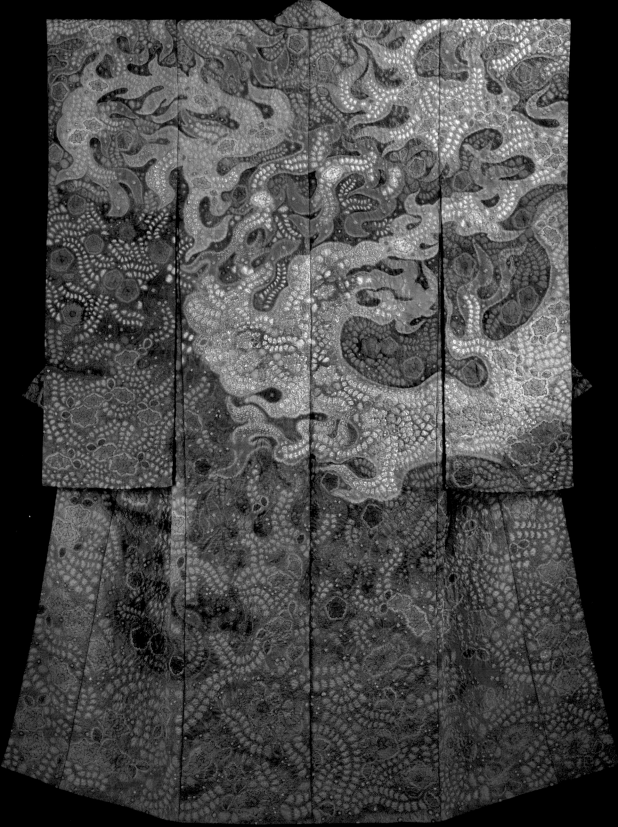

MOUNT FUJI

(CAT. NOS. 41–45)

DALE CAROLYN GLUCKMAN

Mount Fuji (Fujisan), an intermittently active volcano, is Japan's highest mountain at 12,388 feet (3,776 m). As the embodiment of the Japanese spiritual and emotional response to nature, Fuji is also the country's most sacred mountain. Rising majestically above the Yamato plain of the main island, Honshū, Mount Fuji has been the subject of Japanese poetry and the visual arts since at least the eighth century. Kubota specifically chose a location for his museum within sight of Mount Fuji, along the shores of Lake Kawaguchi, west of Tokyo (see "Visions of the Itchiku Kubota Art Museum," p. 12). When the clouds that frequently shroud the mountain's peak part for a moment, the view is indeed breathtaking. Considering Kubota's intense love of the natural world, his interest in the effects of light on color, and his fascination with this particular mountain, it is not surprising that he chose to produce a series of five works with Mount Fuji as its focus. Compared to the two series of woodblock prints by Katsushika Hokusai (1760–1849)— Thirty-six Views of Mount Fuji and One Hundred Views of Mount Fuji—Kubota's series is relatively modest in size, but it was extremely labor intensive, with each piece taking up to a year to create.

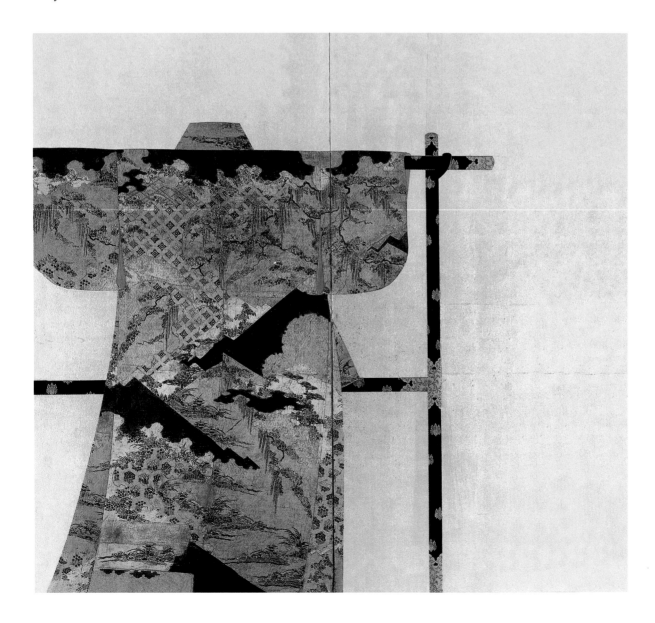

Figure 1
Kosode on Screen
Kosode fragment with mountains, snowflake roundels, wisteria, and plants and flowers of the four seasons
Edo period, early 17th century
Tie-dyeing, embroidery, and stenciled gold and silver leaf on figured silk satin (*rinzu*)
74¼ x 67⅞ in. (189.9 x 172.4 cm)
National Museum of Japanese History, Nomura Collection

Mount Fuji is not often depicted on kimono, despite its popularity as a subject in the other arts.[1] There are, however, two early depictions of note, both datable to the seventeenth century. The first, surviving as ten fragments glued to the gold-leafed surface of a screen, was originally on a kosode and previously unidentified; it may be the earliest extant example of the representation of Mount Fuji on clothing (Figure 1). The steep, conical shape on the upper right of the robe, partially obscured by the "sleeve" (although this may not have been its location on the original garment), with a quarter circle of stylized snow reserved in white, strongly suggests the snow-capped peak of Mount Fuji (Figure 1a). The prominent placement of wisteria vines in delicate embroidery, in addition to the snow-covered shape, could be a reference to a well-known poem by the famous courtier-poet Ariwara no Narihira (c. 825–880), in which he expresses his surprise at seeing snow on Mount Fuji in the fifth lunar month (summer):

> *Fuji is a mountain*
> *That knows no seasons.*
> *What time does it take this for,*
> *That it should be dappled*
> *With fallen snow?*[2]

The Japanese word for wisteria, *fuji*, is also a homonym for the name of the mountain. The plant blooms from mid-June to mid-July, the fifth month of the old Japanese lunar calendar.

The second example is a man's sleeveless military campaign coat (*jinbaori*) dating to the early seventeenth century in the collection of the Osaka Castle Museum. The coat is made of black wool against which a boldly graphic yellow-wool-appliqué silhouette of Mount Fuji stands out in sharp relief. In this case, the image of Mount Fuji probably had a protective function related to its spiritual significance.[3]

Kubota's use of Mount Fuji as the subject of a series is unique in the textile arts of Japan. So, too, is his study of the sacred mountain at different times of day and from slightly shifting viewpoints—not unlike Claude Monet's series of Haystack paintings (1890–91) and his Water Lilies series (1899–1926), which Kubota undoubtedly viewed in Paris in 1983 and/or 1987, when he mounted his own exhibitions there (see biography, p. 151).[4] The first piece in the Mount Fuji series was produced in 1989. Like the Haystack series, and a dozen Water Lilies canvases visitors saw in Monet's studio in 1918,[5] Kubota's Mount Fuji kimono were meant to be viewed together, although each could also be exhibited on its own.

A comment made about Monet's Haystack series at its first showing in 1891 could apply to Kubota's series as well: "the viewer was 'in the presence of sensations of place and of time in the harmonious and melancholic flow of sunsets, ends of day, and gentle dawns.'"[6] Likewise, art historian Richard Brettell's description of Monet's series of Haystacks in his book *Post-Impressionists* (1987) is equally appropriate for Kubota's works: "they were about time and color rather than about the way natural form and light interact. The *Haystacks* were evocations of nature, a series of works unified by an overall surface and a decorative, thematic harmony."[7]

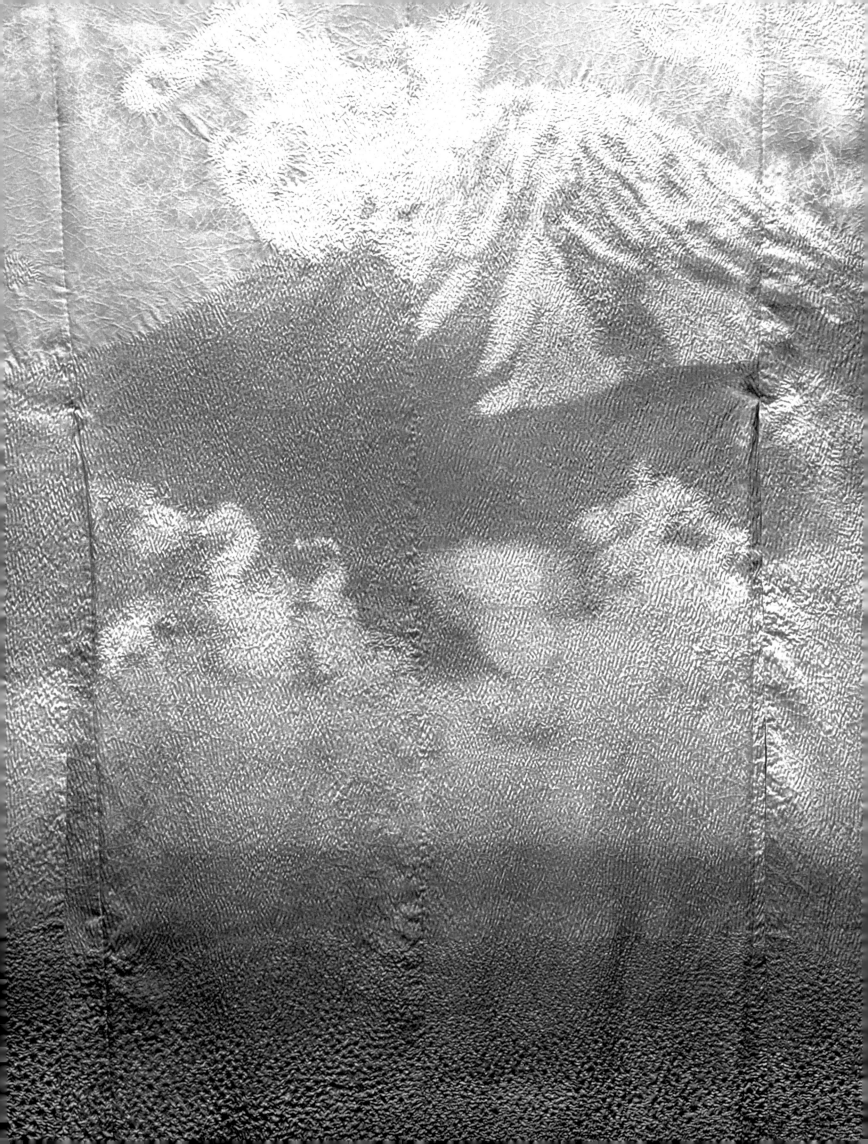

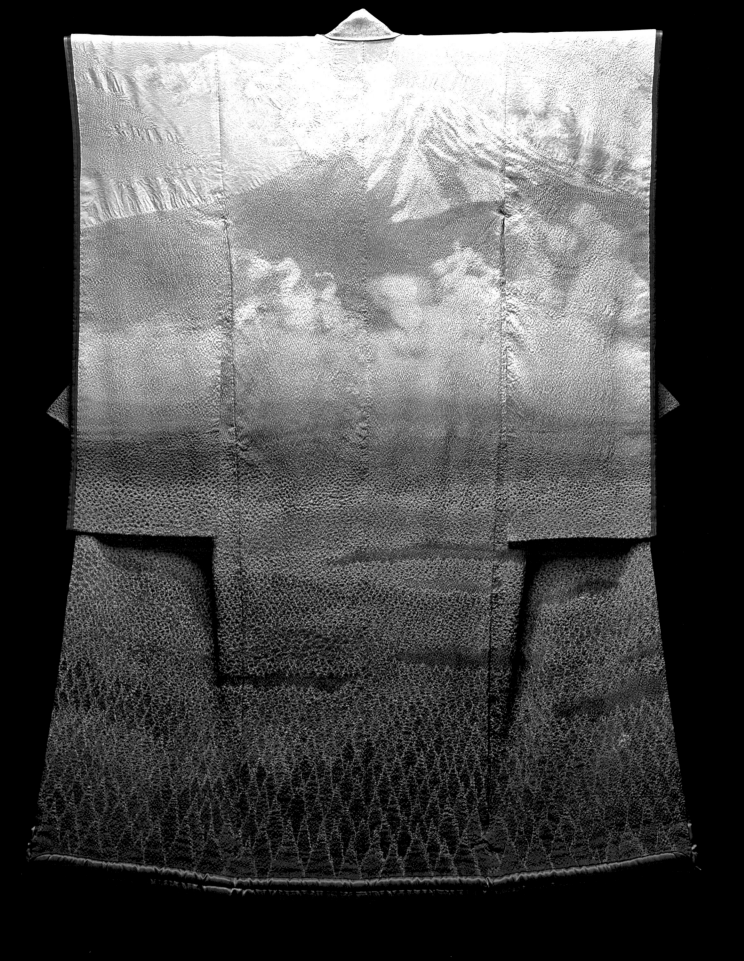

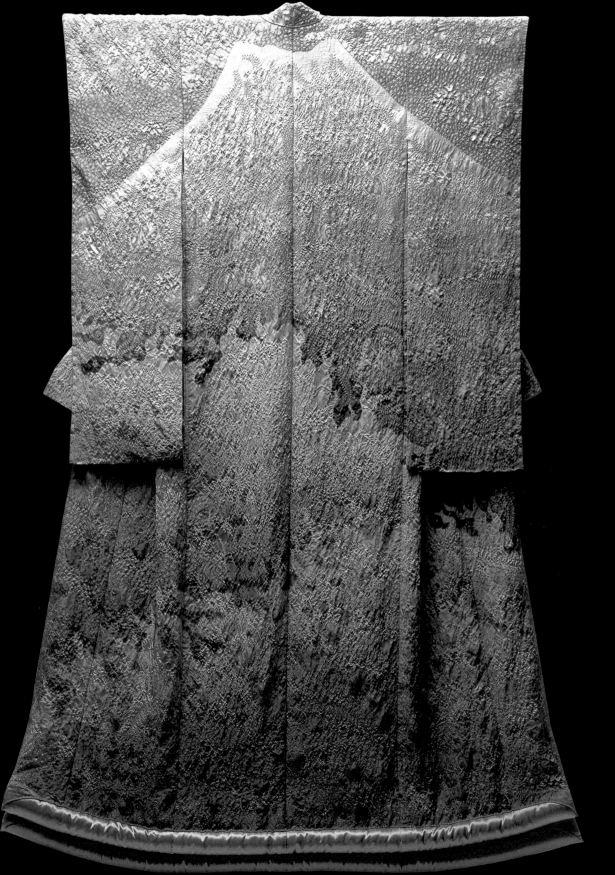

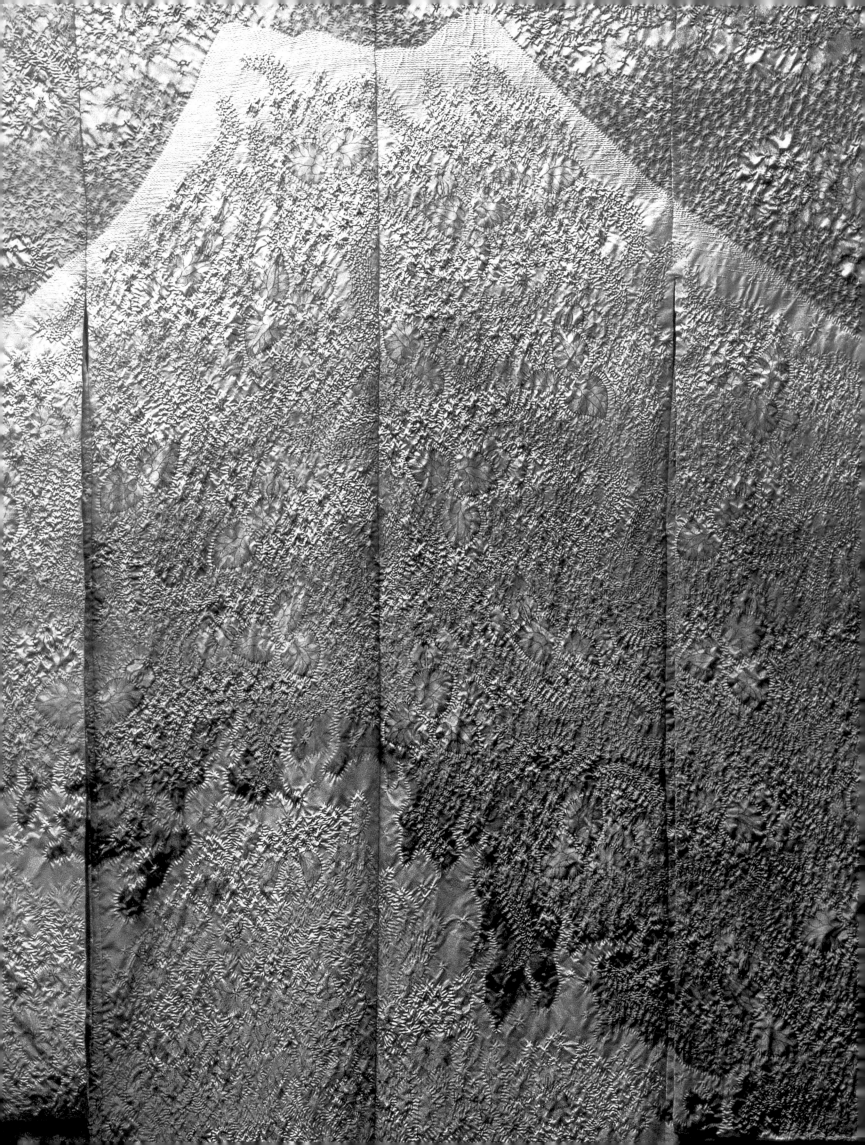

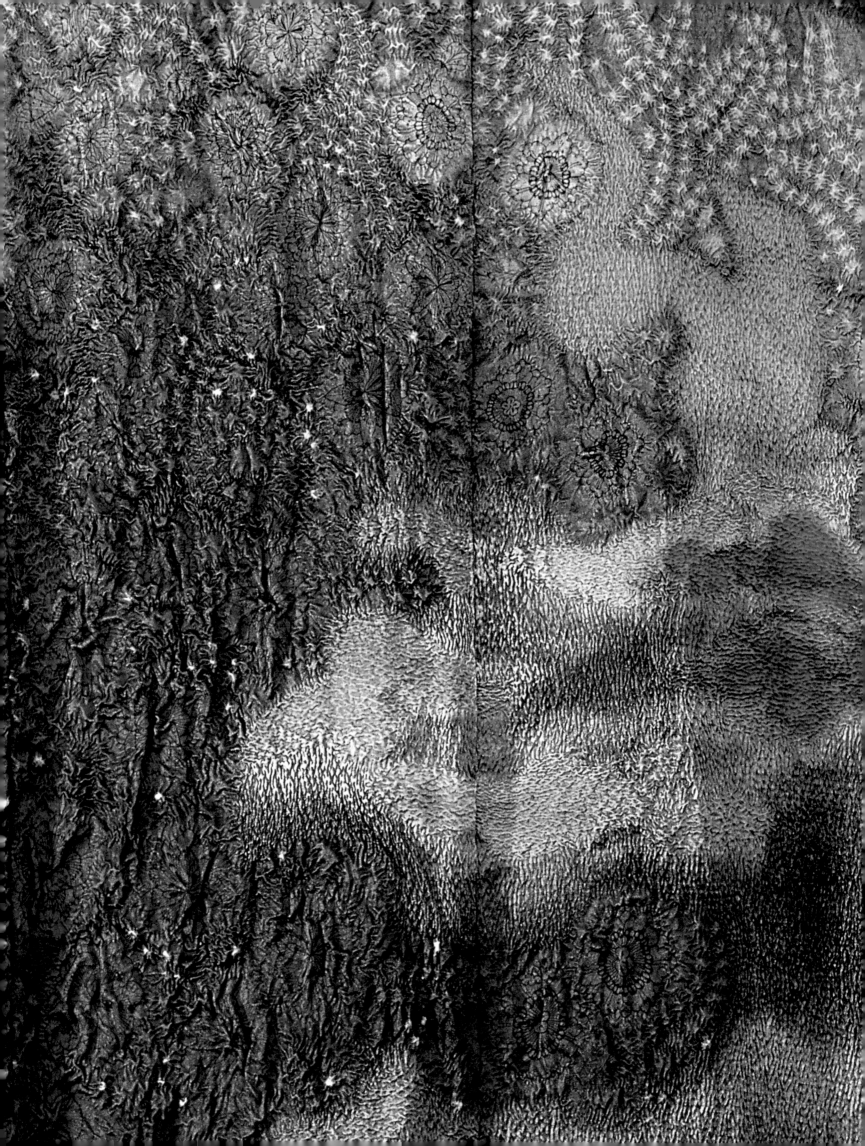

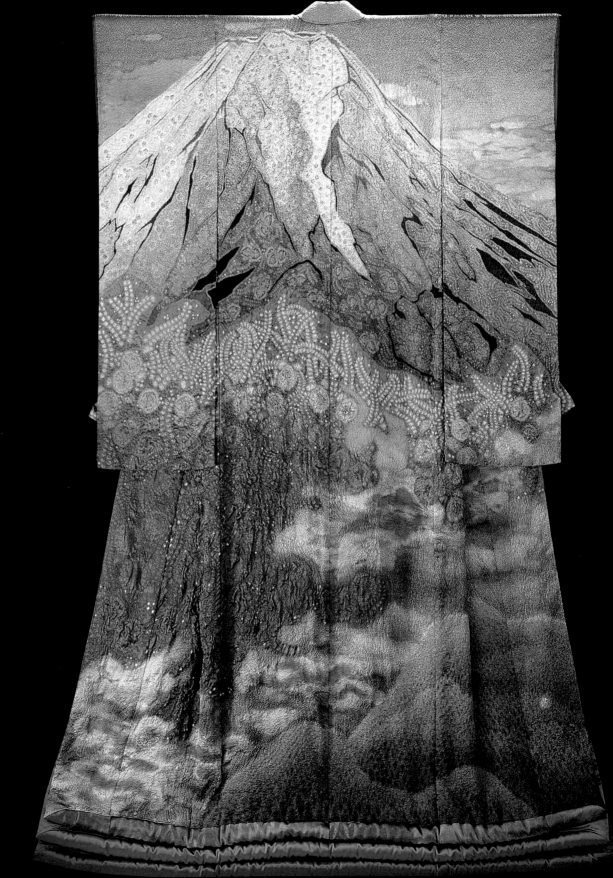

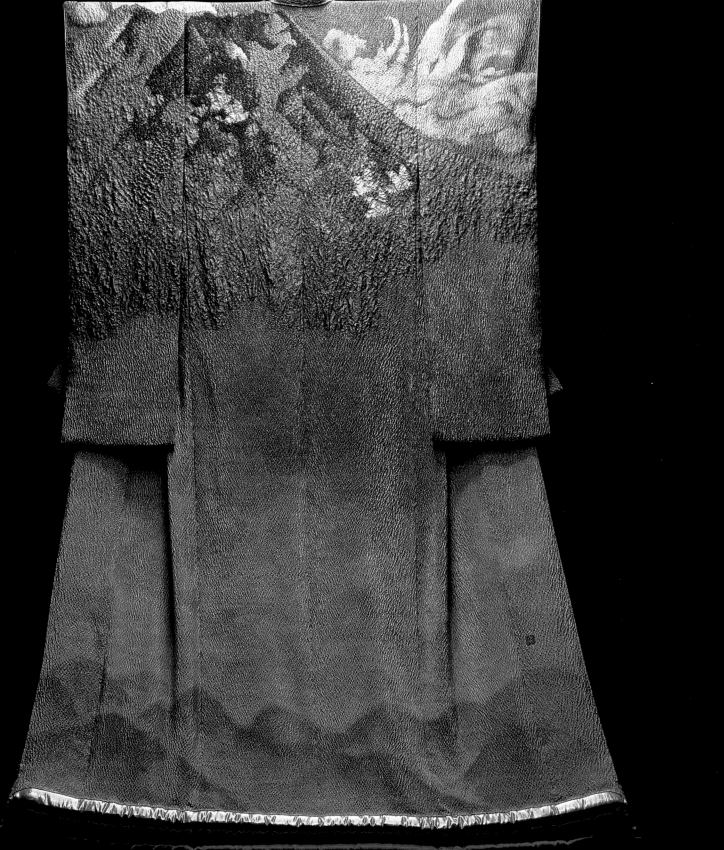

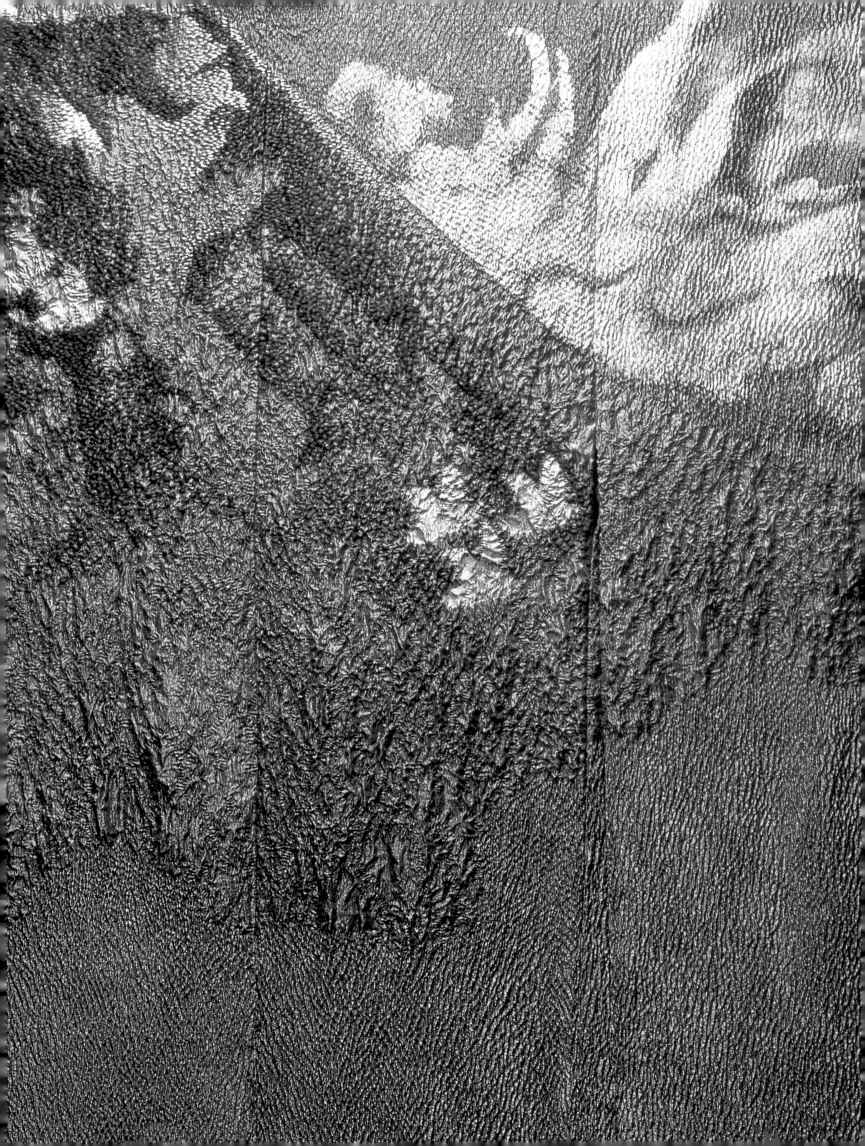

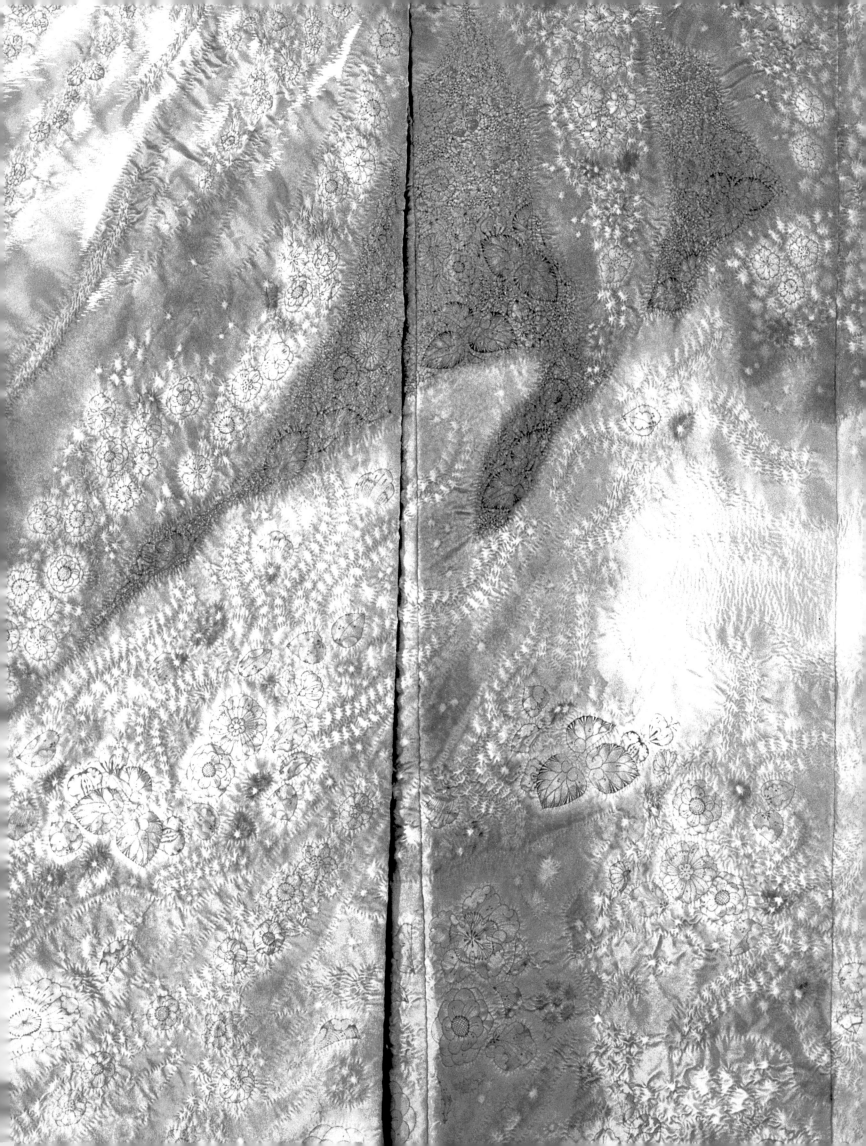

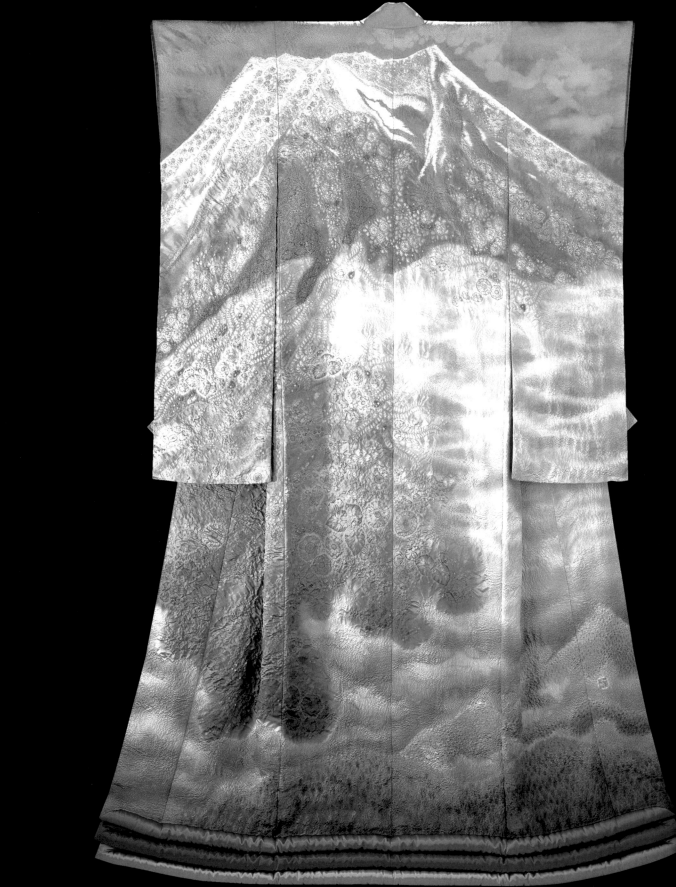

INDIVIDUAL WORKS

(CAT. NOS. 46–55)

DALE CAROLYN GLUCKMAN

Cat. No. 46

San/Burning Sun (1986)

Kubota wrote of his experience in the Siberian prisoner-of-war camp where he was interned from 1945 to 1948: "At the close of a hard day's work I would gaze out across the great Siberian plains and think of my family and friends as I watched the sun set. Its lingering rays were all the hope I had during those dreary days. The setting sun remains a major theme in my work and for me it is filled with a wordless emotion comprising grief, sorrow, solemnity, love and much more."[1] A setting sun on the lower right side of the back of this kimono was first outlined with fine stitches (*nuishime shibori*) and then protected from repeated dye baths with the capped resist technique (*bōshi shibori*). The sun contains delicate leaf and floral shapes, among them wisteria branches, *aoi*[2] leaves, and camellia flowers, all favored motifs in the sixteenth-century textiles called *tsujigahana*. The floral shapes, like the setting sun, were first outlined and pulled tight with nuishime shibori, capped resist dyed, and then filled with freehand ink painting. The sky shades from light yellow-orange at the shoulders to deep red-orange at the hem. The multiple gradations in between required many repetitions of the cycle of stitching, binding, dyeing, unstitching, washing, and restitching.

Cat. No. 47

Gen/Floral Illusion (1976)

Gen was originally part of a four-kimono series that Kubota called "Cherry Trees in Flower, or Kiyohime," exhibited in France in 1983.[3] Kiyohime, the heroine of the noh play *Dōjōji*,[4] is a beautiful woman obsessed with a Buddhist monk who rejects her persistent advances. Ultimately, her uncontrolled passion turns her into a dragon and causes the monk's death. Kubota said of this piece: "her [Kiyohime's] beauty and perseverance can be compared to the flowers of the cherry tree, resplendent in the cold of early spring."[5] Kubota has masterfully balanced the positive and negative space on this kimono. The diagonal lines and asymmetrical placement of the branches, flowing across the shoulders of the robe from the left side and cascading in a graceful arc to the right hem, give a dramatic sense of movement that suggests the format of kosode of the Kanbun era (1661–73). The Kanbun style featured bold, asymmetrical designs descending along the shoulder in an arc to the hem, usually (but not exclusively) on the right side of the robe, against a large expanse of unpatterned ground (Figure 1).[6] Here, Kubota effectively combined the tie-dyeing and ink painting of sixteenth-century tsujigahana with the integrated pictorial format of the second half of the seventeenth century (Kanbun style).

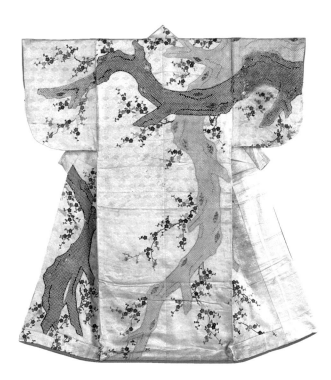

Figure 1
Kosode with Plum Trees
Edo period, third quarter of the 17th century
Tie-dyeing and embroidery on figured silk satin (*rinzu*)
Center back: 55½ in. (141 cm)
National Museum of Japanese History, Nomura Collection

Figure 2
Kosode with Oversized Grass Blades
Edo period, mid-17th century
Tie-dyeing, embroidery, and gold leaf on figured silk satin (*rinzu*)
Center back: 59 in. (150 cm)
National Museum of Japanese History, Nomura Collection

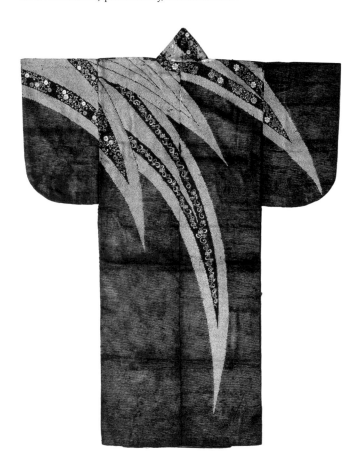

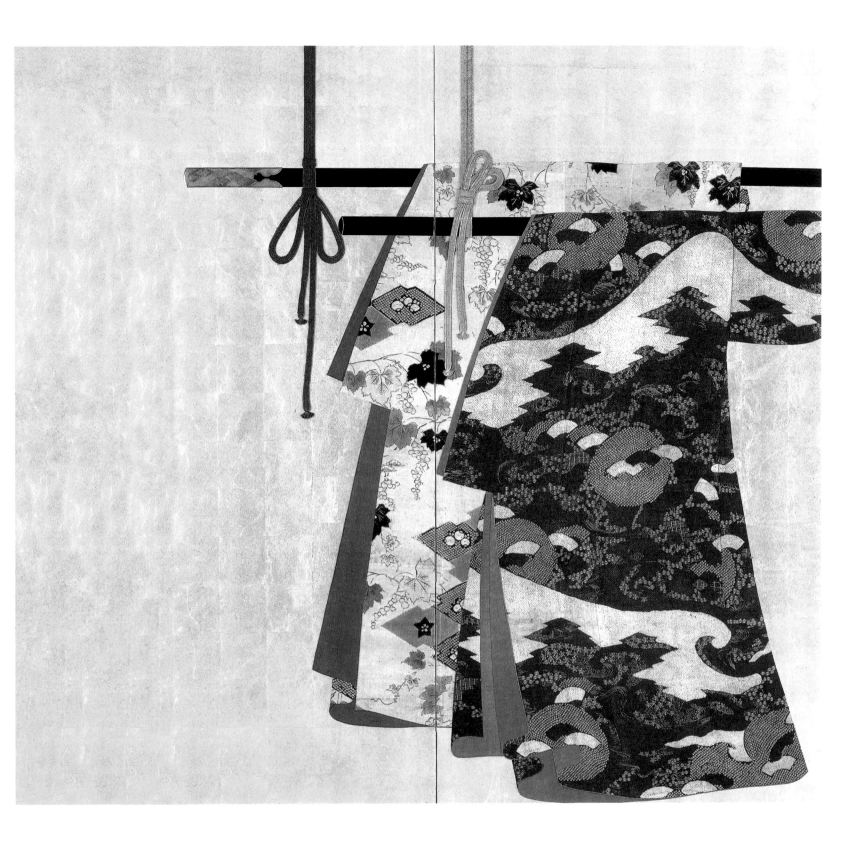

Cat. No. 48

Shuuga / Masses of Blooming Hollyhock (1998)

In *Shuuga*, Kubota has "slashed" the plane of his kimono with a diagonal, pointed shape against a dark green ground filled with an ink-drawn repeat of a serrated diamond pattern called *matsukawabishi* (literally, pine-bark lozenges), highlighted with gold leaf. The design can be read either as a topographic view of a landmass and peninsula against the ocean or as the rending of a floral "fabric" that reveals the infinity of a night sky. Kubota references at least two historical antecedents for the format of this piece. The first is an early Edo period kosode (Figure 2) in the Nomura Collection dating to *c.* 1660 in the Kanbun style.[7] Giant grass blades extending from the left shoulder of the Nomura piece create a series of sharply pointed jagged

Figure 3

Two Kosode on Screen

Left: Kosode fragments with grapevines, leaves, and lozenges
Momoyama period, late 16th–early 17th century
Tie-dyeing and ink painting on plain-weave silk (*nerinuki*)
Right: Kosode fragments with fan papers, mountains or waves, roundels, and flowers
Edo period, early 17th century
Tie-dyeing, embroidery, and gold leaf on figured silk satin (*rinzu*)
75 x 69 in. (190 x 175 cm)
National Museum of Japanese History, Nomura Collection

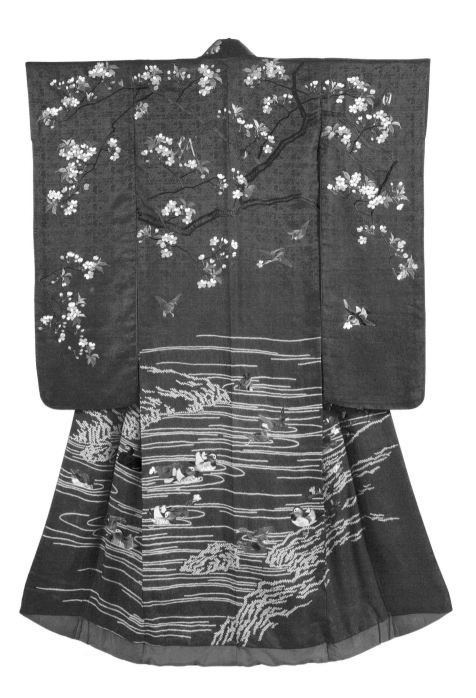

Figure 4
Uchikake with Mandarin Ducks and Cherry Blossoms
Edo period, early 19th century
Tie-dyeing and embroidery on silk crepe (*chirimen*)
Center back: 69⅝ in. (176.8 cm)
Bunka Gakuen Costume Museum, Tokyo

shapes against a dark brownish-black ground that is covered in a tiny geometric stenciled gold-leaf pattern not unlike Kubota's *Shuuga*. The second historical reference is to a sharply pointed diagonal zigzag (*katami-gawari*) dividing two halves of a design field, a popular device in Momoyama period (1573–1615) Japanese decorative arts. One famous example is a lacquer writing box from the early seventeenth century in the Tokyo National Museum, the lid of which is divided diagonally by a bamboo curtain with a pronounced jagged edge.[8]

Cat. No. 49

Hijiri/Saint (1981)

(Alternate titles: *Divinity, Divine Holiness*)[9]

Kubota has described this kosode as "the image of a wood nymph or nature figure,"[10] and as an expression of "all noble and valuable things of the world, sometimes it is a garment, or a color and sometimes it is the viewer standing in front of *Hijiri*."[11] Pine-bark lozenges (matsukawabishi), wisteria, and leaves, grasses, and flowers in black ink are all motifs taken from the shared design vocabulary of lacquer, ceramics, and textiles of the sixteenth century, the height of tsujigahana production. For example, the serrated pine-bark design (*matsukawa*) creates the lower edge of mountains or waves on a kosode fragment (Figure 3) in the fashionable *Keichō-somewake* style of the early seventeenth

OPPOSITE ABOVE
Figure 5
Drawing of *Kosode with Abstract Design*

OPPOSITE BELOW
Figure 6
Drawing of *Kosode with Bridges, Plum Blossoms, and Water Plantain*

century.[12] One of the lozenges, in the lower left skirt area of *Hijiri*, is filled with a wave and wheel design also found on the lid of a famous twelfth-century lacquer cosmetics box in the Tokyo National Museum.[13] The unusual double rows of padded hems (*fuki*) separated by a band of fabric—a Kubota innovation—give added height to the robe, making it larger than life-size.

Cat. No. 50

Kachou/Lovebirds Playing at the Waterside (1997)
The design field of this kimono is divided into three horizontal registers. The first, on the lower skirt, depicts colorful mandarin ducks, a traditional East Asian symbol of marital happiness, frolicking amid waves and water plantain. Water in shades of blue, enlivened with the texture of *shibori*, forms the middle section. Aoi leaves, resisted in white and detailed with ink drawing, stand out against the texture of the stitch resist–created wisteria in the top register. The piece recalls a well-known wedding *uchikake* (full-length outer robe with padded hem), once belonging to a member of the Mitsui family, that depicts mandarin ducks swimming below cherry tree branches (Figure 4). Kubota has given *Kachou* a nontraditional finish by integrating several rows of fuki into the overall design for greater height.

Cat. No. 51

Kikkou—Matsukawa/Tortoiseshell—Pine Bark (2001)
Several historical references can be found in this piece. The format of a bold, serrated zigzag recalls those seen on Momoyama period lacquer (see *Shuuga*, Cat. No. 48), as well as many surviving garments and garment fragments of the sixteenth and early seventeenth centuries (Figure 5).[14] The shape of the zigzag is known as pine bark (matsukawa), but here it also brings to mind the motif of angled plank bridges over a stream with irises or water plantain, both popular designs on robes of the Edo period (Figure 6).[15] The background is filled with wisteria against small repeat patterns of pine-bark lozenges (matsukawabishi), interlocking circles (shippō), and tortoiseshell hexagons (kikkō), all of which are from the design lexicon of Japanese decorative arts, here given Kubota's own textural and black-ink interpretation. The dark orange, light orange, and yellow trim around the garment not only adds to the overall dimensions of the piece but also, particularly at the sleeve edges, suggests the layered court robes of the Heian period.[16]

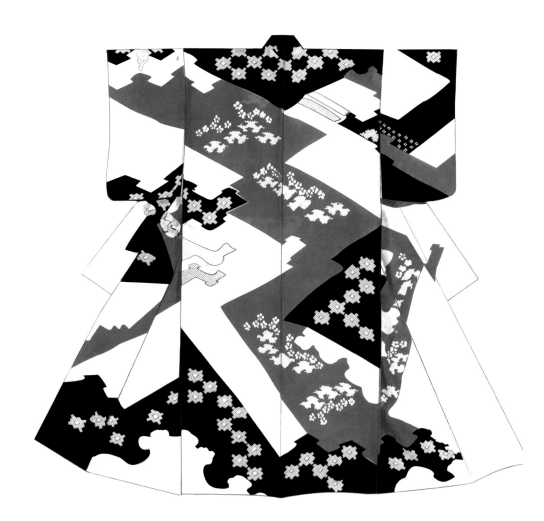

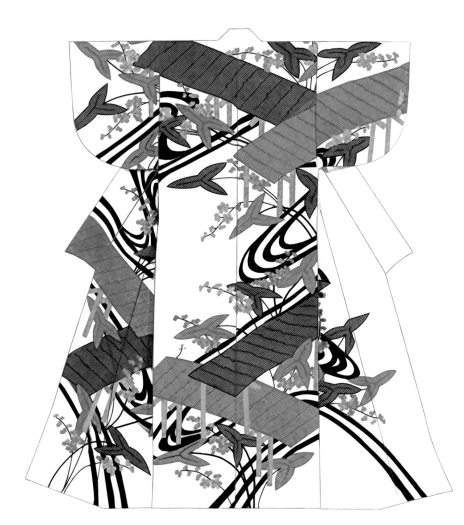

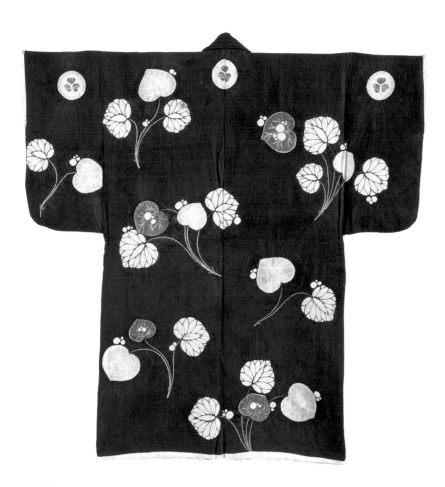

Figure 7
Dōbuku (Coat) with Aoi Crest and Leaves
Edo period, early 17th century
Stitch resist on plain-weave silk (*nerinuki*)
Center back: 45 in. (114.2 cm)
Tokugawa Art Museum

BELOW
Figure 8
Kosode with Flower-Filled Maple Leaves
Edo period, third quarter of the 17th century
Tie-dyeing and embroidery on figured silk satin (*rinzu*)
Center back: 58⅛ in. (147.6 cm)
National Museum of Japanese History, Nomura Collection

Cat. No. 52

Aoi/Hollyhock (1983)

The aoi plant (see footnote 2), with its distinctive heart-shaped leaves, has a long, symbolic history in Japan. Considered for centuries to have magical properties, the aoi is the emblem of Kamo Shrine in Kyoto, site of an annual Aoi Festival since 807. The scattering of oversize leaves on Kubota's *Aoi* is reminiscent of an example of a man's short, informal coat (*dōbuku*) that was said to have belonged to the first Tokugawa shogun, Ieyasu (Figure 7). The coat has his three-leaf family crest, as well as clusters of aoi leaves, rendered in stitch resist (*nuishime shibori*) and capped resist (*bōshi shibori*). Kubota's aoi leaves are filled with water plantains, chrysanthemums, peonies, wisteria, and Chinese bellflowers. The ground is a grid of the interlocking coin pattern (*shippō tsunagi*), which is also the dominant motif in *Shippou* (Cat. No. 54).

Cat. No. 53

Shuuyou/Autumn Sunlight (1983)

Maple leaves—some outlined and filled with fine inked lines and shading, others highlighted with gold thread—recall the tsujigahana style. The rendering of the decaying sections of the leaves conveys the same poignancy it did in the sixteenth century—a sense of the passing of the seasons and by extension, the transitory nature of life. Maple leaves, one of the most important seasonal symbols in Japanese art, also featured prominently in classical poetry. The swirling design in the center field suggests water eddies, evoking the theme of maple leaves floating on water (*tatsutagawamon*), a reference to the Tatsutagawa, a river near the city of Nara where aristocrats during the Nara and Heian periods would go to view maple leaves in autumn. A possible historical antecedent for *Shuuyou* is a kosode with flower-filled maple leaves on a (now faded) red-orange ground dating from the third quarter of the seventeenth century (Figure 8). Its format, however, differs from Kubota's *Shuuyou*; it is typical of the style of the Kanbun era (1661–73): oversized leaves mass up the right side of the back and across the shoulder, against a large, undecorated area on the left side of the design field.[17]

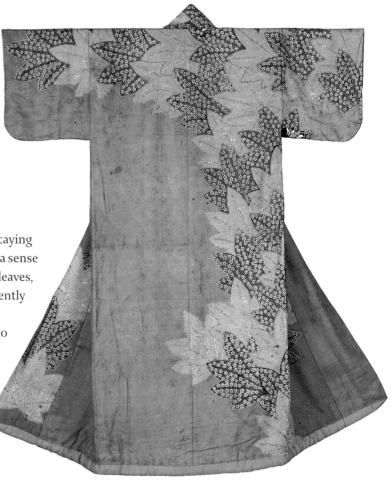

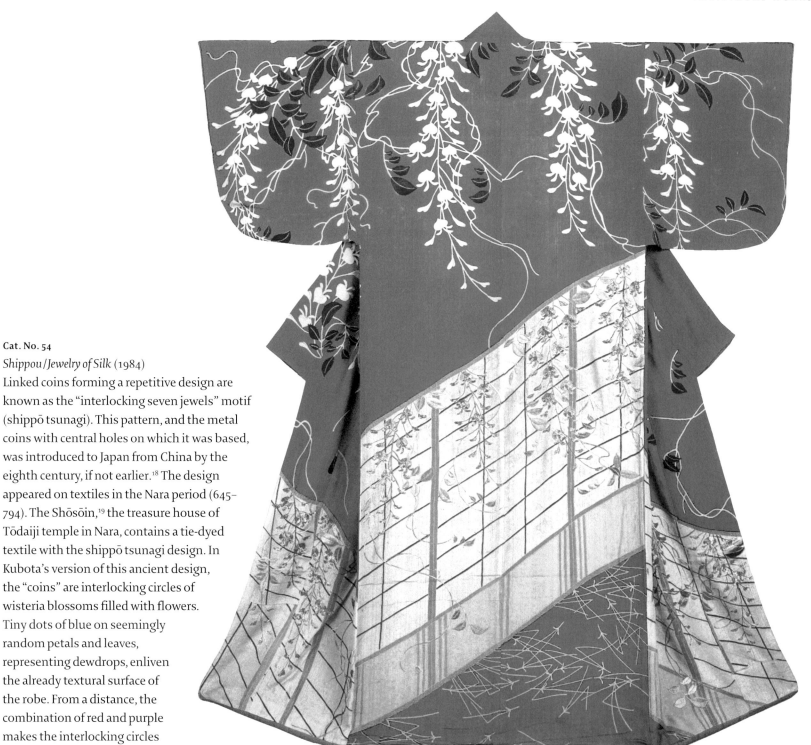

Cat. No. 54

Shippou / Jewelry of Silk (1984)

Linked coins forming a repetitive design are known as the "interlocking seven jewels" motif (shippō tsunagi). This pattern, and the metal coins with central holes on which it was based, was introduced to Japan from China by the eighth century, if not earlier.[18] The design appeared on textiles in the Nara period (645–794). The Shōsōin,[19] the treasure house of Tōdaiji temple in Nara, contains a tie-dyed textile with the shippō tsunagi design. In Kubota's version of this ancient design, the "coins" are interlocking circles of wisteria blossoms filled with flowers. Tiny dots of blue on seemingly random petals and leaves, representing dewdrops, enliven the already textural surface of the robe. From a distance, the combination of red and purple makes the interlocking circles of *Shippou* vibrate.

Cat. No. 55

Izutsu / Kimono within Kimono (1985)

(Alternate title: *Windows*)[20]

Two "illuminated" rectangles pierce the darkness of a starry night (that is, the ground fabric woven with gold thread). Flowers fill the lower portion of each rectangular "window," making it appear as if the observer were looking into a garden. The wide, vertical stripes in the lower rectangle suggest the view through the slats of a bamboo curtain (*sudare*), or through a series of sliding paper screens (*shōji*). In fact, an eighteenth-century kosode in the Nomura Collection (Figure 9), which depicts a shōji screen on the lower half of the back and wisteria vines descending from the shoulders, may have served as Kubota's inspiration for *Izutsu*. For Kubota, however, these windows do not look out over a garden but rather into the interior of a kimono, which reveals another kimono. *Izutsu* is a metaphor for a window into the soul, heart, or mind of the imagined wearer.

Figure 9
Kosode with Wisteria, Shōji, and Pine Needles
Edo period, second quarter of the 18th century
Paste-resist dyeing and embroidery on silk crepe (*chirimen*)
Center back: 57⅛ in. (145.7 cm)
National Museum of Japanese History, Nomura Collection

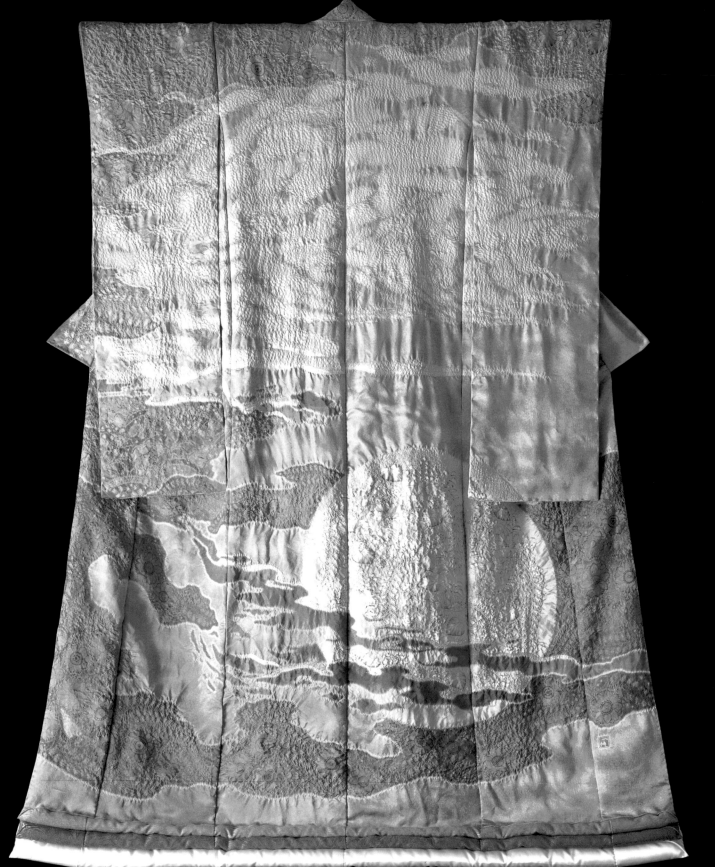

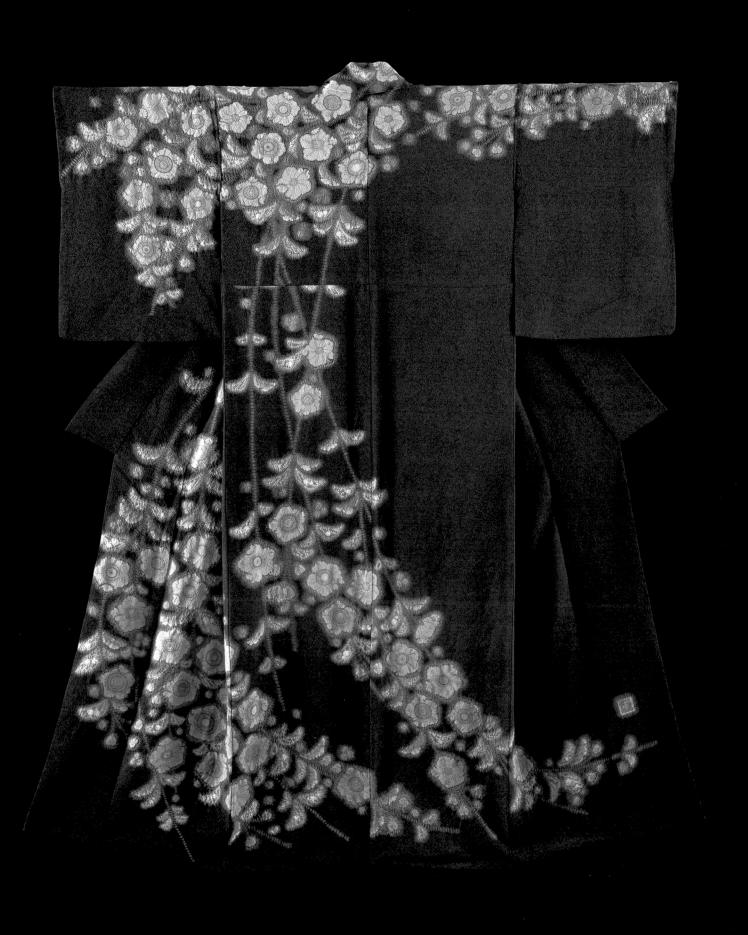

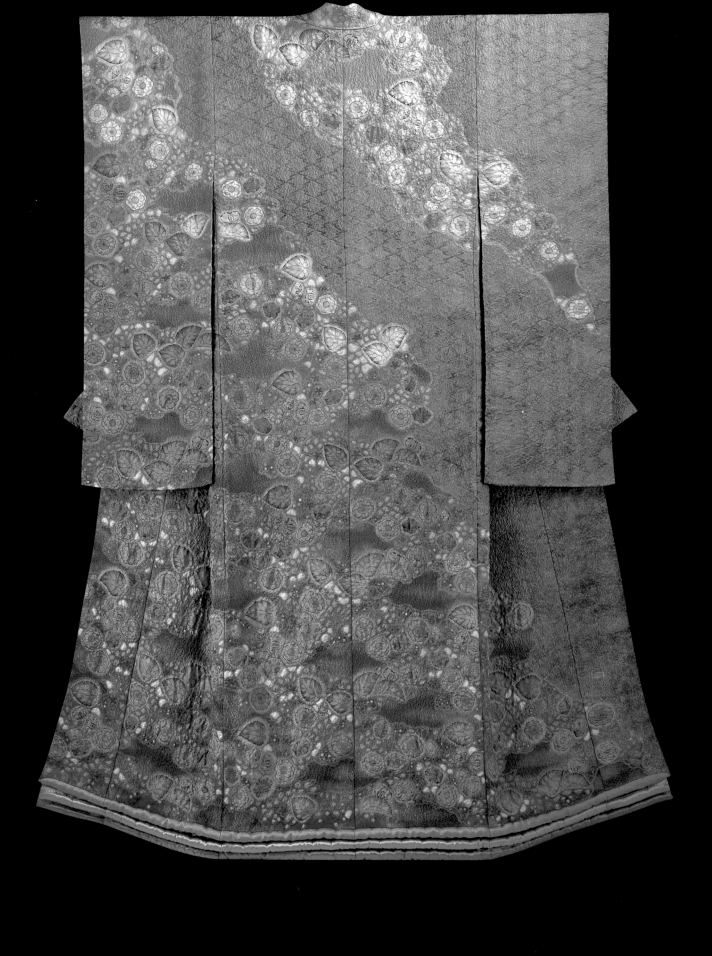

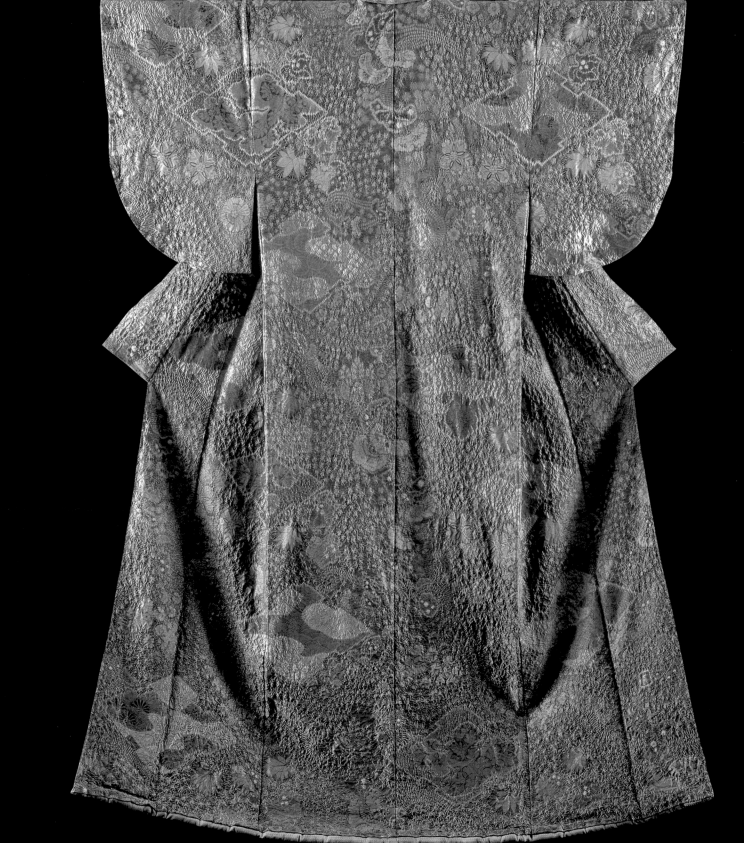

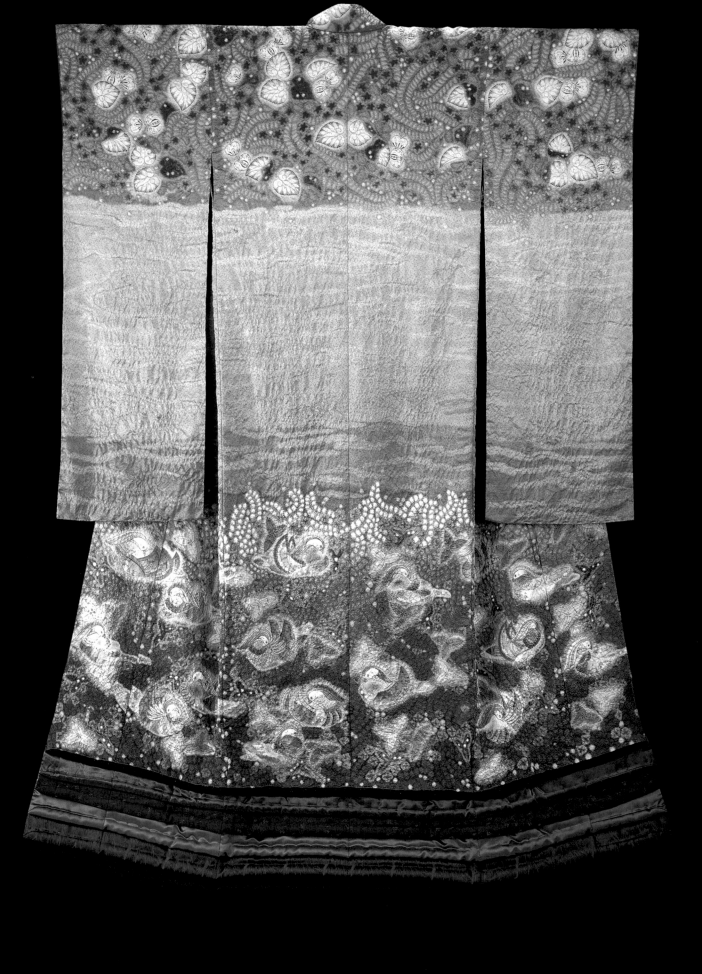

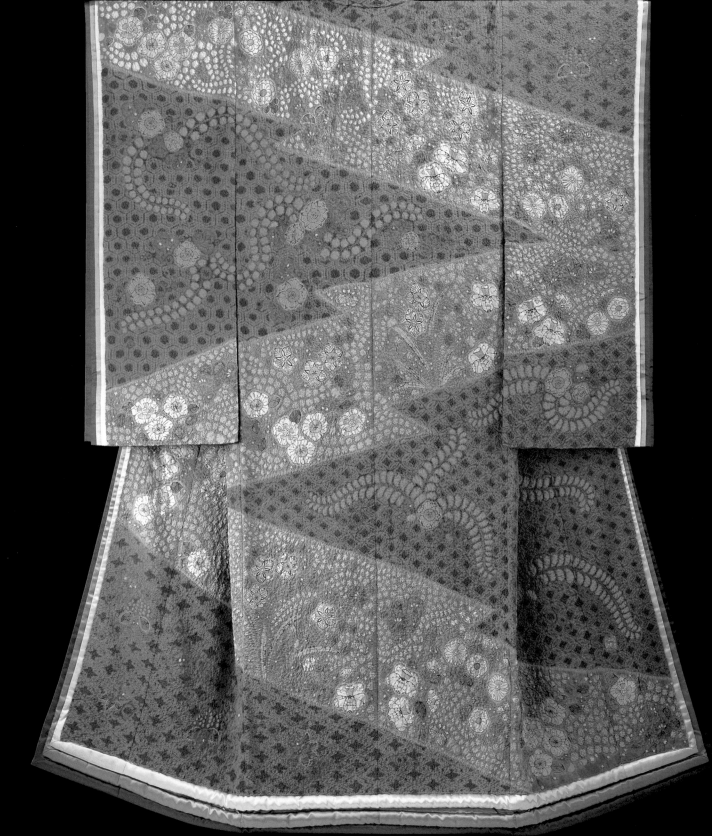

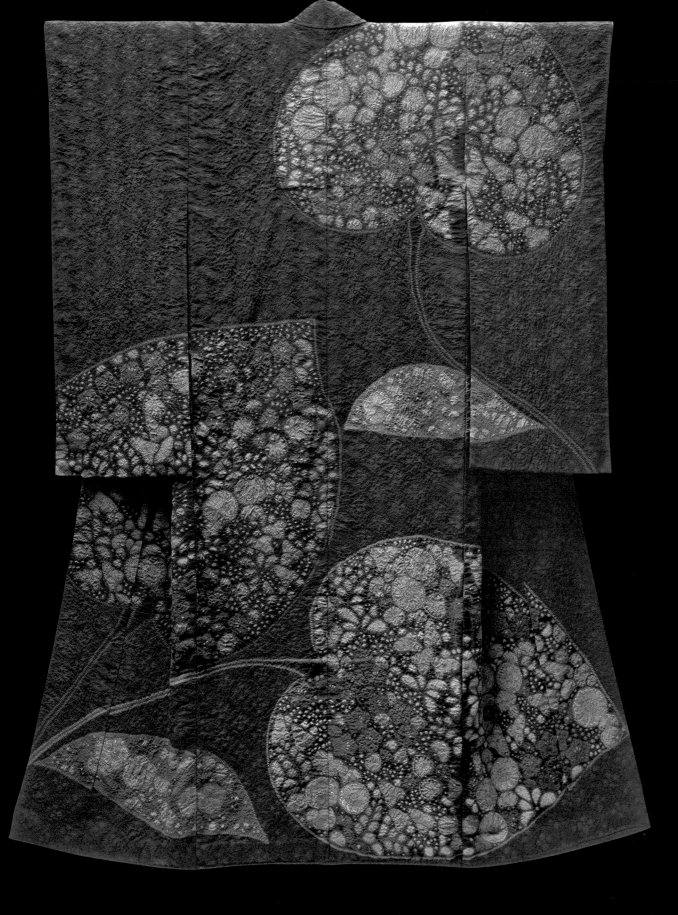

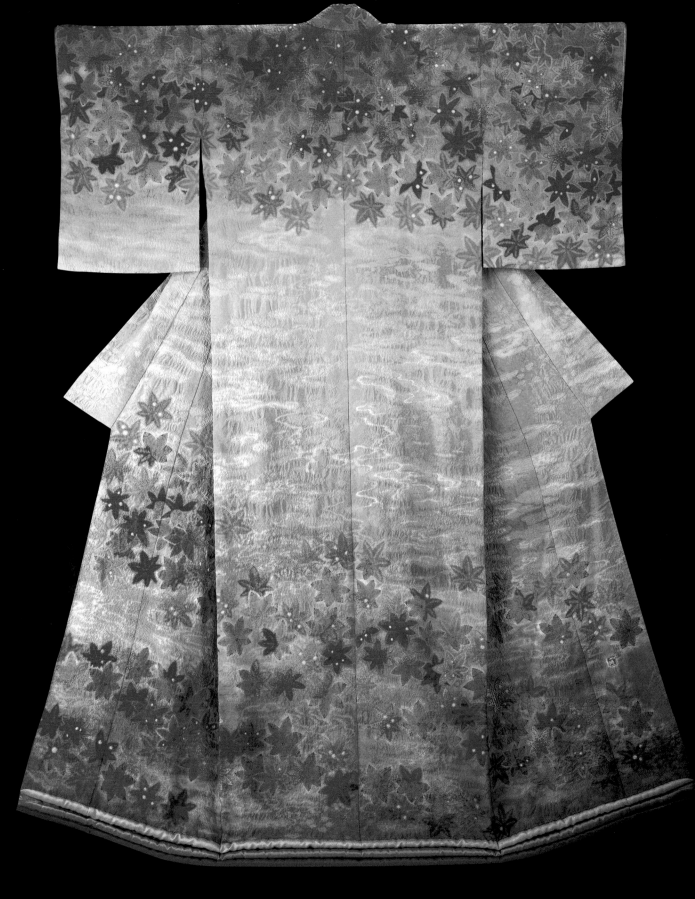

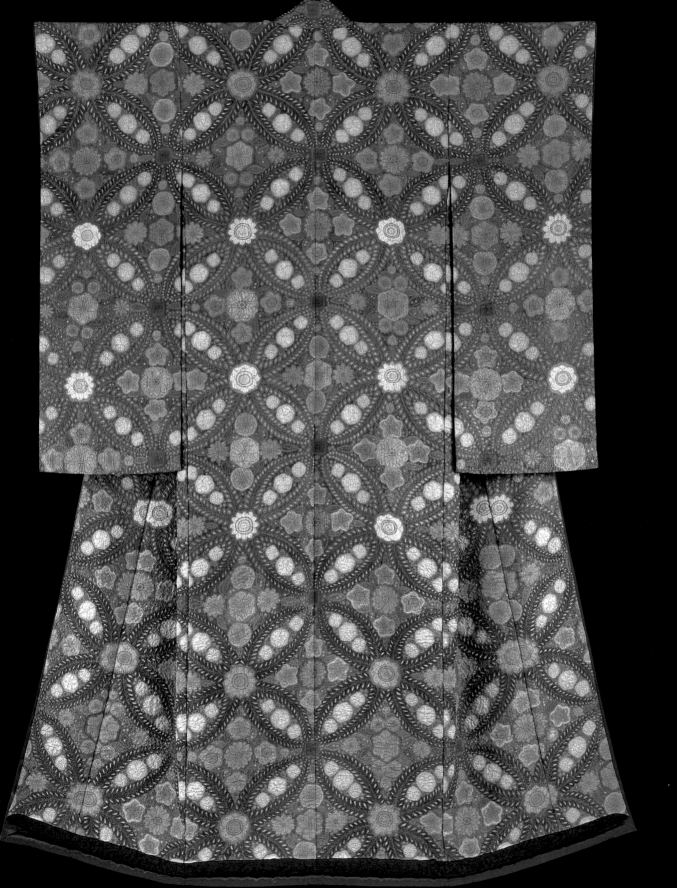

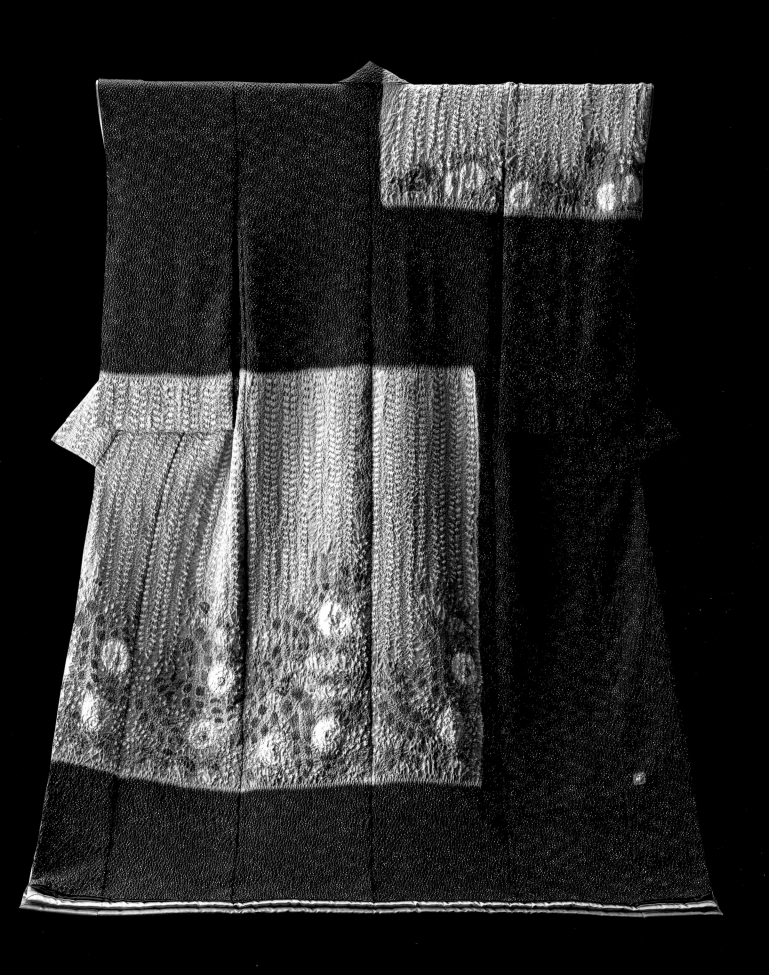

LIST OF WORKS

Where available, additional descriptive information from the artist about the works has been included within quotation marks. All of the descriptions were translated from the Japanese by Hollis Goodall.

SYMPHONY OF LIGHT

The Symphony of Light series consists of The Four Seasons (Cat. Nos. 1–34) and The Universe (Cat. Nos. 35–40). The Four Seasons is further composed of Autumn (Cat. Nos. 1–16) and Winter (Cat. Nos. 17–34), with The Oceans comprising Cat. Nos. 20–25 within Winter. All pieces in Symphony of Light are in the *furisode* (long-hanging sleeve) style. In the dimensions, height is followed by width and rounded to the nearest inch or centimeter. The height is measured from the top of the collar to the hem along the center back seam; the width is measured along the shoulder line, from sleeve edge to sleeve edge. The dimensions for all works in Symphony of Light are the same: 78 x 55 in. (198 x 139 cm).

THE FOUR SEASONS

Cat. No. 1
Beni/Combustion (1981)
"Mountain dyed in glossy red"
Tie-dyeing, ink painting, and gold and silver leaf on silk crepe (*chirimen*) with gold wefts

Cat. No. 2
Hi/Incandescence (1981)
"Moment when clouds are woven with sunset"
Tie-dyeing, ink painting, gold and silver leaf, and embroidery on silk crepe (*chirimen*) with gold wefts

Cat. No. 3
Kyou/Twilight on the Lake (1981)
"Mid-sunset, clouds reflecting gold"
Tie-dyeing, ink painting, gold leaf, and embroidery on silk crepe (*chirimen*) with gold wefts

Cat. No. 4
Hiwacha/The Uncertain Hour (1981)
"An instant of twilight"
Tie-dyeing, ink painting, and embroidery on silk crepe (*chirimen*) with gold wefts

Cat. No. 5
Aihatoba/Autumn Peninsula (1981)
"Clear surface of water and a quiet mountain"
Tie-dyeing and ink painting on silk crepe (*chirimen*) with gold wefts

Cat. No. 6
Shoujoutou/Reflections before Nightfall (1983)
"Evening light reflected on a mountain lake"
Tie-dyeing and ink painting on silk crepe (*chirimen*) with gold wefts

Cat. No. 7
Rurikon/Emerald Moment of the Lake (1983)
"Lingering memories of the sinking sun"
Tie-dyeing and ink painting on silk crepe (*chirimen*) with gold wefts

Cat. No. 8
Kougaki/Scene Changing in Persimmon Color (1984)
"Mixture of the beautiful colors of nature"
Tie-dyeing and ink painting on silk crepe (*chirimen*) with gold wefts

Cat. No. 9
Benigara/The Purple Hour: Temperance (1984)
"Land of scenic beauty"
Tie-dyeing and ink painting on silk crepe (*chirimen*) with gold wefts

Cat. No. 10
Kakimurasaki/Uncertainty of Evening (1984)
"Early evening illusions"
Tie-dyeing and ink painting on silk crepe (*chirimen*) with gold wefts

Cat. No. 11
Jo/Autumn Prologue (1986)
"Prologue to late autumn"
Tie-dyeing, ink painting, and embroidery on silk crepe (*chirimen*) with gold wefts

Cat. No. 12
Ryou/Certitude (1986)
"Beams of light/Late autumn in the mountain range"
Tie-dyeing, ink painting, and embroidery on silk crepe (*chirimen*) with gold wefts

Cat. No. 13
Kou/Change (1986)

"Shifts and changes of late autumn"
Tie-dyeing and ink painting on silk crepe (*chirimen*) with gold wefts

Cat. No. 14
Hin/Nostalgia (1987)
"Enduring mountains of late autumn"
Tie-dyeing and ink painting on silk crepe (*chirimen*) with gold wefts

Cat. No. 15
Hou/Late Autumn Melancholy (1987)
"Late autumn, mountain range cloaked in mist"
Tie-dyeing and ink painting on silk crepe (*chirimen*) with gold wefts

Cat. No. 16
Kou/Twixt Autumn and Winter: Involution (1989)
"Winter visit"
Tie-dyeing and ink painting on silk crepe (*chirimen*) with gold wefts

Cat. No. 17
Ei/Unexpected Snow (1989)
"Sleet passing through mountains"
Tie-dyeing and ink painting on silk crepe (*chirimen*) with gold wefts

Cat. No. 18
Sei/Blue Trace of Hope in Sudden Snow (1989)
"Mountain with rising sleet"
Tie-dyeing and ink painting on silk crepe (*chirimen*) with gold wefts

Cat. No. 19
Shou/Last Light of Autumn in the Sky (1988)
"Cloudy atmosphere in the heavens"
Tie-dyeing, ink painting, and embroidery on silk crepe (*chirimen*) with gold wefts

Cat. No. 20
Ai/Obliteration (1987)
"Dense fog amidst the late autumn mountain range"
Tie-dyeing, ink painting, and embroidery on silk crepe (*chirimen*) with gold wefts

Cat. No. 21
Byou/Beginning of Winter on the Lake: Final Rustlings (1988)
"Endless surface of water"
Tie-dyeing, ink painting, and

embroidery on silk crepe (*chirimen*) with gold wefts

Cat. No. 22
Bou/First Chill of Water (1988)
"A broad, deep, and distant space"
Tie-dyeing, ink painting, and embroidery on silk crepe (*chirimen*) with gold wefts

Cat. No. 23
Tou/Eddies (1986)
"Rays of setting sun"
Tie-dyeing, ink painting, and embroidery on silk crepe (*chirimen*) with gold wefts

Cat. No. 24
Kyoku/Spellbound Anticipation (1986)
"The utter beauty of water"
Tie-dyeing, ink painting, and embroidery on silk crepe (*chirimen*) with gold wefts

Cat. No. 25
Ryou/The Moment of First Cold (1986)
"Mountain reflected in a lake"
Tie-dyeing, ink painting, and embroidery on silk crepe (*chirimen*) with gold wefts

Cat. No. 26
Chou/First Blushes of Winter (1986)
"Beauty of snow falling on trees and lake"
Tie-dyeing, ink painting, and embroidery on silk crepe (*chirimen*) with gold wefts

Cat. No. 27
Kan/Winter (1996)
"Beauty of deep and quietly falling snow"
Tie-dyeing, ink painting, and embroidery on silk crepe (*chirimen*) with silver wefts

Cat. No. 28
Jo/Endless Snow (1988)
"The gentle beauty of floating snow"
Tie-dyeing, ink painting, and embroidery on silk crepe (*chirimen*) with silver wefts

Cat. No. 29
Jou/Empire of Snow (1989)
"Mountain range embraced by pure white snow"
Tie-dyeing, ink painting, and

embroidery on silk crepe (*chirimen*) with silver wefts

Cat. No. 30
Shi/Silver Purity (1989)
"The gentle beauty of floating snow"
Tie-dyeing, ink painting, and embroidery on silk crepe (*chirimen*) with silver wefts

Cat. No. 31
Kan/Deepening Silence after Snowfall (1996)
"Silence that runs deep"
Tie-dyeing, ink painting, and embroidery on silk crepe (*chirimen*) with silver wefts

Cat. No. 32
Rei/Snow in Late Winter (1991)
"Late winter snow scenery"
Tie-dyeing and ink painting on silk crepe (*chirimen*) with silver wefts

Cat. No. 33
Yuu/Spring Air Approaching the Snowy Mountains (1991)
"Feeling of spring"
Tie-dyeing and ink painting on silk crepe (*chirimen*) with silver wefts

Cat. No. 34
Baku/Snow on the Mountains Begins Thawing (1995)
"Mountain snows slightly melted"
Tie-dyeing and ink painting on silk crepe (*chirimen*) with silver wefts

THE UNIVERSE

Cat. No. 35
Uzu/Fire Vortex (2006)
Tie-dyeing, ink painting, gold leaf, and embroidery on silk crepe (*chirimen*) with gold wefts

Cat. No. 36
En/Fire (1999)
Tie-dyeing, ink painting, gold leaf, and embroidery on silk crepe (*chirimen*) with gold wefts

Cat. No. 37
Chuu/Air (1999)
Tie-dyeing, ink painting, gold leaf, and embroidery on silk crepe (*chirimen*) with gold wefts

Cat. No. 38
Zu/Dragon Head (2000)

Tie-dyeing, ink painting, gold leaf, and embroidery on silk crepe (*chirimen*) with gold wefts

Cat. No. 39
Shu/Master (2000)
Tie-dyeing, ink painting, gold leaf, and embroidery on silk crepe (*chirimen*) with gold wefts

Cat. No. 40
U/Deep Space (1999)
Tie-dyeing, ink painting, gold leaf, and embroidery on silk crepe (*chirimen*) with gold wefts

MOUNT FUJI

All pieces in the Mount Fuji series are in the *furisode* (long-hanging sleeve) style.

Cat. No. 41
Ohn/Fuji and Woodland (1989)
"Fuji with trees and sea smothered in mist"
Tie-dyeing, ink painting, gold leaf, and embroidery on silk crepe (*chirimen*)
79 x 52 in. (200 x 132 cm)

Cat. No. 42
Ohn/Fuji, Glittering in Gold (1989)
"Burning red Fuji at dawn"
Tie-dyeing, ink painting, and embroidery on silk crepe (*chirimen*) with gold wefts
93 x 53 in. (236 x 135 cm)

Cat. No. 43
Ohn/Fuji and Burning Clouds (1991)
"Fuji shining in yellow gold"
Tie-dyeing and ink painting on silk crepe (*chirimen*) with gold wefts
95 x 54 in. (241 x 136 cm)

Cat. No. 44
Ohn/Burning Fuji (1994)
"Burning clouds linger over Fuji"
Tie-dyeing, ink painting, gold leaf, and embroidery on silk crepe (*chirimen*) with gold wefts
93 x 53 in. (236 x 135 cm)

Cat. No. 45
Ohn/Fuji Standing in a Sunset Glow (1993)
"Fuji appearing in sunset after a sudden shower"
Tie-dyeing, ink painting, and

embroidery on silk crepe (*chirimen*) with gold wefts
94 x 53 in. (238 x 135 cm)

INDIVIDUAL WORKS

Individual works are either in the *furisode* (long-hanging sleeve) or *tomesode* (shorter sleeve) style, as indicated.

Cat. No. 46
San/Burning Sun (1986)
Furisode; tie-dyeing, ink painting, gold leaf, and embroidery on silk crepe (*chirimen*) with gold and silver wefts
77 x 49 in. (196 x 124 cm)

Cat. No. 47
Gen/Floral Illusion (1976)
"Apparent illusion of the spirit of the cherry blossom unfolding"
Tomesode; tie-dyeing and ink painting on silk crepe (*chirimen*)
60 x 78 in. (199 x 132 cm)

Cat. No. 48
Shuuga/Masses of Blooming Hollyhock (1998)
Furisode; tie-dyeing and ink painting on silk crepe (*chirimen*) with gold wefts
77 x 50 in. (196 x 128 cm)

Cat. No. 49
Hijiri/Saint (1981)
"Esteemed holy man"
Tomesode; tie-dyeing and ink painting on silk crepe (*chirimen*) with gold wefts
75 x 53 in. (190 x 135 cm)

Cat. No. 50
Kachou/Lovebirds Playing by the Waterside (1997)
"In spring, a flock of mandarin ducks plays at the shoreline"
Furisode; tie-dyeing, ink painting, and embroidery on silk crepe (*chirimen*)
78 x 54 in. (197 x 136 cm)

Cat. No. 51
Kikkou—Matsukawa/Tortoiseshell—Pine Bark (2001)
"Tsujigahana within tortoiseshell pattern"
Furisode; tie-dyeing and ink painting on silk crepe (*chirimen*)
76 x 53 in. (193 x 135 cm)

Cat. No. 52
Aoi/Hollyhock (1983)
"Symbol"
Furisode; tie-dyeing and ink painting on silk crepe (*chirimen*)
76 x 52 in. (193 x 132 cm)

Cat. No. 53
Shuuyou/Autumn Sunlight (1983)
"Maples of autumn dyed pure red"
Tomesode; tie-dyeing, ink painting, and embroidery on silk crepe (*chirimen*)
75 x 51 in. (190 x 130 cm)

Cat. No. 54
Shippou/Jewelry of Silk (1984)
"Seven treasures"
Furisode; tie-dyeing and ink painting on silk crepe (*chirimen*) with gold wefts
75 x 51 in. (190 x 130 cm)

Cat. No. 55
Izutsu/Kimono within Kimono (1985)
Tomesode; tie-dyeing, ink painting, and embroidery on silk crepe (*chirimen*) with gold wefts
78 x 51 in. (199 x 130 cm)

BIOGRAPHY OF ITCHIKU KUBOTA

DALE CAROLYN GLUCKMAN

1917 Born in the Kanda district in Tokyo; father is a curio dealer.

1931 Leaves school at age fourteen to apprentice to Kobayashi Kiyoshi (active second quarter of the twentieth century), a Tokyo kimono artist of the Ozaki School of hand-painted *yūzen*.

1932 Studies batik (*rōketsuzome*) and Okinawan-style dyeing (*bingata*) after work.

1934 Studies Japanese-style landscape painting with Kitagawa Shunkō (active second quarter of the twentieth century), also on his own time.

1936 Learns portraiture and drafting from Ōhashi Gekkō (b. 1895), a *nihonga* painter of actors' portraits.

Enters Waseda Art School.

1937 Encounters a textile fragment labeled *tsujigahana* at the Tokyo National Museum and studies it for more than three hours. Kubota vows to devote his life to rediscovering this lost technique.

Begins to study Kanazawa-style yūzen (*Kaga-yūzen*).

1940 Becomes an assistant to a master stage designer for kabuki and *shinpa* (new school) theater. Produces custom-designed costumes for both male and female actors.

Embarks on a study of traditional Japanese dance (*nihon buyō*).

1942 Starts the study of natural dyes.

1944 Marries [1]; drafted into the army and sent to Siberia.

1945 Captured and detained in a Russian prisoner-of-war camp for three years. For a short time, Kubota designed paper costumes and produced plays for fellow prisoners. When these were prohibited, he watched the spectacular Siberian sunsets, which provided some emotional comfort.

1948 Returns to Japan and resumes yūzen dyeing professionally, but practices tie-dyeing techniques related to tsujigahana in his spare time.

1959 Continues his experimentation in recreating tsujigahana, but comes to question whether natural dyes are superior to synthetic. He begins to work with synthetic dyes to achieve the same effect, although his first efforts fail.

1961 Opens his own studio, Itchiku Kōbō (Itchiku Atelier), in Tokyo. Invents a new process that allows him to achieve a delicate mix of colors, finally conquering the problem of synthetic dyes becoming muddy when colors are overdyed [2].

1962 Decides to call his new technique "Itchiku Tsujigahana." Works tirelessly to perfect it over the next fifteen years.

1976 Receives encouragement from Professor Yamanobe Tomoyuki, the foremost textile historian in Japan at the time. He advises Kubota to combine his yūzen painting skills and the tie-dyeing techniques (*shibori*) associated with tsujigahana.

1977 Presentation of his first exhibition at Mikimoto Hall, Tokyo. Kubota is sixty years old [3].

1978 Holds his second exhibition in Mikimoto Hall in March. Then, recovering from a serious illness, he decides that he will no longer try to recreate the past but will develop his own style. He begins to work with creped silk (*chirimen*) woven with gold thread, which is more difficult to pattern with tie-dyeing methods but adds to the light-reflective quality of the finished kimono.

Receives an award from the Society for the Dissemination of Folk Costumes and Customs.

1979 His third exhibition travels to Tokyo, Osaka, Nagoya, and Kyoto.

Release of *Itchiku Tsujigahana: Kubota Itchiku's Collected Works* by Fuji Art Publishing, Japan.

1980 Exhibitions in Tokyo, Kyoto, and Kobe.

Exhibition and catalogue, *Itchiku Kubota: Kimono in the Tsujigahana Tradition*, the Art Gallery, Visual Arts Center, at California State University, Fullerton, in Fullerton, California.

1981 Visits the Canadian Rockies and is fascinated by the colors created by the setting sun, inspiring him to capture the colors of natural light in his work.

1981–82 A traveling exhibition of his work in which the Symphony of Light series is shown for the first time is held in twenty-six galleries and museums in twenty-one cities in Japan.

1982 Deluxe edition of *Itchiku Tsujigahana* is published by Heibon-sha, Japan.

Opens a school for yūzen dyeing in Tokyo.

"Itchiku Tsujigahana Grand Show" is held in Tokyo. Kubota, in a radical departure from established norms, updates the kimono by having his works worn by Western models in high heels and by wrapping the kimono in a nontraditional way.

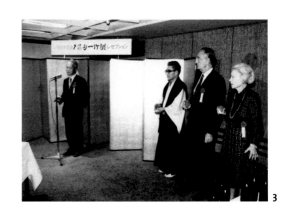

1983 Exhibition at Musée Cernuschi, Paris.

Fascinated by the effects of light on water, he visits the tropics.

Honored with the Fourth Annual Award of the Society for the Furthering of Studies on Costume.

Presented with the Fifth Annual Award for Outstanding Contributions from *Senken*, a trade newspaper for the Japanese textile industry.

1984 The exhibition *Itchiku Tsujigahana: Light and Wind* is held at the Laforet Museum, Tokyo.

Provides costumes for an original dance performance, "Dance of the Dream Robe," at the Shinbashi Theater, Tokyo.

An exhibition of his work travels to fourteen galleries and museums in as many cities in Japan.

Publication of Kubota's bilingual (Japanese/English) catalogue *Opulence: Itchiku Tsujigahana* by Kodansha, Japan.

1985 Creates costumes for a theatrical performance at the Exhibition of Science and Technology, Tsukuba, Japan.

1986 Organizes a traveling exhibition to eleven galleries and museums in as many cities in Japan.

1987 Exhibits a wall hanging at the Musée d'Art moderne de la Ville de Paris, France.

1988 Exhibition at the Museum of Modern Art, Saitama, Japan.

Designs a noh costume presented to Pope John Paul II.

1989 An exhibition of Kubota's work travels to the European venues of the Royal College of Art, London; the Centre Culturel le Botanique, Brussels; and the Museum Volkenkunde, Rotterdam.

1990 Organizes a traveling exhibition that goes to three venues in Spain: the Museo de Arte Contemporáneo, Madrid; the Museo Camón Aznar de Ibercaja, Zaragoza; and the Museo Etnológico de Barcelona.

Exhibition at the Westpac Gallery, Melbourne, Australia.

Exhibition at the Palais de Tokyo, Paris.

Receives the decoration of Chevalier de l'Ordre des Arts et des Lettres from the French Ministry of Culture [**4**].

1991–92 Traveling exhibition to nineteen galleries and museums in as many cities in Japan.

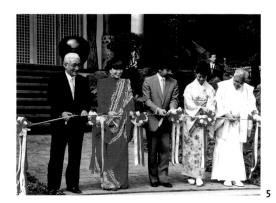

1994 Opens Itchiku Kubota Art Museum, Lake Kawaguchi, Yamanashi, Japan [**5**].

1995–96 The exhibition *Homage to Nature: Landscape Kimonos by Itchiku Kubota* opens at the Canadian Museum of Civilization, Hull, Quebec, and the National Museum of Natural History, Smithsonian Institution, Washington, D.C.

The bilingual (French/English) catalogue for the exhibition *Itchiku Tsujigahana: Itchiku Kubota* is published by the Canadian Museum of Civilization.

1997 An exhibition travels to twelve cities in Japan.

2000 The exhibition *Sinfonie des Lichts: Landschaften auf Kimonos von Itchiku Kubota* (*Symphony of Light: Landscape Kimonos of Itchiku Kubota*) opens at the Kunstforum der GrundkreditBank, Berlin, and the Museen des Hofmobiliendepots, Vienna [**6**].

2001 Creates costumes for a noh theater performance at the Itchiku Kubota Art Museum [**7**].

2002 Traveling exhibition to two cities in Japan.

2003 Passes away at the age of eighty-five.

2004 Kubota's son Satoshi, following Japanese artistic tradition, becomes Itchiku Kubota II and continues his father's work and studio.

2008 Exhibition and catalogue *Kimono as Art: The Landscapes of Itchiku Kubota* organized by the San Diego Museum of Art and presented jointly at the San Diego Museum of Art and the Timken Museum of Art, San Diego (November 1, 2008–January 4, 2009).

2009 *Kimono as Art* presented at the Canton Museum of Art, Canton, Ohio (February 8–April 26, 2009).

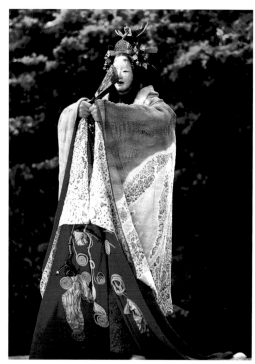

OVERVIEW OF THE BASIC PRODUCTION TECHNIQUES OF ITCHIKU KUBOTA

DALE CAROLYN GLUCKMAN

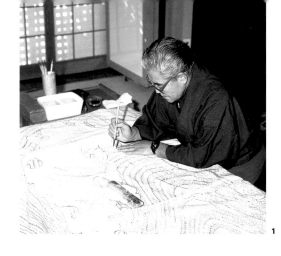

Because Kubota produced pieces in more than one style, he varied the combination of methods he used based on the requirements of each kimono. The methods described here form the basis of his work, but they are just a few of the techniques in his repertoire, which he continued to expand and develop throughout his lifetime. All aspects of the process require great skill, years of experience, patience, and care. A single kimono can take up to a year to complete. Kubota's atelier continues production under the supervision of his son Satoshi.

The original sketch
The components of a kimono are cut from silk crepe (*chirimen*), either plain or with gold or silver wefts, and temporarily basted into the shape of the finished garment. The design is sketched on the white silk with charcoal. Even at this early stage, Kubota would already have the full-color image of the final design worked out in his mind.[1]

The design is drawn with *aobana*, a liquid extracted from the flowers of the dayflower plant[2] (*Commelina communis* L.), a member of the spiderwort family [1]. The light blue color of the aobana is highly fugitive in water and sensitive to heat; it disappears during the dyeing process.

Fine details of the pattern are painted in aobana and the garment is taken apart. The design is then continued to the selvedges (woven edges of the fabric).

Creating the resist
Large patterns are outlined with stitches in a technique known as stitched tie-dye (*nuishime shibori*). Dye-resistant plastic thread is used.[3] The threads are pulled up tightly, wound around three times, and secured with a double knot [2].

Areas of the fabric that "puff up" as a result of the gathering of the outlining threads are covered with plastic sheets and secured with a plastic binding thread (*bōshi shibori*) [3]. These are "resisted" areas, or the parts of the fabric that are to remain white during the dyeing process. The gathering and the plastic covering prevent the dye from reaching the fabric.

Dyeing the ground
The individual lengths of the kimono are sewn into a single, long strip and immersed in the dye bath for the ground color.

Chemical dyes have a tendency to separate when heated, creating an uneven, blotchy ground. After years of experimentation, Kubota learned how to control this effect and incorporate it to advantage in his work. Shaded gradations are sometimes added, and the combination of the two effects gives an illusion of depth to the surface of the cloth.[4]

Brushing on color
More resist threads are sewn into the white areas and bound off.

Where required by the design, dye colors are brushed on exposed areas (*hikizome*) [4].

Steaming the silk
The silk cloth is steamed to fix the dye [5]. The cloth is surrounded by newspaper after it is placed in the steam box to prevent the steam from damaging the fabric.

The depth of color can be controlled by varying the temperature. Usually, the cloth is steamed at 180° F (82° C) for forty to ninety minutes. To assure proper penetration of the dyes, this process is repeated up to ten times.

Rinsing the silk
The cloth is rinsed to remove excess dye [6]. Because silk can only absorb a given amount of dye at a time, rinsing between dye applications allows the same piece to be dyed multiple times.

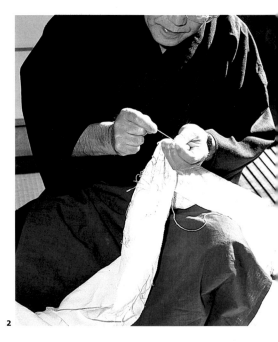

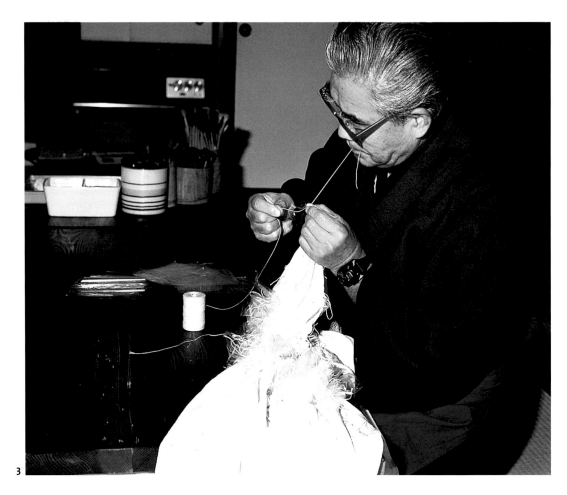

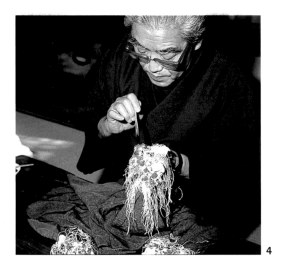

Drying the silk

Bamboo stretchers (*shinshi*) keep the cloth taut while it dries. Pins on the ends of the stretchers are inserted at the selvedges. These hold the weft threads under tension so that they remain horizontal to the warp. The cloth is then suspended in a room with good ventilation to dry.

The process of tying, dyeing, cutting the threads, steaming, rinsing, dyeing, and restitching is repeated in various combinations up to thirty times.

Applying the ink

While the dry cloth is still stretched taut by the shinshi, designs are drawn and shading added with a brush and ink (*sumi*).

Adding texture

The entire piece is restitched and bound to restore the texture created by the tie-dyeing techniques (*shibori*).

Cutting the threads

The threads are cut to undo the tie-dyeing [**7**]. It requires great skill to cut the knots very close to the fabric for easy removal, while not cutting the fabric itself.

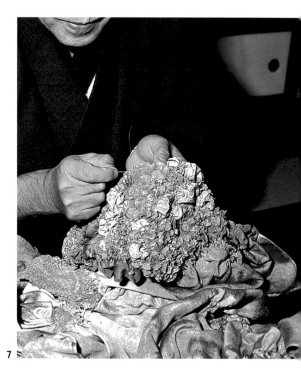

Removing the threads and finishing

Pulling the fabric in various directions makes removal of the threads easier and also allows for a final check of the dyeing [**8**].

The fabric is lightly pressed with a steam iron to open the cloth and make the edges lie flat. Sometimes more freehand drawing, embroidery, or gold leaf is added.

At last the fabric is sewn into a garment.

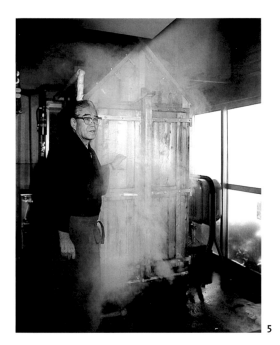

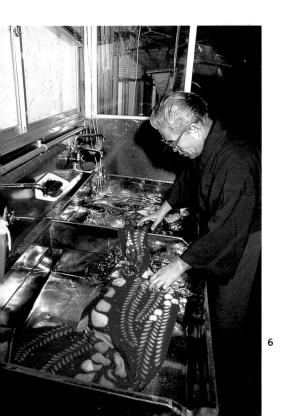

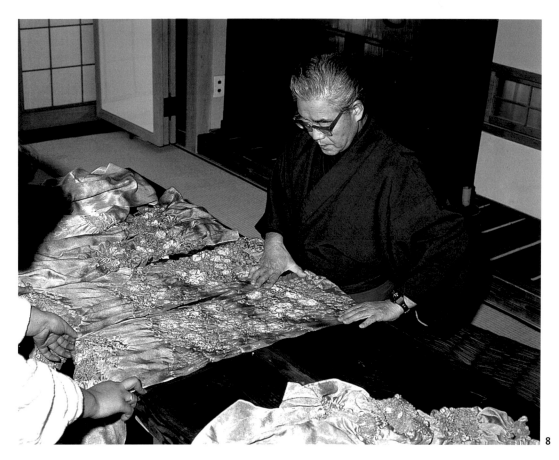

NOTES

The Kimono Redefined: Tradition and Innovation in the Art of Itchiku Kubota (pp. 16–25)

1. See also his description of amateur theatrical performances in the prisoner-of-war camp (Kubota 1984, p. 128). Although previously cited in both Japanese and English publications as a six-year imprisonment, Kubota's son is clear that it was three years (see "Homage to My Father," this volume).

2. For a fuller exposition of this subject, see the author's essay "Toward a New Aesthetic: The Evolution of the Kosode and Its Decoration," in Gluckman and Takeda 1992, pp. 65–93.

3. Neither the stylistic parameters nor the temporal boundaries of tsujigahana are clear; scholars differ in their definition and dating. However, the modern term generally encompasses the techniques of shibori, ink painting, metallic leaf, and embroidery, used in various combinations on garments worn by men and women, extending into the early seventeenth century (see Itō 1985 and Kawakami 1993). Japanese textile historian Terry Milhaupt, however, proposes in her 2002 doctoral dissertation that in the sixteenth century, the term tsujigahana (literally, flowers at the crossroads) applied only to designs with a combination of intersecting lines and flowers executed in tie-dyeing and ink painting (sometimes with the addition of metallic leaf), but without embroidery. Milhaupt further asserts that tsujigahana was worn primarily by elite women and young men (see Milhaupt 2002/2007).

4. Maruyama 1988, p. 18.

5. Kubota 1984, p. 128.

6. CSU Fullerton 1980, p. 31.

7. CSU Fullerton 1980, p. 33.

8. Discussed in Wada, Rice, and Barton 1983, p. 217.

9. Kubota 1984, p. 129.

10. Kubota 1995, p. 26.

11. Kubota 1984, p. 130.

12. Ibid.

13. Ibid.

14. See, for example, an embroidered noh robe with flowers of the four seasons in squares in the collection of the Kyoto National Museum, illustrated in Kyoto Shoin's Art Library of Japanese Textiles, vol. 7, Japanese Embroidery (Kyoto: Kyoto Shoin, 1993), no. 19, pp. 30–31.

15. According to Satoshi Kubota, Itchiku's son and artistic heir, he intends to finish The Four Seasons series as his father envisioned it but has not yet begun to do so.

16. For an example, see Nagasaki 2002, cat. no. 91, pp. 208–9.

17. Paul 1984, pp. 20–21.

18. Kubota 1984, pp. 78–79.

19. Illustrated in Boston, Chicago, and Los Angeles 1982–83, cat. nos. 49, 70.

20. In Stevens and Wada 1996. Edson's four season pieces are illustrated on pp. 116–17; Ray's work is illustrated on p. 119.

Kubota as Imagist: Reinventing Pictorial Icons in Kimono Form (pp. 26–37)

1. Emakimono are paintings in a long handscroll format, viewed from right to left, often with a narrative theme. Text usually precedes, follows, or is interspersed with the images.

2. Shiki-e are paintings of the four seasons that include migratory birds and seasonal flowers as well as human activities that take place at set times throughout the year. The paintings are usually arranged as spring, summer, autumn, and winter.

3. Ippen Shōnin proselytized the teaching of the chanting of the name of the Amida Nembutsu throughout Japan, to honor and invoke the Buddha of the Western Paradise.

4. In 1979, Higashiyama Kaii executed a second series of paintings at Mieidō—Moonlit Night at Guilin, Dusk on the Lijian, and Huangshan after Rain—based on sketches he made while traveling in China.

5. Hōsōge (literally, flowers of precious appearance) are imaginary flowers of even-numbered petals that combine the tree peony, lotus, and pomegranate flower. The motif may have originated in Iran or Central Asia and traveled east via the Silk Road. It was introduced into Japan from China in the eighth century as a design element in Buddhist ornamentation.

6. The low horizon line, a European invention, was first employed by Japanese artists in ukiyo-e prints and Western-influenced paintings.

7. In the thirteenth century, members of the court had determined and defined the differences between native painting (yamato-e) or native style (wayō), and Chinese-inspired painting (kara-e) or Chinese style (karayō). Native topography in painting became a signifier of native style from that time forward.

8. Torii (literally, a bird's perch) is the gate at the entrance to the sacred precincts of a Shinto shrine.

Symphony of Light (p. 38)

1. Kubota 1984, pp. 129–30.

2. Kubota 1995, p. 18. The thirty pieces were displayed at the Canadian Museum of Civilization in Hull, Quebec (June 2–Oct. 29, 1995) and the National Museum of Natural History, Smithsonian Institution, Washington, D.C. (Nov. 16, 1995–Apr. 7, 1996).

3. The Oceans have been included in the Winter section of the Four Seasons. Oceans appears to be a general word Kubota used for both the idea of a very large lake as well as the seas. Takamura Fumihiko, e-mail message to author, April 16, 2008.

4. Takamura Fumihiko, e-mail message to author, March 2, 2008.

Mount Fuji (pp. 120–21)

1. Images of Mount Fuji occasionally appear on ceremonial cloths for wrapping or covering gifts (fukusa), the lining of jackets (haori) for men, doorway hangings (noren), and bedding (futon covers), primarily dating from the nineteenth century and later; direct representations on women's silk kimono of any period, however, are rare.

2. McCullough 1968, p. 76.

3. For an illustration, as well as a discussion of the idea that the image was intended to provide protection during battle, see Nagasaki 2002, cat. no. 25, pp. 125–27.

4. In 1984, Kubota said of his acquaintance with impressionism, "…I was also intrigued by the French Impressionist landscapes filled with sun and particularly by Monet's Water Lilies. I liked the way in which the lilies seemed to sway right and left in an overflow of reflected light. Their surface catches the inexhaustible richness of natural light as it shifts and changes" (Kubota 1984, p. 130).

5. MoMA 1999/2004, p. 98. Visitors to Monet's Giverny studio in 1918 "found a dozen paintings laid out on the floor" the way the artist planned to install them, one next to the other in an oval configuration. In this author's opinion, the Mount Fuji series has more in common with Haystacks in its concept and presentation, although it also incorporates the concern for changing natural light Kubota saw in the Water Lilies paintings. It may have been the installation of eight Water Lilies in the Musée de l'Orangerie in Paris that initially provoked Kubota to think about a series. For additional commentary on the role of impressionism on Kubota's work, see "Kubota as Imagist," this volume.

6. Quoted in Brettell 1987, p. 35.

7. Ibid.

Individual Works (pp. 132–37)

1. Kubota 1984, p. 128. *San* was originally shown as part of The Setting Sun series, about which Kubota commented in 1984: "[the series] reflects the emotions which arose as a result of my long sickness and subsequent resolve" (Kubota 1984, p. 129). Kubota was hospitalized with acute hepatitis in 1978 at the age of sixty-one and, while recuperating, made a decision to develop his own style rather than continue trying to recreate historical tsujigahana. As he had in Siberia, Kubota turned to the setting sun as a source of solace and as a vehicle for the expression of his emotions.

2. There are at least three distinct plants with heart-shaped leaves popularly called *aoi* in Japanese. The term actually refers to *futaba-aoi*, or wild ginger (*Asarum caulescens* Maxim). In modern usage, however, *aoi* is often translated as "hollyhock" (*tachi-aoi*) (Itō 1985, p. 195). In this volume, the use of "hollyhock" as a translation of *aoi* in the titles of Kubota's work follows the artist's preference. The term *aoi* is used in the publication text without translation.

3. See Musée Cernuschi 1983, cat. nos. 16–19; *Gen* is cat. no. 16. *Gen* is titled *Imaginaire* (*Imaginary*) and includes the comment, "In the darkness, the cherry tree spreads its blossoming branches" (my translation).

4. In the eighteenth century, *Dōjōji* was adapted for the kabuki stage and has become a standard in the repertoire of this popular form of traditional theater.

5. Musée Cernuschi 1983, cat. no. 16 (my translation).

6. *Kosode with Plum Trees* is a good example of the Kanbun style, despite its reconstruction from an altar cloth (*uchishiki*) donated to a Buddhist temple.

7. Date suggested by Nagasaki Iwao, former curator of costume and textiles, Tokyo National Museum, personal communication, 1990.

8. Illustrated in Murase 2003, cat. no. 144.

9. Published with the title *Divinity*, Musée Cernuschi 1983, cat. no. 29, and Kubota 1984, p. 145; published with the title *Divine Holiness*, Kubota 1995, p. 122.

10. Kubota 1984, p. 145.

11. Takamura Fumihiko, e-mail message to author, March 13, 2008.

12. See "The Kimono Redefined," this volume.

13. Illustrated in Tokyo National Museum 1990, cat. no. 190, p. 242. For a discussion of the relationship of lacquer and textiles in the Momoyama period (1573–1615), see Milhaupt 2003. The half-submerged-wheel pattern had been used on clothing since at least the early fourteenth century; for example, the design can be seen on the robe of a retainer in the *Kasuga Gongen reigen-ki*, a painted scroll dated 1309 in the Imperial Household Collection (illustrated in Gluckman and Takeda 1992, fig. 14b, p. 71).

14. *Kosode with Abstract Design*, Edo period, early 17th century, tie-dyeing on figured silk satin (*rinzu*), center back: 58 in. (147 cm), Kanebo Collection, Osaka; illustration by Gaby Beebee. *Kosode with Abstract Design* is illustrated in Nishimura 1976, plate 2. For examples of tsujigahana fragments with pine-bark lozenge (*matsukawabishi*) designs, see Kawakami 1993, plates 10, 11, 20, 22, 24.

15. *Kosode with Bridges, Plum Blossoms, and Water Plantain*, Edo period, early 18th century, tie-dyeing and embroidery on silk crepe (*chirimen*), center back: 61 in. (156 cm), Kanebo Collection, Osaka; illustration by Gaby Beebee. *Kosode with Bridges, Plum Blossoms, and Water Plantain* is illustrated in Nishimura 1976, plate 11.

16. See "The Kimono Redefined," this volume.

17. In the Nomura Collection, National Museum of Japanese History, Chiba; illustrated in Gluckman and Takeda, cat. no. 9, p. 241. For a discussion of Kanbun style, see "The Kimono Redefined," this volume, and Gluckman in Gluckman and Takeda 1992, pp. 88–90.

18. Baird 2001, pp. 230–31.

19. The Shōsōin is a wooden storehouse that preserved objects associated with or owned by the imperial family, particularly the Emperor Shōmu (d. 756) and his wife, Empress Kōmyō (d. 760). The collection includes the oldest surviving textiles in Japan.

20. Kubota 1995, p. 121.

Overview of the Basic Production Techniques of Itchiku Kubota (pp. 152–53)

1. Kubota 1984, p. 120.

2. The earliest reference to "dayflower blue" appears in the eighth-century compilation of poems *Man'yōshū* (Collection of ten thousand leaves), where it is called *tsukikusa*. In the Edo period (1615–1868), it was called *tsuyukusa* or *bōshibana*, the former being the most widely used term. Milhaupt transliterates the term as *tsuyugusa* or *tsukigusa*. See Sasaki 2001, and Milhaupt 2002/2007, p. 41.

3. In the late sixteenth to the early seventeenth century, bast-fiber thread was used for the stitch resist. Because the thread swelled with moisture when the fabric was dyed, removing it was extremely difficult and time-consuming. In some surviving textiles from this period, there are bast-fiber threads remaining in the cloth, indicating that some of the threads could not be removed without damaging the delicate silk and thus were left in place. See Yamanobe Tomoyuki in Kubota 1984, p. 82.

4. Kubota 1984, p. 121.

GLOSSARY OF TERMS

Aobana Light blue liquid from a variety of the dayflower plant (*tsuyukusa*; Lat. *Commelina communis* L.); used for drawing the initial designs on white fabric at the commencement of *yūzen* and tie-dyeing; disperses when heat or water is applied.

Aoi Wild ginger plant (*futaba-aoi*; Lat. *Asarum caulescens* Maxim); a popular motif on silk kimono from at least the sixteenth century. Two other plants with heart-shaped leaves are also called *aoi*: pickerel weed (*mizu-aoi*) and hollyhock (*tachi-aoi*). "Hollyhock" is a common translation of *aoi* in modern times.

Bast fiber Plant fibers used to make rope, matting, baskets, paper, and clothing before the widespread introduction of cotton into Japan in the nineteenth century. The most commonly used bast fibers in Japan are hemp, ramie, and China grass, although there are many others.

Batik Technique of patterning a textile by applying molten wax to areas of the cloth to prevent the absorption of dye during the dyeing process.

Bingata Okinawan technique of patterning textiles by using a dye-resistant paste to stencil brightly colored designs on cloth.

Borrowed view (*shakkei*) Scenery visible beyond the confines of a garden, such as a distant mountain, that becomes an integral part of the view.

Bōshi shibori (literally, capped *shibori*) Technique used to protect (or reserve) large areas from the dye bath. After an area to be reserved is stitched off, with the thread pulled tightly around it (*nuishime shibori*), it is wrapped or "capped" in a bamboo sheath or, more recently, plastic. See also *shibori*.

Byōbu-e Paintings on folding screens (*byōbu*) consisting of two to eight joined panels; usually created in pairs.

Chirimen Plain-weave creped silk fabric. The warp is untwisted; the weft is highly twisted and starched to maintain the twist during weaving. After weaving, the starch is removed, releasing the twist in the wefts and creating a crinkled surface.

Chōnin Urban residents not in the samurai class; for example, merchants, craftsmen, and actors. Chōnin were the lowest social class during the Edo period.

Dan-gawari Style of patterning a *kosode* with alternating blocks of different colors, designs, or materials. Popular from the late sixteenth to the early seventeenth century, after which the style was used almost exclusively for noh robes.

Dōbuku (also *dōfuku*) Hip-length, open-fronted coat worn as leisure attire by men of the merchant class beginning in the late Muromachi period (first half of the sixteenth century); it was soon adopted by the samurai class for informal indoor or outdoor wear from the late sixteenth through the seventeenth century.

Fuki Roll of padding covered by the lining that is an addition to or extension of the hemline of a kimono, especially the *uchikake*. It weights the garment, controlling the fall of the skirt, and protects the expensive fabric of the *kosode* from soil and wear.

Fukusa Gift wrapping or cover made of cloth, often elaborately decorated with pictorial imagery.

Furisode (literally, swinging or waving sleeves) Long-sleeved, heavily patterned variation of the kimono worn by young girls and unmarried women on special occasions. Because waving sleeves were thought to attract a husband, the garment was not considered appropriate for married women.

Fusuma-e Paintings on the sliding-door panels (*fusuma*) that separate rooms of a Japanese building.

Futon Quilted sleeping pad filled with cotton.

Glossed silk Reeled silk with the *sericin* removed. See also *nerinuki*, *sericin*, *unglossed silk*.

Goshodoki (literally, imperial court style) Designs of landscapes with seasonal flowers and grasses, among which are scattered objects such as fans and oxcarts that allude to classical literature and noh plays. Once exclusively worn by women of the samurai class, goshodoki designs today are common on formal kimono.

Haori Short jacket worn over the kimono, and of similar cut. The haori is open at the front and held together with a pair of braided silk cords.

Hikizome Applying dye with a brush; used in *yūzen* dyeing.

Jinbaori Short, sleeveless coat worn by warriors on the battlefield. Jinbaori patterns were often designed to highlight a warrior's military prowess or to offer symbolic protection.

Kabuki Popular form of theater with exaggerated costumes and make-up as well as dramatic stage effects. It originated in the late sixteenth century, after a Shinto shrine attendant, Okuni, and her troupe of women gave a public performance of a drama that included dances. Edo period kabuki was performed by men only (including women's roles), and kabuki actors were the celebrities of their day.

Kaga-yūzen Dyeing technique developed in the city of Kanazawa, Ishikawa prefecture, in the late seventeenth century. Using the rice starch and paper stencils common to *yūzen* dyeing in other areas of Japan, it is characterized by color gradations and the predominance of shades of deep red, purple, and indigo.

Kaki-e Textile term for brush-painted pictorial imagery on fabric using ink, dyes, or pigment; for example, the ink painting in *tsujigahana*.

Kami Shinto deity of any gender, often considered formless, that inhabits a sacred site or object. Some people have been deified as kami,

such as the late seventh–early eighth-century poet Kakinomoto no Hitomaro, considered the god of poetry.

Kanbun kosode *Kosode* style popular in the Kanbun era in which a large design is concentrated on the right side of the back of the robe while the left side is undecorated; considered a high point in kosode fashion.

Kanoko shibori (*kanoko*: literally, fawn spots) Tie-dyeing technique in which tiny amounts of fabric are pinched up and wrapped to protect them from the dye bath, resulting in small white dots on a dyed ground.

Kara-e Paintings done in larger formats in the Chinese style. Kara-e were often displayed in public rooms as an homage to the Chinese source for much Japanese law and learning. Opposite of *yamato-e*.

Karayō Chinese style (as contrasted with *wayō*, Japanese style) in Japanese art, architecture, poetry, and calligraphy.

Kasane shōzoku (literally, layered clothing) Dress style of aristocratic women of the Heian period. Garments were layered to display set combinations of colors. These combinations were often given names that referred to natural phenomena such as seasonal flowers or plants and were meant to recall specific poems in classical literature.

Katabira Unlined summer *kosode* made of fine bast fiber (hemp or ramie); often *yūzen*-dyed and embellished with embroidery. Katabira were frequently decorated with patterns that suggested coolness, such as flowing water or snow. Prior to the Edo period, the katabira could also be made of lightweight silk or cotton, but it was always unlined.

Keichō-somewake Decorative style on *kosode* worn by samurai-class women during the Keichō era, and remaining in fashion until the end of the Kan'ei era. Characterized by a parti-colored ground (*somewake*) created by stitch resist (*nuishime shibori*) of irregularly

shaped areas of black, red, brown, deep purple, or white. Additional decoration included various combinations of embroidery, *kanoko shibori*, and stenciled gold leaf (*surihaku*).

Kikkō Hexagonal motif—usually an allover repeat but sometimes used alone—said to represent a tortoiseshell design. Considered an auspicious motif, because the tortoise is a symbol of longevity.

Kimono (literally, the thing worn) Term that has replaced the word *kosode* in reference to the standard Japanese garment since the Meiji period, although stylistic variations also have their own specific names. *Kosode* is the appropriate term to refer to the kimono-like garments worn prior to the end of the Edo period.

Kosode (literally, small sleeves) Forerunner of the modern *kimono* and the contemporary generic term for any full-length robe with a small sleeve (that is, a small wrist opening) prior to the Meiji period. In the Heian period, it was worn as an undergarment by both men and women of the court nobility; by the late fifteenth century, it had become the outer garment for all classes. The term *small sleeves* referred to the small opening for the wrist, not the length of the sleeve, which distinguished the kosode from the *ōsode*.

Mandala (from Sanskrit) Diagram representing a view of a cosmic order; most often Buddhist but, in Japan, also showing sacred Shinto sites.

Matsukawa (literally, pine bark) Zigzag-shaped outline used to divide the design field on a *kosode* or *kimono* into large, flowing diagonals or horizontal divisions, usually filled with smaller pattern elements.

Matsukawabishi (literally, pine-bark lozenges) Stylized motif of three superimposed, offset diamond shapes forming an allover repeat pattern or scattered units. Commonly found on lacquer, ceramics, and textiles from the Momoyama through the Edo periods. The pine tree (*matsu*)

in China and Japan is a symbol of virtue and longevity and is associated with winter and the New Year.

Meisho (literally, famous place) Site noted in poetry, and later painted showing the season most befitting to it, such as the Tatsutagawa (a river in Nara) in autumn. References to meisho function as *utamakura* (poem pillows), or pivotal words in poetry that set a specific mood, based on collected imagery found in poems about that place in the past.

Mi-dots Clusters of dots applied horizontally with wet ink to indicate foliage in Chinese painting and Chinese-style Japanese painting. Originated by the Chinese artist Mi Fu (1051/52–1107), from whom they take their name.

Murasaki Purple dye from gromwell root (Lat. *Lithospermum erythrorhizon*) imported from China. In the Nara period, it was highly prized and its use restricted to the emperor and his family. By the sixteenth century, a less costly substitute from sappanwood (*suō*) imported from Southeast Asia made the color available to all classes.

Nerinuki Plain-weave silk composed of *unglossed silk* warps and *glossed silk* wefts. It has a distinctive firmness and luster that was particularly well suited to the so-called *tsujigahana* style. In use since at least the tenth century, nerinuki lost popularity after silk damask (*rinzu*) became widely available in the early seventeenth century.

Nihon buyō (literally, Japanese dance) Artistic dance based on classical techniques derived from earlier forms and performed on the stage.

Nihonga Painting using traditional Japanese materials, such as *iwaenogu* (natural mineral pigments bound with deer-skin glue) and *sumi* ink on silk or paper. Opposite of *yōga*, Western-style painting with oil or acrylic on canvas or alternate materials.

Noh Classical Japanese musical drama that developed in the fourteenth

century from a combination of popular, folk, and aristocratic art forms to become a slow, stylized performance. Actors wear masks and elaborate costumes. Noh drama is often performed at Shinto shrines on outdoor stages.

Noren Decorative doorway hanging, usually of cotton or ramie with two or more panels joined at the top and suspended from a bamboo pole.

Nui (literally, sewing) The term for embroidery until the Meiji period; in modern usage, *nui* now refers to Western-style embroidery, and *nihon shishū* is the term for Japanese-style needlework using traditional motifs, materials, and techniques.

Nuishime shibori Tie-dyeing (*shibori*) technique that uses running stitches to outline the area to be resisted; the sewing threads are drawn up tightly and securely knotted; the puffed-up fabric in the center can be wrapped with more thread or protected from the dye with a covering (formerly, a bamboo sheath, now plastic sheeting). The result is a shaped area protected from the dye bath. A more precise method than *kanoko shibori*, nuishime can also be used for larger and more complex shapes. The main dyeing technique in *tsujigahana*, nuishime also played a key role in creating the *Keichō-somewake* style.

Obi Fabric sash used to keep the kimono robe closed.

Ōsode (literally, large sleeves) Any garment with a wrist opening that extends the full width of the sleeve; worn by the aristocracy in the Heian period and still worn by certain people, such as the imperial family or Shinto priests, for ceremonial occasions.

Rinzu Self-patterned satin weave in which the pattern is produced by the juxtaposition of the warp and weft faces of the weave. It is woven with the *sericin* still in the warps and wefts and is degummed (glossed) and dyed after being woven.

Rōketsuzome Resist-dyeing technique in which wax is used as the resist;

characterized by the small, broken lines that form when the wax cracks and allows dye to seep through. Although examples survive in Japan from the Nara period, rōketsuzome is a revival by Tsurumaki Tsuruichi, a textile artist and scholar of the Taishō period. See also *batik*.

Sericin Gummy substance secreted by the silkworm that coats the threads as it forms its cocoon, from which silk thread is ultimately derived.

Shibori Type of resist dyeing in which certain areas on the cloth are reserved from the dye by techniques that include binding, stitching, or wrapping, among others. It results in a raised and wrinkled surface on the finished cloth that is usually retained but can be removed by steaming or ironing.

Shin-hanga Prints using traditional Japanese materials and publishing techniques, in which a publisher commissions a design from an artist, a carver creates the printing blocks, and a printer produces the final works. Blocks are carved from wood, with a separate block for each color, and organized around a keyblock bearing the black outline.

Shinpa (literally, the new school) Meiji period theater genre that depicted the manners and customs of contemporary Japan. Unlike highly stylized kabuki, shinpa favored a more naturalistic approach, and women as well as *onnagata* (men performing as women) were cast in female roles. Shinpa dramas were usually sentimental in content, but with a tragic ending.

Shinshi Pliable bamboo rods with pins at either end to keep fabrics flat while drying; the rods are bent and the pins are inserted into the edges of the fabric, holding the fabric under tension across its width. There are two kinds of shinshi: thin rods used singly and placed across the width of the fabric at right angles to the edges, and thicker rods used in pairs and joined together in a cross shape.

Shippō tsunagi (*shippō*: literally, seven treasures or jewels; *tsunagi*: interlocked) Design of interlocking coins (with a central hole) said to symbolize the Seven Treasures of Buddhism: crystal, lapis, gold, silver, mother-of-pearl, coral, and carnelian.

Shōji Paper-covered sliding screens used as room dividers or window covers.

Sode (literally, sleeve) Terms for specific styles of the basic *kimono* are based on their sleeve type, either distinguished by the size of the wrist opening or the length or shape of the sleeve. See *furisode, kosode, ōsode, tagasode byōbu, tomesode*.

Somewake (literally, divide by dyeing) Style of *kosode* decoration popular in the Keichō-Genna-Kan'ei eras in which large areas of the background are dyed in different colors and shapes using stitch resist (*nuishime shibori*) and capped resist (*bōshi shibori*). See also *Keichō-somewake*.

Sotoguma Shading or wash applied around a blank area or outlined form to indicate the presence of snow, mist, or clouds, or to emphasize volume.

Sudare Traditional bamboo curtain that, when rolled up, is held by metal hooks with large tassels.

Sumi Black ink made from pinewood charcoal or lamp soot mixed with a gum-like substance soluble in water. Used for painting on silk or paper.

Surihaku Metallic leaf. Paste is first applied to the fabric, and gold and/or silver leaf is pressed on. After the paste has dried, the excess leaf is rubbed off to articulate a motif.

Tagasode byōbu (*tagasode*: literally, whose sleeves?) Paintings on folding screens (*byōbu*) popular in the late sixteenth and seventeenth centuries showing *kosode* (and sometimes men's garments) hanging on racks. In the Nara and Heian periods, aristocratic women sat behind bamboo screens, with only the very wide sleeves of their robes visible to a visitor. The name *tagasode* derives

from a line frequently used in classical poetry to refer to the unseen presence of a woman.

Tan Standard bolt of cloth sufficient to make one kimono. The width is approximately 14 inches (36 cm) and the length approximately 12 yards (10.6 m).

Tatsutagawamon Design of maple leaves floating on water, a reference to the Tatsutagawa, a river near Nara, where aristocrats during the Nara and Heian periods went to view maple leaves in autumn. See also *meisho*.

Tomesode Modern women's kimono with short sleeves (which end at approximately the top of the thigh) and a small wrist opening.

Tsujigahana (literally, flowers at the crossroads) Modern term given to textiles of the late fifteenth and early sixteenth century that combine stitch resist and ink-painted flowers. The term is also loosely used to refer to textiles produced throughout the sixteenth and even the early seventeenth century that exhibit stitch resist, along with delicate ink painting, embroidery, and metallic leaf equally balanced in emphasis. There is no definite connection between the word *tsujigahana* in historical texts and any surviving textile examples. One textile historian suggests tsujigahana was primarily confined to stitch resist, cross-hatched lines, and ink painting, and was only worn by elite women and young men, but there is still no consensus among Japanese textile scholars.

Uchikake Full-length, unbelted outer robe with a trailing hem. Until the Edo period, it was worn by women of the aristocracy or samurai class on special occasions. The lower edge is padded to give added weight and shape to the hemline.

Uchishiki Decorative cloth for a Buddhist altar table. Often made of the clothing of deceased women or young children to pay for memorial services at a temple.

Ukiyo-e Paintings and prints of the "floating world"; mainly composed of entertainers and courtesans, the floating world flourished from the seventeenth to the nineteenth century in Edo, Kyoto, and Osaka, and was patronized primarily by the townsmen class (*chōnin*).

Unglossed silk Reeled silk with the *sericin* left in. See also *glossed silk, nerinuki, sericin*.

Wayō Native Japanese style, as opposed to Chinese style (*karayō*), in Japanese art, architecture, poetry, and calligraphy.

Yamato-e Paintings in which the subject, format, composition, and stylization represent a native Japanese manner. Yamato-e were often displayed in private rooms or viewed by people of shared interests. Opposite of *kara-e*.

Yūzen Resist-dyeing technique in which designs are created either freehand with a brush (*hikizome*) or with stencils as guides (*katazome*). Developed in Kyoto during the late seventeenth century—possibly by Miyazaki Yūzensai, a fan painter, from whom the name derives—yūzen gradually became the dominant method of patterning *kimono* by the middle of the eighteenth century and has remained so to the present. A rice-paste resist is used to outline the designs and protect previously dyed areas from subsequent dye baths, resulting in a sharp-edged pictorial design with a thin white outline. Yūzen allowed for the development of detailed pictorial imagery on kimono.

BIBLIOGRAPHY

Akanoma 1989.
Akanoma Yukinori, ed. *Kaii Higashiyama*. Sandy Hook, CT: Shorewood Fine Art Books, 1989.

Asian Art Museum 1997.
Classical Kimono from the Kyoto National Museum: Four Centuries of Fashion. Exh. cat. San Francisco: Asian Art Museum. Seattle: University of Washington Press, 1997.

Baird 2001.
Baird, Merrily. *Symbols of Japan: Thematic Motifs in Art and Design*. New York: Rizzoli, 2001.

Boston, Chicago, and Los Angeles 1982–83.
Living National Treasures of Japan. Exh. cat. Boston: Museum of Fine Arts, Boston; Chicago: Art Institute of Chicago; and Los Angeles: Japanese American Cultural and Community Center. Tokyo: Committee of the Exhibition of Living National Treasures of Japan, 1982.

Brettell 1987.
Brettell, Richard. *Post-Impressionists*. Chicago: Art Institute of Chicago; New York: Harry N. Abrams, 1987.

CSU Fullerton 1980.
Itchiku Kubota: Kimono in the Tsujigahana Tradition. Exh. cat. Fullerton: The Art Gallery, Visual Arts Center, California State University, Fullerton, 1980.

Gluckman and Takeda 1992.
Gluckman, Dale Carolyn, and Sharon Sadako Takeda. *When Art Became Fashion: Kosode in Edo-Period Japan*. Los Angeles: Los Angeles County Museum of Art; New York: Weatherhill, 1992.

Guth 1996.
Guth, Christine. "Textiles." In *Japan's Golden Age: Momoyama*, edited by Money L. Hickman with John J. Carpenter. Exh. cat. Dallas: Dallas Museum of Art. New Haven, CT: Yale University Press, 1996.

Hokkaidō Kenritsu Bijutsukan 1995.
Hokkaidō Kenritsu Bijutsukan. *Yokoyama Taikan: Umi, yama, sora no sekai*. Sapporo: Sapporo terebi, 1995.

Itō 1985.
Itō Toshiko. *Tsujigahana: The Flower of Japanese Textile Art*, trans. by Monica Bethe. 1st standard ed. Tokyo: Kodansha International, 1985.

Kaufman 1992.
Kaufman, Laura S. "Nature, Courtly Imagery, and Sacred Meaning in the *Ippen Hijiri-e*." In *Flowing Traces: Buddhism in the Literary and Visual Arts of Japan*, edited by James H. Sanford, William R. LaFleur, and Masatoshi Nagatomi, pp. 47–75. Princeton, NJ: Princeton University Press, 1992.

Kawakami 1993.
Kawakami Shigeki. *Tsujigahana*, trans. by Shimoyama Ai and Judith A. Clancy. Kyoto Shoin's Art Library of Japanese Textiles 2. Kyoto: Kyoto Shoin, 1993.

Kubota 1984.
Kubota Itchiku. *Opulence: Itchiku Tsujigahana*. Tokyo: Kodansha International, 1984.

Kubota 1995.
Kubota Itchiku. *Itchiku Tsujigahana*. Exh. cat. (*Homage to Nature: Landscape Kimonos by Itchiku Kubota*). Hull, Quebec: Canadian Museum of Civilizations; Washington, D.C.: National Museum of Natural History, Smithsonian Institution, 1995.

Maruyama 1988.
Maruyama Nobuhiko. "*Kosode* of the Pre-Modern Age." In *Robes of Elegance: Japanese Kimonos of the 16th–20th Centuries*, edited by Ishimura Hayao and Maruyama Nobuhiko. Exh. cat. Raleigh: North Carolina Museum of Art, 1988.

McCullough 1968.
McCullough, Helen Craig, trans. *Tales of Ise: Lyrical Episodes from Tenth-Century Japan*. Stanford, CA: Stanford University Press, 1968.

Milhaupt 2002/2007.
Milhaupt, Terry Satsuki. "Flowers at the Crossroads: The Four-Hundred-Year Life of a Japanese Textile." Ph.D diss. Washington University, 2002. University of Michigan: UMI Dissertation Services, 2007.

Milhaupt 2003.
Milhaupt, Terry Satsuki. "*Tsujigahana* Textiles and Their Fabrication." In Murase 2003.

MoMA 1999/2004.
Museum of Modern Art. *MoMA Highlights*. New York: Museum of Modern Art, 1999, rev. ed. 2004. http://www.moma.org/collection/browse_results.php?object_id=80220

Murase 2003.
Murase, Miyeko, ed. *Turning Point: Oribe and the Arts of Sixteenth-Century Japan*. Exh. cat. New York: Metropolitan Museum of Art. New Haven, CT: Yale University Press, 2003.

Musée Cernuschi 1983.
Kimonos de Kubota Itchiku. Exh. cat. Paris: Musée Cernuschi, 1983.

Nagasaki 2002.
Nagasaki, Iwao. "Women's Kosode and Social Status." In *Kazari: Decoration and Display in Japan, 15th to 19th Centuries*, edited by Nicole Coolidge Rousmaniere. New York: Japan Society, 2002.

Nishimura 1976.
Nishimura Hyōbu, et al. *Tagasode: Whose Sleeves...Kimono from the Kanebo Collection*. New York: Japan Society, 1976.

Paul 1984.
Paul, Margot. "A Creative Connoisseur: Nomura Shōjirō." In *Kosode: 16th- to 19th-Century Textiles from the Nomura Collection*, by Amanda Mayer Stinchecum et al. New York and Tokyo: Japan Society and Kodansha International, 1984.

Sasaki 1996.
Sasaki, Jōhei. *Maruyama Ōkyo kenkyū*. Tokyo: Chūō Kōron Bijutsu Shuppan, 1996.

Sasaki 2001.
Sasaki, Shiho. "Review of MA Paper Conservation: Japanese Prints." *V&A Conservation Journal* 38 (summer 2001). http://www.vam.ac.uk/res_cons/conservation/journal/issue38/index.html

Stevens and Wada 1996.
Stevens, Rebecca A. T., and Yoshiko Wada, eds. *The Kimono Inspiration: Art and Art-to-Wear in America*. Exh. cat. Washington, D.C.: The Textile Museum. San Francisco: Pomegranate Artbooks, 1996.

Stinchecum 1984.
Stinchecum, Amanda Mayer, et al. *Kosode: 16th- to 19th-Century Textiles from the Nomura Collection*. Exh. cat. New York and Tokyo: Japan Society and Kodansha International, 1984.

Takeuchi 1992.
Takeuchi, Melinda. *Taiga's True Views: The Language of Landscape Painting in Eighteenth-Century Japan*. Stanford, CA: Stanford University Press, 1992.

Tokyo National Museum 1990.
Tokyo National Museum. *National Treasures of Japan*. Tokyo: Yomiuri Shimbun, 1990.

Tyler 1993.
Tyler, Royall. "'The Book of the Great Practice': The Life of the Mt. Fuji Ascetic Kakugyo Tobutsu Ku." *Asian Folklore Studies* 52, pp. 251–331. Nagoya: Nanzan University Press, 1993.

Wada, Rice, and Barton 1983.
Wada, Yoshiko, Mary Kellogg Rice, and Jane Barton. *Shibori: The Inventive Art of Japanese Shaped Resist Dyeing*. Tokyo: Kodansha International, 1983.

Wheelwright 1989.
Wheelwright, Carolyn, ed. *Word in Flower: The Visualization of Classical Literature in Seventeenth-Century Japan*. Exh. cat. New Haven, CT: Yale University Art Gallery, 1989.

Overleaf Detail of San, Cat. No. 46 (see also p. 138).

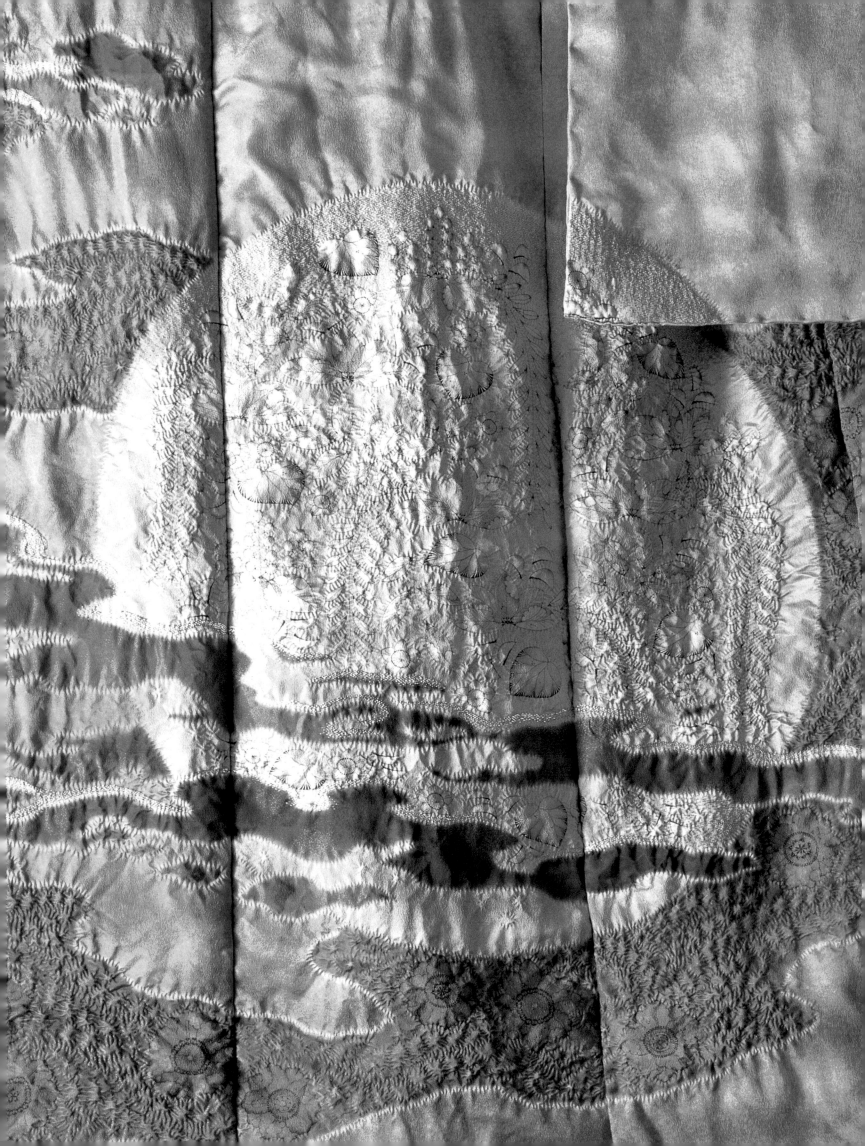